CHAGALL

Gill Polonsky

Phaidon Press Limited
Regent's Wharf, All Saints Street, London N1 9PA

First published 1998
Reprinted 2000
© 1998 Phaidon Press Limited

A CIP catalogue record for this book is available from the British Library

ISBN 0 7148 3403 3

Printed in Singapore

Cover illustrations:
Front: *Self-Portrait with Seven Fingers* (Pl. 13)
Back: *Pregnant Woman (Maternity)* (Pl. 15)

The author would like to thank Michael Polonsky and John Lahr for their encouragement over the years.

Chagall

'I had only to open my bedroom window and blue air, love and flowers entered with her.' Marc Chagall's poetic evocation of the magical moments before he married his great love Bella captures the essentially lyrical and celebratory nature of his life's work. Floating lovers, flying horses, a fiddler on the roof, 'blue air, love and flowers' – forms dissolved in swirling streams of saturated colour. It is a world of dreams, but paradoxically not quite a world apart. The mystical, the fantastic, and the imaginary are rooted in the Vitebsk of his childhood memories, a place of mud and poverty, but the potent and inexhaustible source of his imagery and inspiration. Memories of Vitebsk settled like a sediment in Chagall's consciousness. They fed his art with the images, the colours and the endless transformations with which we are now so familiar. Yet running like a thread through a lifetime of exuberant, often funny, sometimes sentimental image-making, is a profoundly tragic, reflective side. Here the persecution and suffering of the Jews – of all humanity – found expression in contemporary icons which must stand as collective symbols of hope for a different future. Chagall is the great 'poet-painter' of the twentieth century, a visionary who, despite incorporating, or in some instances prefiguring, the different movements which have characterized the art of our century, would never allow himself to be defined by those movements or their manifestos. And if, in the end, over-repetition and a nostalgic whimsicality took the tension and raw energy out of his work, he nevertheless remains one of those rare individuals who was able, at very many times in his life, to give form and expression to the formless and the inexpressible – to chart the inward and secret life of the psyche.

Marc Chagall, the eldest of nine children, was born as Moyshe Segal on either 6 or 7 July 1887 in the Russian city of Vitebsk. His father Zachar, who, in Chagall's eyes, was nothing more than 'a galley slave', hauled brine-soaked barrels for a herring merchant throughout his life. His mother Feiga-Ita, the linchpin of the family, supplemented the monthly wage of twenty roubles by setting up a small grocery store next to the house. In his autobiographical sketch *My Life*, written intermittently between 1915 and 1922, Chagall paints a word-picture which brings to life this world which was to become the stuff of his art. It is more a poetic *rêverie* – a work of lyrical confession – than a strict narrative of events; but paradoxically it is the main source of 'information' about Chagall's family and early life. Written with great affection and a certain wry amusement, he describes the idiosyncratic tendencies of this large, extended family which nurtured and surrounded him with all-loving, all-embracing warmth and tenderness in his childhood years.

My Life is anecdotal, funny, nostalgic, fantastical and sad – a mosaic of different memories which, like his paintings, rarely conveys what he saw, but suggests, in language as visually descriptive as any image, what he felt. And like his paintings, his prose is characterized by frag-

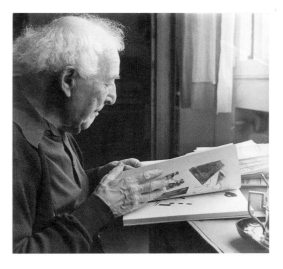

Fig. 1
ALFRED NEUMAN
Marc Chagall
c.1975. Photograph
Collection of Alfred and
Irmgard Neuman
Leo Baeck College,
London

mentation, expressionist dysjuncture, and the extraordinarily powerful desire to conceal at the very moment of confession and revelation. By the time Chagall completed this memoir both his parents were dead, and his recollections are tinged with melancholy. He laments over lives – particularly his father's – which were tedious and unremittingly harsh: 'Why try to hide it? How tell about it?' he wrote; 'No word will ever ease my father's lot … He lifted heavy barrels and my heart used to twist like a Turkish bagel as I watched him lift those weights …' Chagall wrote about his brother and sisters, and his innumerable uncles and aunts, but his most affectionate memories were of his grandfather – the ritual butcher of Lyozno, who, if legend is to be believed, liked spending hot summer evenings sitting eating carrots on the roof of the house. He was the synagogue's cantor, with a voice so melodious that the memory of it resonated for Chagall down through the years. It was, he wrote, 'as though an oil-mill were turning in my heart! Or as though a new honey, recently gathered, were trickling down inside me.'

Although Chagall's life does not *explain* his art, it was invariably his personal and cultural context which provided the memories and myths he transformed into poetic metaphor. 'Here is my soul,' he wrote; 'Look for me over here … here are my pictures, my origin…' However, as Chagall came to realize, and eventually to accept, his family completely ignored his art – an art which did not pretend to creating resemblances – and instead, as he put it, 'valued meat very highly'. Such misunderstanding, such insatiable longing to be understood, such urgency and determination to find a different way eventually forced Chagall to break the physical, although never the emotional, bonds which held him to Vitebsk. It was with great generosity, if a hint of frustration, that he was able to confess: 'If my art played no part in my family's life, their lives and their achievements greatly influenced my art … But … have you ever heard of traditions, of Aix, of the painter with his ear cut off, of cubes, of squares, of Paris? Vitebsk, I'm deserting you. Stay alone with your herring!'

At the time of Chagall's birth, conditions for Jews in Russia were very circumscribed. With the exception of a few thousand rich and educated individuals who were permitted to live and work in cities such as St Petersburg, Moscow and Kiev, some five million Jews were forced, from the late eighteenth century until the Revolution of 1917, to live within the so-called Pale of Settlement – a vast area of conquered territory on the western fringes of the Empire. They kept their religious and cultural identity intact; and, despite frequent pogroms and the constraints imposed on Jews by politically oppressive and discriminatory legislation, were nevertheless allowed unrestricted movement within the Pale itself.

Vitebsk was in the north-eastern corner of the Pale of Settlement. It was an important centre of commerce, with its own cathedral, a thriving port and a railroad junction with easy access to St Petersburg and Moscow. By the end of the nineteenth century, Vitebsk was also one of the routes by which Russian and Western European culture and ideas filtered through into the Pale, reinforcing the secular, enlightenment tendencies already manifest among Jewish artists, writers and intellectuals. Over 50 per cent of Vitebsk's total population of some 65,000 were Jews, the majority living away from the city centre in a suburban hinterland of rough wooden houses, muddy unpaved streets, and often extreme poverty. Chagall's family, like most Jews within the Pale, were Yiddish-speaking and, for geographical reasons, members of a Hasidic sect (the 'Lubavitsher' or 'Chabad') which valued scholarship as well as delighting in the activities more usually associated with Hasidism – singing, dancing and the spontaneous outpouring of emotion.

Chagall once described 'the mystique of Hasidism' as one of the fundamental sources of his art. He did not mean the esoteric doctrine and occult lore of Cabala ('received tradition'), in which hidden meanings in the Bible find interpretation, but, in the words of Erich Neumann, 'the warm, earthly fervour of Hasidic mysticism' which became the matrix for an entire universe of forms and symbols – a universe in which logic was overturned by magic and metamorphosis, where reality became myth, and where the word gave way to the image. Chagall's Hasidism represented that 'gold-land' of childhood where the symbolic and the supernatural were as unsurprising and familiar as the everyday. It was a world which – like Rimbaud's 'child-man' – Chagall never wanted to escape. His life-long attachment, first to Vitebsk, and then to the *idea* of Vitebsk, was supported by unclouded memories which nourished and fortified him at times of loss and in exile and found their way into paintings time and again, throughout his life.

This of course is not the whole story. At this time in history, when conventions of every kind were being questioned, Chagall and his generation of artists were uniquely placed to examine new structures of expression and to forge new ways of seeing. Nothing seemed impossible. As the process of secularization and enlightenment gathered pace, traditional Jewish opposition to image-making also began to break down. By the early years of the twentieth century an emergent Jewish avant-garde – which would later include Chagall – had already joined their Russian and Western European contemporaries in challenging the fine art traditions of an earlier generation. A whole range of images and objects – whether of Christian, Jewish or secular origin – which had not previously been recognized as appropriate aesthetic sources, had now become available, including folk art, popular prints (*lubok*), embroidery, icons, illuminated manuscripts, gravestones, and painted synagogues. At the same time, the work of European artists such as Paul Gauguin (1848–1903) and Henri Matisse (1869–1954) – both of whom used areas of pure colour for emotional and decorative effect – and the Symbolists – who gave visual expression to the mystical and the poetic – was beginning to make a considerable impact in Russia, and reproductions of their paintings were circulating in art journals, together with Symbolist poetry and contemporary music criticism. Within a few years, however, the impact of Russian culture on the West would be just as dramatic.

Fig. 2
The Cattle Dealer
1912. Oil on canvas,
97 x 200.5 cm.
Öffentliche
Kunstsammlung,
Kunstmuseum, Basle

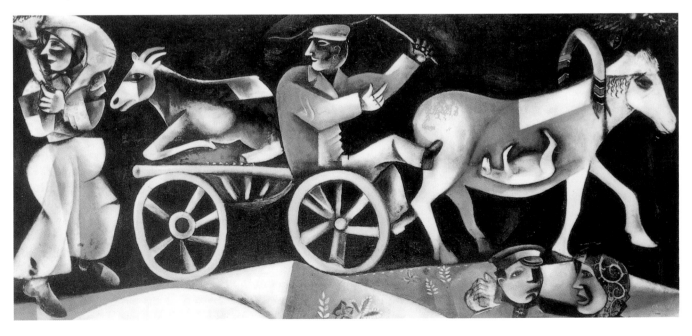

Fig. 3
Peasant Life
1925. Oil on canvas,
100 x 81 cm.
Albright-Knox Art Gallery,
Buffalo, NY; Room of
Contemporary Art Fund

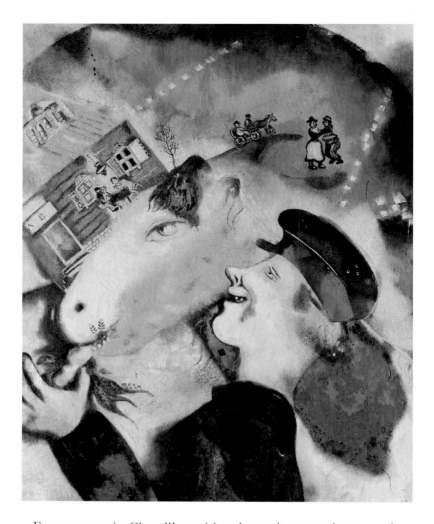

For someone in Chagall's position, becoming an artist seemed an impossible dream. He was born into a community where the word 'artist' had scarcely been uttered, and where superstition and prohibition attached to the idea itself. But while Chagall dreamed of escape, perhaps by becoming a singer, or a musician, a dancer, a poet – even something 'as fantastic ... as out of this world as ... an "artist"' – his mother plotted his destiny, clerking or accountancy, and bribed a teacher at the Russian school to overlook its ban on Jews, thus ensuring, she believed, his future success. Such encouragement meant little to Chagall. He wanted to be 'saved' from the starkness of his father's fate, and saw a way out through enrolment at Yehuda Pen's School of Painting and Design. Pen was primarily an academic portrait painter with a great mastery of technique; and Chagall, whose only previous experience was copying from illustrated magazines, learned certain basic skills there, while feeling instinctively that Pen's methods and aims were alien to his own. His 'daring' introduction of violet into a painting caused astonishment and excitement – as well as the offer of free tuition – but by then Chagall had already decided to accompany a friend to St Petersburg. He arrived towards the end of 1906 with 27 roubles in his pocket – the money which his father had 'flung under the table' to help him on his way. ' I forgive him,' Chagall wrote, 'it was his way of giving.'

Life in St Petersburg was precarious for a Jew, particularly after the political uprisings of 1905. Chagall did not have the necessary authorization to live and work in the city and was at first wholly dependent for support on the generosity of various wealthy patrons – notably Max Vinaver, one of the first Jewish deputies in the Duma (Parliament). He

was sufficiently impressed to buy Chagall's work and eventually to sponsor his years in Paris, at that time the undisputed art capital of the world. After a year spent studying in a traditional academy, Chagall entered the Zvantseva School, where he was taught by Léon Bakst (1866–1924), an aesthete and one of the leaders of the Symbolist-inspired World of Art movement ('where stylization, aestheticism, all sorts of worldly manners and mannerisms flourished'), which at that time represented the Russian avant-garde. Bakst was soon to achieve international acclaim as the set- and costume-designer for Sergei Diaghilev's *Ballets Russes*, and it was from him that Chagall learned to long for Paris – to dream of seeing at first hand paintings by Edouard Manet (1832–1883), Claude Monet (1840–1926), Vincent Van Gogh (1853–1890), Gauguin and Paul Cézanne (1839–1906). But he was also absorbing all that St Petersburg had to offer: its museums and churches, its atmosphere of openness and assimilation, its poetry readings, the discussions, and the restless agitation of a new generation of would-be avant-gardists – painters whose impulse was towards an expressionist art using 'primitive' distortion, simplified line, and large areas of bold unbroken colour for maximum effect. Matisse and the French Fauves (Wild Beasts), who used colour without inhibition, were an unmistakable influence on these artists, but this influence mingled with eclectic iconographic borrowing from the Russian Byzantine tradition (icons), from folk art, shop signs, and from the simple decorative surfaces of everyday objects.

In time Chagall would produce the most unselfconscious, the most authentic reconciliation or synthesis between these differing traditions. In that fusion of motifs taken from Jewish and Russian folk art, Christian iconography, and contemporary Western art he began to develop an original language of symbols – a 'Chagallian' universe in which the visual image became a metaphor for a different, internalized reality, mediated through the skein of memory and emotion. Biography, however mythologized and self-constructed, has rarely seemed so central to the understanding of an artist's *œuvre*.

During his years in St Petersburg or on his extended visits back to Vitebsk – where he met and fell in love with his future wife, Bella Rosenfeld – Chagall experimented with a number of styles. He began to edge towards a form of hallucinatory realism in which a narrative of events – frequently dramatic, but drawn from everyday life – took on an aura of mystical unreality. In a series of enigmatic figure compositions which included *The Dead Man* (Plate 2) and *Birth* (Plate 3), the means remain semi-naturalistic but the palette, whilst still sombre, creates an illusion of mysterious intensity. It underlines Chagall's interest in the independent expressive power of colour to evoke ideas and emotions beyond the 'mere' representation of the tangible world. This emphasis on the 'psychic value of colour' links up too with his awareness of Van Gogh, but more significantly, with Gauguin, with whom, as the *Self-Portrait* suggests, he felt the most profound affinity (Plate 1; Fig. 18).

Chagall arrived in Paris at a moment of astonishing vitality in the arts. It was an age of determined individualism, yet painters, writers and musicians of the avant-garde lived and worked closely together and frequently collaborated in one another's endeavours. Cubism, which was the dominant movement in painting at the time, had evolved as Pablo Picasso (1881–1973) and Georges Braque (1882–1963), working alongside each other like 'two mountaineers roped together', questioned the basic assumptions underlying Western art. In Cubist painting itself, references to the natural world can always be found, but as a conceptual rather than representational aesthetic, Cubism was to become the main source of abstraction and non-figurative painting in the twentieth

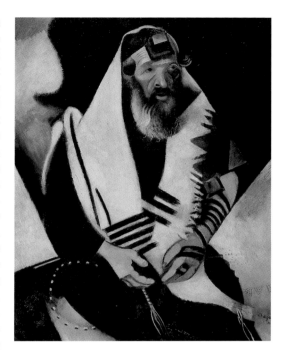

Fig. 4
The Praying Jew
(Rabbi of Vitebsk)
1914. Oil on canvas,
101.1 x 81 cm.
Stiftung Sammlung Karl
und Jürg im Obersteg,
Geneva

Fig. 5
Wounded Soldier
1914. Watercolour and
gouache on cardboard,
49 x 38 cm.
Private Collection

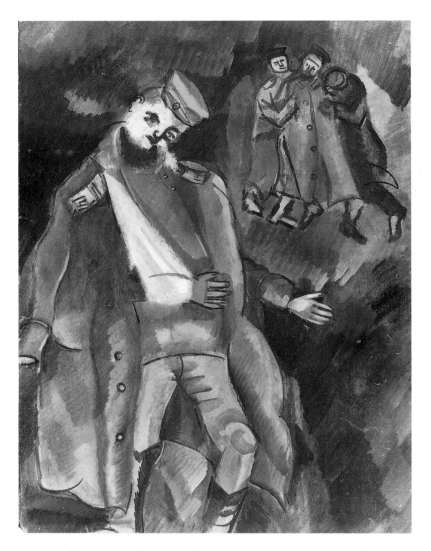

century. Picasso and Braque left it to others – most notably the critic-poet, Guillaume Apollinaire (1880–1918) – to support and theorize the movement, and it was through lectures, articles and exhibitions that its influence spread. It was part of the intellectual and artistic currency of the time and much under discussion in the cafés and salons of Paris.

After four days of travel, Chagall's first impressions of Paris were unfavourable, and he longed to return to Vitebsk. But within days he overcame those feelings and began to enjoy all that Paris had to offer – its museums, galleries and salons, as well as the bustling life of the streets and the people he met. He felt this was more of an education than any academy could have given him. He relished the atmosphere of teeming excitement and the intensity of the artistic ferment into which he was thrust – Paris in the late summer of 1910 was dizzy with celebrating the excesses of its self-conscious avant-garde.

In Paris, Chagall was very poor, but free in a way in which, as a Jew in Tsarist Russia, he could never have been free. He rented the Montparnasse studio of a fellow Russian painter, then in 1912 he moved to 'La Ruche' – the now legendary 'beehive' of ramshackle studios situated in the slaughter-house district, Vaugirard, where (he wrote) 'the artistic bohemia of every land' lived. Chagall enrolled at two art schools which he attended intermittently, and began painting on his own – using anything that came to hand, 'table napkins … bed sheets … nightshirts torn into pieces' and old pictures which were cheaper to buy than new canvas. The subdued, rather spectral nature of the Russian paintings now gave way, under the impact of a myriad of

new sensations, to a Fauve-inspired palette of strong, pure colour. In early paintings such as *The Studio* (Plate 5) and *The Sabbath* (Plate 4), the influence of Van Gogh is very marked, and colour, which floods the canvas, is used to convey a mood rather than to delineate form. The visionary element is further enhanced by distortion and, in *The Sabbath*, by the intense, eerie glow of candles and lamplight on an interior 'pervaded by the void of eventless time' (Franz Meyer) It is a painting which continues that series begun while Chagall was still in St Petersburg, and the nostalgia – even for ennui – is palpable, underpinning his recollection of that time: 'I brought my objects with me from Russia. Paris shed its light on them.'

The rigorous pictorial language of Cubism was inimical to Chagall's nature. It was too rational, too analytic for a painter whose endemic myth-making formed the backdrop to his entire life's work, and who, through his earlier experience of Bakst, Gauguin and the Fauves, now wanted to use colour as a vehicle for the immediate, dynamic expression of such a vision. 'What', he wrote in *My Life*, 'is this era that sings hymns to technical art, that makes a god of formalism ... let them eat their fill of their square pears on their triangular tables ... Down with naturalism, impressionism and realistic cubism!' But however much Chagall railed against the prevailing dogma – what had in reality become a mandatory aesthetic programme – he nevertheless began to use the formal and spatial procedures of Cubism to very good effect. It became a means of controlling the high levels of fantasy and irrationality which invaded his imagery from 1911 onwards, imagery which, without the discipline and organized rhythm imposed by a loose Cubist grid, would have run the risk of collapsing into formless chaos (Plate 6). So, although Chagall tried to distance himself from the Cubist aesthetic, characterizing his art as 'a wild art, a blazing quicksilver, a blue soul flashing on my canvases', it is clear that Cubism actually gave him exactly what he needed at that particular moment – a structure of containment, around, through and over which he could weave his poetic tapestry, a life-dream redolent with the memory and myth of an ecstatic culture, and sustained by the power of imagination.

Cubism itself became more and more diffuse; and after paintings such as *Half Past Three (The Poet)* (Plate 8) and *Adam and Eve* (Plate 11), which were Chagall's most elaborate attempts at the fragmentation and faceting of forms, he became interested in one of its offshoots – Orphism (or Simultanism). The name Orphism, which revives memories of an earlier Symbolist interest in the 'correspondences' between painting, poetry and music, was coined by Apollinaire, and while it had developed within the Cubist ambit, its exponents rejected the monochromatic austerity of 'high' Cubism in favour of a more lyrical art based on nineteenth-century principles of colour theory. These ideas were taken up with enthusiasm, especially by Robert Delaunay (1885–1941), who used them to promote his belief in the primary significance of light and its effects on colour, space and form.

Delaunay's conviction that 'colour alone is form and subject' sent him down the road to non-representational colour abstraction. For Chagall it was a breakthrough of a different kind. Delaunay's series of abstract or near-abstract compositions – *Discs*, *Windows* and *Circular Forms* – revealed to Chagall how a combination of interpenetrating transparent planes (Cubism) and transparent colour (Orphism) could be applied as a method of structuring to suit his own very different aesthetic ends: to lay out the exotic, lost world of his childhood – an 'otherness' retrospectively constructed and located in the neverland of memory and imagination. Here, all juxtapositions, however heterogeneous, all transformations, emblematic allusions, symbols and inven-

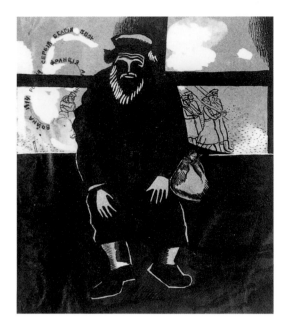

Fig. 6
War
1914. India ink and
opaque white with pen
and brush on paper,
22 x 18 cm.
Museum Lunatcharsky,
Klasnodar

tions were made concrete through an expressive and lyrical arrangement of colour and form (Plate 9). It was an arcane and completely original vocabulary of images and it came to exert such a powerful influence on the Surrealists in the 1920s and 1930s that André Breton (1896–1966), the doctrinaire theorist of that movement, and author of the *Surrealist Manifesto* of 1924 (where Surrealism was defined as 'pure psychic automatism' – freeing artists to create according to the dictates of their unconscious mind and vision), would later hail Chagall's work as 'the triumphal appearance ... of the metaphor in modern painting'. 'No work', he wrote, 'was ever so resolutely magical ...'

Throughout his life Chagall resisted being described as a 'literary' painter. He was not in the business of telling stories (except when commissioned to illustrate books), and, while rejecting interpretation and refusing to explain 'meaning', he was always at pains to define his painterly goals: '... My first aim', he said, 'is to construct my paintings architecturally – exactly as the Impressionists and Cubists have done in their own fashion and by using the same formal means. The Impressionists filled their canvases with patches of light and shadow; the Cubists filled them with cubes, triangles and cones. I try to fill my canvases in some way with objects and figures treated as forms ... sonorous forms like sounds ... passionate forms designed to add a new dimension which neither the geometry of the Cubists nor the patches of the Impressionists can achieve.'

Despite Chagall's dislike of the term 'literary' being applied to his painting, he was always most at ease in the company of the literati of the day – at this time the writers and poets of Apollinaire's circle whom he met through his friendship with Delaunay and his Russian wife, the artist Sonia Delaunay Terk (1885–1979). At their regular weekly salons Chagall came into contact with Riciotto Canudo – editor of the avant-garde periodical *Montjoie!* – who described him as the 'best colourist of our day'. He also formed a close friendship with the Swiss poet and writer, Blaise Cendrars, who had lived for some years in St Petersburg and was a fluent Russian speaker. Cendrars's influence was seminal; Chagall certainly cited their meeting as one of the two most important events in his life (the other was the Russian Revolution). Cendrars encouraged the anti-naturalistic, irrational impulses in Chagall's art, providing the esoteric – even bizarre – titles for a number of the great paintings of this period. In *Portraits*, one of two poems he dedicated to Chagall, Cendrars showed his complete understanding of Chagall's purpose – one close to his own taste for surprise and ambiguity, where arbitrary juxtapositions of unrelated objects and startling dislocations of form play back and forth across the line between dream and nonsense:

> *Suddenly he paints*
> *He takes a church and paints with a church*
> *He takes a cow and paints with a cow*
> *With a sardine*
> *With heads, hands, knives ...*

While Cendrars was Chagall's closest friend, it was Apollinaire who championed him, as indeed he did the whole generation of avant-garde artists working in Paris in those critical years before the outbreak of the First World War. On his first visit to Chagall's studio in 'La Ruche', Apollinaire was struck by the '*surnaturel*' quality of his painting, which anticipated by a dozen years or so the arrival of Surrealism. He wrote a poem, *Rotsoge*, in celebration of this strange new talent, but placed Chagall outside the Parisian mainstream. He

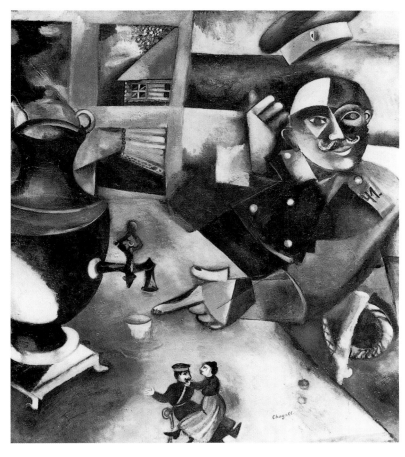

Fig. 7
The Soldier Drinks
1912. Oil on canvas,
109 x 94.5 cm.
The Solomon R.
Guggenheim Museum,
New York

also introduced Chagall to Herwarth Walden (1878-1944), fellow impressario and editor of the Berlin literary and artistic weekly *Der Sturm* (*The Storm*), the name also given to the theatre and gallery he ran. At the time, Walden was the most influential promoter of German Expressionism (painting and literature which gave voice to the instinctive, spontaneous, and subjective expression of the 'innermost essence of life') – a movement which was beginning to have a distinct identity, and where Chagall's arcane fantasies were likely to find a sympathetic audience.

Walden liked what he saw of Chagall's work. He agreed to show three of his paintings at the First German Salon d'Automne in 1913, an exhibition at which the European avant-garde was well represented, and where the German Expressionist artist Franz Marc (1880-1916) – whose ideas were close to Chagall's – showed his visionary series of animal paintings (Plate 9 and Figs. 2, 3 and 22). A solo exhibition was arranged at the Sturm Gallery for the summer of 1914 which was to set the seal on Chagall's future success. It was here that *Homage to Apollinaire* (Plate 10), Chagall's great masterpiece, was shown for the first time. A complex and mysterious work, it acknowledged Chagall's gratitude not only to Apollinaire but also to Cendrars, Canudo, Walden and Delaunay, and marked the climax of his first Paris period.

Chagall locked up his studio at 'La Ruche' and travelled to Berlin for the opening of the exhibition. He then went on to Russia – intending to spend no more than three months visiting his family and fianceé Bella, but the outbreak of war and then the Revolution meant that he had to postpone his return indefinitely. His reputation and celebrity grew during what would become an eight-year absence from the centre of European art.

In Paris and nostalgic for Russia, Chagall sublimated and transfigured the worlds of Jewish, peasant and even Christian Russia, so mys-

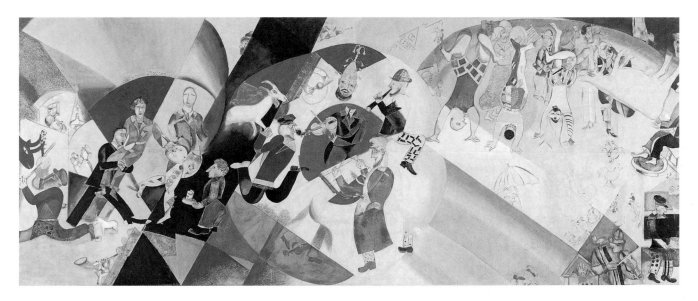

Fig. 8
Introduction to the
Jewish Theatre
1920. Tempera, gouache
and opaque white on
canvas, 284 x 787 cm.
Tretyakov Gallery,
Moscow

terious and unfamiliar to a Western metropolitan audience. At the
same time he began to incorporate emblematic images of Paris – such
as the Eiffel Tower – which appeared in paintings side by side with
images from his mythologized Russian past (Plate 13). Now home in
Vitebsk, he again found himself looking back with nostalgia at what he
had just left. 'There it is,' he wrote in *My Life*, 'Paris, you are my second
Vitebsk.' But if, at first, he found Vitebsk 'strange', 'unhappy' and
'boring' – as *Clock* (1914) with its tiny figure staring wistfully out of the
window suggests – it would (he confirmed) always be '... only my
town, mine', the one 'I come back to ... with emotion'.

Chagall began to 'document' provincial reality in a series of straight-
forward studies from family and village life. He also began painting
portraits of itinerant Jewish preachers and beggars who found their
way to his parents' house and, for a few kopeks, agreed to pose. In
these, Chagall combined a sharply observed naturalism with modified
Cubist structuring, and in some instances – *Feast Day (Rabbi with
Lemon)* (Plate 18) and *Over Vitebsk* (Plate 19) – with the *surnaturel* (the
image as magic) which he always sensed hovering beyond the real
world. The most powerful in this series – *The Praying Jew (Rabbi of
Vitebsk)* (Fig. 4) – exhibits a monumentality and Old Testament piety
which is spell-binding.

In March 1915, Chagall showed twenty-five of these new paintings
at an exhibition in Moscow – 'The Year 1915'. He continued to exhibit
regularly with the Russian avant-garde, his reputation as one of the
leading artists of the younger generation attracting a number of
wealthy patrons. In July 1915, in an event of enormous importance to
him, both personally and artistically, he married Bella. Until her death
in 1944, she remained Chagall's constant companion and inspiration.
He continued to celebrate their love in painting after painting for the
rest of his life.

After a short honeymoon in the countryside near Vitebsk (Plate 21),
they moved to Petrograd (formerly St Petersburg), where Chagall was
employed as a clerk in the Office of War Economy. Although he was
totally unsuited to the job, it exempted him from active service. He
nevertheless portrayed the tragedy of war with many images of hope-
lessness and despair, generally turning to graphics at this time and
restricting himself to black and white to heighten the impact. 'I hear, I
feel', he wrote, 'the battles, the cannonading, the soldiers buried in
trenches ... The smell of the front ... the fields, the trees, the sky, the
clouds, human blood and guts.' On a small scale and using watercolour

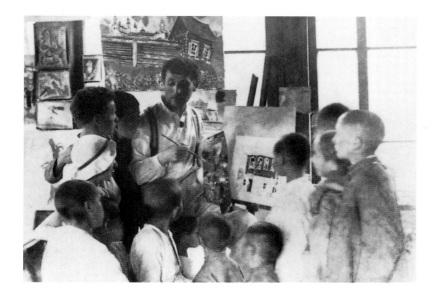

and gouache instead of pen and ink, *Wounded Soldier* (Fig. 5) captures this trauma. An ashen-faced soldier with one arm in a sling gestures with the other towards a moment – revisited in memory – when wounded, but supported by two friends, he staggers to safety. This and other bleak reminders of the reality of war, such as the graphic work *War* (Fig. 6) could be contrasted with *The Soldier Drinks* (Fig. 7). This latter painting, in which war was far from his thoughts, was one of Chagall's poetic fantasies from his Paris period. It refers back to the Russo-Japanese War of 1904–5, when soldiers were billeted on private families, including Chagall's.

The October Revolution of 1917 brought the emancipation of the Jews. It also introduced Chagall to the political arena for the only time in his life. The romantic belief that revolutionary politics and revolutionary art shared a common purpose was to prove wholly illusory; but, in those euphoric first years before the dead hand of Socialist Realism – the official artistic style of the Soviet Union – took hold, the arts were free and everything seemed possible. In the spring of 1918, the first monograph on Chagall was published in Russian. Later that year Anatoly Lunacharsky, Director of the People's Commissariat of Enlightenment – whom Chagall had met in Paris – appointed him Commissar for Art in Vitebsk. Until 1920, when Chagall left Vitebsk for good and moved to Moscow with his wife and daughter Ida (born in 1916), his life was entirely devoted to setting up and running his Academy of Art, a museum, and various other projects designed to involve 'the people' in the production and enjoyment of art.

The first anniversary of the Revolution was marked throughout Russia with celebrations. Chagall organized a vast street spectacle for Vitebsk – a festival of flags and banners which was subsequently described by a critic as a 'mystic and formalistic bacchanal'. Chagall was asked to account for why the banners displayed green cows and flying horses. 'What has that to do with Marx and Lenin?' it was queried. But in the end, it was the ideological disputes which erupted within the art school itself which forced Chagall – by this time deeply disillusioned – to leave Vitebsk. He had been naïve enough to think that all artistic tendencies could be accommodated on the teaching staff of the Academy, but factions soon developed. Two leading figures of the Russian avant-garde, El Lissitzky (1890–1947), a former disciple of Chagall's, and Kasimir Malevich (1878–1935) – the charismatic founder of Suprematism (non-objective painting which derives from geometrical elements, especially the square) – tried, with missionary zeal, to

Fig. 10
Grandfather's House
1923. Etching,
20.9 x 16 cm.
Mein Leben, Portfolio,
Berlin, Paul Cassirer, 110
numbered copies

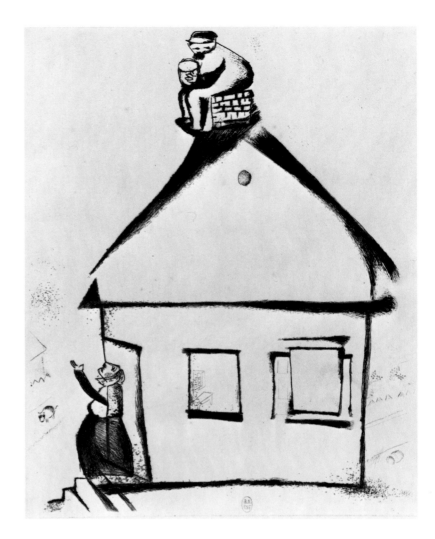

force Chagall to accept their revolutionary ideas. When he refused, they mounted a putsch against him – changing the inscription over the entrance of the school from 'Free Academy' to 'Suprematist Academy' – and deprived him of his status. Chagall wrote bitterly: 'I understood then that no man is a prophet in his own country.'

Despite these problems, Chagall did explore the flat, geometricized forms which were to become synonymous with Revolutionary Art. This influence can be seen particularly in his work for the theatre. He always loved the atmosphere of the circus and the theatre, and while still in Vitebsk designed sets for plays which were never carried out. Now in Moscow, he began working for the State Jewish Chamber Theatre (Yiddish Theatre) under the direction of Alexander Granovsky. It was a time of civil war and famine. Chagall and his family lived in a damp little room under conditions of extreme hardship, scavenging, like everyone else, for the bare essentials of life – food and fire-wood. Even in these wretched circumstances, he produced an ensemble of paintings which are not only considered to be among his finest achievements, but which also marked the beginning of the major new direction his career would take from the 1940s onwards.

Chagall was commissioned to design sets and costumes for the theatre's inaugural production – three one-act plays by the great Yiddish writer, Sholem Aleichem. It was, he wrote, his chance to 'do away with the old Jewish theatre, its psychological naturalism, its false beards'. In a matter of weeks, and without ever being paid, Chagall created a complete theatrical environment. Most remarkable were the

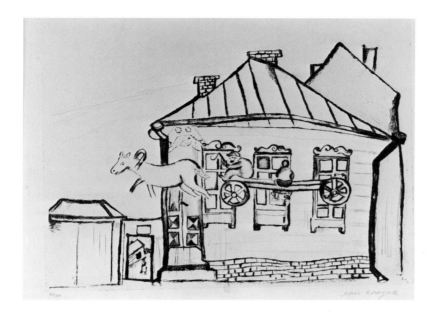

Fig. 11
House in Vitebsk
1923. Etching,
18.9 x 24.9 cm.
Mein Leben, Portfolio,
Berlin, Paul Cassirer, 110
numbered copies

huge canvas murals which covered the ceiling and walls of the auditorium, extending the action on stage out into the audience. 'Chagall's box', as it became known, determined the anti-naturalistic, irrational style of the Yiddish theatre for many years.

The largest of the murals, *Introduction to the Jewish Theatre* (Fig. 8), is a visual manifesto, packed with references and complex metaphors. It is a summation of Chagall's experiences and achievements at this critical time in his career, and prefigures some of the concerns of his future work. He uses the model of Jewish – specifically Hasidic – exaltation and carnival revelry, set against a flattened, geometricized backdrop, to express both his political and cultural position in the 'new' Russia, and to reassert his authority as a foremost avant-gardist after the débâcle in Vitebsk. The *Introduction* teems with humorous details and colourful vignettes – some drawn from his repertoire of familiar images, while others reflect the world of the theatre itself.

However desperate the circumstances, Chagall's disposition was basically cheerful – 'We are happy and empty,' he wrote in *My Life*. But his work for the theatre was over, he was out of favour, and he found the political and artistic atmosphere in Russia increasingly uncongenial. Sometime in 1921 Chagall and his family moved to Malkhovka, a settlement for war orphans outside Moscow. Here he taught art to children brutalized by war and ill-treatment (Fig. 9). Conditions continued to deteriorate, and by the summer of 1922, Chagall – now determined to leave this flawed utopia – obtained a passport through Lunacharsky (with permission for Bella and Ida to follow shortly). After a brief stay en route in Lithuania, he arrived in Berlin with a collection of paintings and nine notebooks containing the manuscript copy of *My Life*. He was not to return until June 1973, when he paid a short visit to Leningrad and Moscow.

Chagall discovered he was famous. Walden had acted scrupulously during his absence, exhibiting the works that had been left in Berlin, selling them, and publishing reproductions of them regularly in *Der Sturm*. His work was acclaimed, but post-war inflation had eroded the sale proceeds Walden had deposited with a lawyer. Furious to find that he had no paintings and no money either, Chagall began legal action to recover his work. More importantly for the long term, however, the dealer Paul Cassirer commissioned him to produce illustrations for the text of *My Life*. Once he had mastered etching and drypoint techniques, it was a commission which allowed Chagall to indulge his narrative flair.

Fig. 12
The Police Arrive
1923–7. Etching,
29 x 22 cm.
Plate xxv from Nicolai
Gogol, *Les Ames Mortes*
(Dead Souls), Paris,
Tériade, 1948, 3 vols

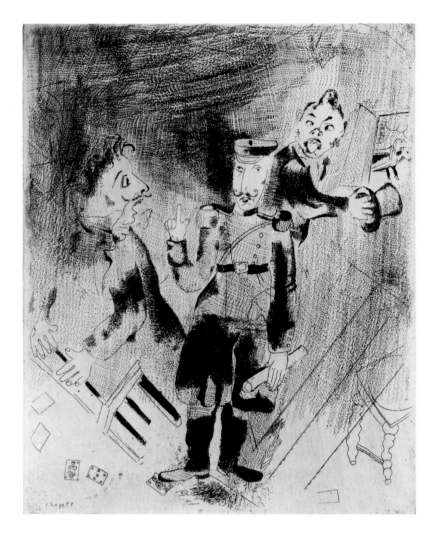

It also started him off on his hugely successful career as one of the most skilled and prolific printmakers of the twentieth century, his work (especially in colour lithography) becoming widely available to a mass audience. When translation difficulties prevented publication of the text of *My Life*, a folio of twenty etchings and drypoints – entitled *Mein Leben* – was published on its own in 1923 (Figs. 10, 11).

Word spread that Chagall had survived the war and the revolution. Cendrars wrote from Paris to say that Ambroise Vollard (1865–1939), the art dealer and publisher who was responsible for launching the careers of many leading artists, now wanted Chagall to begin doing book illustration for him. By September 1923, Chagall was back in Paris, and for the next few years worked tirelessly to produce a series of etchings for Gogol's *Dead Souls*, images which expressed Chagall's own affectionately idiosyncratic view of his homeland and its larger-than-life characters (Fig. 12). Other commissions from Vollard followed: the seventeenth-century French classic, the *Fables* of La Fontaine (Plate 28), the *Cirque Vollard* and the Bible – this last a project closely tied to his visit to Palestine in 1931 (a visit which also produced the melancholy and enigmatic *Solitude*, Chagall's prophetic image of an exiled and sorrowing Jew (Fig. 13)). The drama and poetry of the biblical message – so much a part of Chagall's childhood imagination – combine with his deeply felt spirituality to demonstrate, in subtle gradations of black and white (resonant with memories of Rembrandt), the range of painterly expression in his graphic work at the time (Figs. 14, 40).

These commissions, most of which went unpublished until after Vollard's death in 1939, were a vital source of income for Chagall as he

began to re-establish himself in Paris. As in Berlin, he found that the paintings left behind in 'La Ruche' had either been looted or sold, a loss he found hard to bear a second time. He began – almost obsessively – to replicate, repeat and reconstruct his old paintings, either from memory, from photographs, or occasionally from borrowed originals. This activity conflicts with our modern belief that the value of a work of art depends on its uniqueness. It was not a belief shared by Chagall, for his symbolic paintings tended – as emblematic representatives – to refer to one overarching system of signification, a unified Chagallian universe, which he carried with him as memory wherever he went. Like icons, the images drawn from his personal domain were selected again and again – the powerful aesthetic expression of a mystic enthralled by the idea of painting as the authentic language of poetry. They were a refuge from the world – 'If there were a hiding place in my pictures I would slip into it…', Chagall once said.

While Chagall continued to re-create this imagery or its variants for the rest of his life (his basic iconography changed very little from this period onwards, except that, from the 1950s, Paris to some extent replaced Vitebsk as the site of his dreams), the passage of time and over-repetition eventually drained them of much of their earlier vitality. Chagall – probably unwittingly – became his own follower. So it was in the exploration of new media and in the dramatic shift to colour – intense, rapturous, non-naturalistic and often independent of the forms – that Chagall continued to enchant audiences around the world. 'Generally speaking,' wrote Wassily Kandinsky (1866–1944) in 1911, 'colour directly influences the soul'; and Chagall, who believed art to be 'above all a state of soul', was pre-eminently the 'maestro' in Kandinsky's musical analogy: 'Colour is the keyboard, the eyes are the hammers, the soul is the piano with many strings. The artist is the hand that plays, touching one key or another purposely, to cause vibrations in the soul.'

From the mid-1920s, Surrealism became the major new influence on Parisian intellectual life. Chagall, whose psychic distortions appeared to prefigure its fantasies and non-logical insights, was invited to join the movement. But he chose not to ally himself with a group so self-consciously reliant on 'automatic writing' to tap the wellsprings of the unconscious: 'Everything in art ought to reply to every movement in our blood, to all our being, even our unconscious,' he said later. 'For my part, I have slept very well without Freud!' Instead, old friendships were taken up again and new ones begun in what appears to have been a particularly happy and settled period for Chagall and his family. They made many trips into the French countryside, and *Ida at the Window* (Plate 26) recalls a holiday on an island off the north coast of Brittany. But although nature, colour, light and landscape became a preoccupation, Chagall very rarely painted *en plein air*, preferring (like Matisse) the view from the window – that boundary between indoors and out which had always intrigued him and which occurred as a characteristic motif in a great many paintings throughout his life.

By 1927, Chagall was one of the leading painters of the *Ecole de Paris*, and his work was exhibited around the world. While the 1920s were characterized by extensive travel within France, during the 1930s he began travelling abroad – to Palestine, Holland, Spain, Poland and Italy – and his painting gained a new monumentality as a result of seeing at first hand the work of Rembrandt (1606–69) and the Spanish masters, El Greco (1541–1614), Velázquez (1599–1660) and Goya (1746–1828).

Lovers, flowers and the circus – quintessentially Chagallian motifs – were by now firmly established as thematic cycles. But it would be

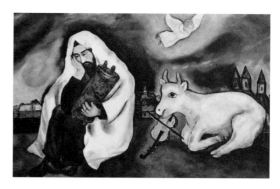

Fig. 13
Solitude
1933. Oil on canvas,
102 x 169 cm.
The Tel-Aviv Museum;
gift of the artist, 1953

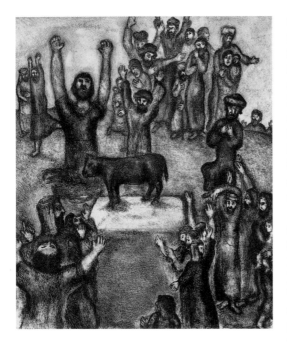

Fig. 14
The Golden Calf
Etching and drypoint,
29.2 x 23 cm.
Plate xxxviii from The
Bible, Paris, Tériade,
1956, 2 vols; 105 etchings
from 1931–9 and 1952–6

wrong to imagine that his paintings were now always lighthearted fantasies – colour-filled and exuberant. Alongside portraits of Bella, and the major 'surrealist' work, *Time is a River without Banks* (Plate 33), large, often sombre figure compositions began to occupy Chagall – frequently over a period of years. The largest and most ambitious of these, *The Revolution* (Plate 31) – of which this fully developed small oil sketch survives – attempted to synthesize Chagall's response to the Spanish Civil War (then raging) with his memories of the Russian Revolution. Like the *Introduction to the Jewish Theatre* (Fig. 8), it is a stocktaking of familiar motifs; but in addition it is both an ironic reflection of the loss of innocence and hope to harsh experience, and a harbinger of bitter things to come.

Chagall was also capable of producing the most potent expressions of suffering and despair seen in painting this century. *White Crucifixion* (Plate 32), one of many depictions of crucifixions in his *œuvre* after 1938, is the culminating image of a decade of growing anguish. In 1938 Jacques Maritain, a devout Catholic and Chagall's close friend, wrote: 'The immense clamour which arises from the German concentration camps, as well as from the Russian, is not perceptible to our ears, but it penetrates the secret fibres of the life of the world, and its invisible vibration tears them apart.' Seen against this descent into barbarism, this enactment of a great catastrophe, *White Crucifixion* is both a powerful political statement and a searing image of Jewish martyrdom, as the central symbol of Christianity – the Passion of Christ – becomes the cross of persecution. 'How should I weep…' Chagall wrote in his poem *For the Slaughtered Artists*:

> *I see the fire , the smoke and the gas*
> *Rising to the blue cloud,*
> *Turning it black.*
> *I see the torn-out hair and teeth.*
> *They overwhelm me with my rabid*
> *Palette*
> *I stand in the desert before heaps of boots,*
> *Clothing, ash and dung, and mumble my*
> *Kaddish.*

During the 1940s, with Chagall's prophetic vision of the catastrophe now a reality, crucifixion-related imagery increased dramatically. There was presumably a degree of self-identification with such imagery – symbolic of the pain inherent in artistic creation – as a painting entitled *The Painter Crucified* (1940–3) suggests; while *Yellow Christ* (Fig. 15) is clearly influenced by Gauguin's own *Yellow Christ* (Fig. 16), an image in which he represented himself as 'the new Christ of painting', but which also reflected his state of mind at a time of great despair. *The Crucified* (Fig. 17), perhaps commemorating the destruction of Chagall's homeland by invading German forces, is also a stark reminder that the persecution of the Jews was not just a Nazi proclivity. For as Chagall revisited, in this painting, the deserted, snow-bound and crucifix-lined streets of a Russian *shtetl*, it was his impotent desire, as expressed in *My Life*, 'to put them down on my canvases to get them out of harm's way' (Plate 37). It recalls earlier horrors, as Jews, in punishment for Russian army setbacks during the First World War, were systematically driven from their homes and killed. In fact, whenever Chagall returned to troubling subject-matter, as in *The Falling Angel* (Plate 39) or *War* (Plate 45), with their apocalyptic scenes of death and despair, it was invariably in the pre-industrial, almost

medieval Vitebsk of his childhood imagination that he located such human tragedy.

By 1941 France had become too dangerous for Jews, and Chagall and Bella – who were now French citizens and living in the South of France – accepted an invitation to find sanctuary in the United States. They travelled via Marseilles and Lisbon, arriving in New York on 23 June, the day after German troops marched into Russia. Although there were many European artists and intellectuals sheltering in America, Chagall never mastered English, and was somewhat isolated from this group. The thriving ex-patriate Russian community became his focus, and, after Vitebsk was reduced to ashes, his greatest support.

Despite the proliferation of crucifixion and war-related imagery during these years, Chagall was capable of diversion. In the spring of 1942, the Russian choreographer Léonide Massine invited him to design scenery and costumes for his ballet *Aleko* – based on music by Tchaikovsky and a poem by Alexander Pushkin. It premiered in Mexico City in early September, with Chagall involved in every aspect of the production; it then transferred to New York, where it was a huge success – as much for the stage design and costumes as for the ballet itself. *Wheatfield on a Summer's Afternoon* (Plate 34), one of four vast backdrops painted by Chagall himself, is a stunning reminder of just how great a colourist he was. In the simplicity and immensity of a space flooded with pure colour, Chagall created another world, his imagination fired by the measurelessness of the American landscape and the blaze of Mexican light. Over the years other commissions followed: for a production of Stravinsky's *The Firebird* in 1945, where on the opening curtain, a swirling stream of saturated colour flows and expands into boundless space – intense, rhapsodic and mesmerizing; for the Paris Opéra's production of Ravel's *Daphnis and Chloë* in 1958 (following a 1952 commission to produce a series of gouaches on the same theme, as illustrations for a book); and finally, in 1967, for the New York Metropolitan Opera's production of Mozart's *The Magic Flute*. In all these, Chagall created a total environment, a realm of unreality – much as he had for the Jewish Chamber Theatre. They were spectacles independent of all but colour and sensation. It is here, with these magnificent sets, that the 'correspondence' between music, painting and poetry reaches its apotheosis.

Bella's sudden death in 1944 from a viral infection plunged Chagall into a deep depression. He was unable to paint for nearly nine months. *Around Her* (Plate 36), a memorial work, signalled his recovery, although her image – as lover or bride – haunted his compositions until his own death in 1985. Towards the end of 1945, with *The Firebird* commission under way, Chagall formed a relationship with Virginia Haggard McNeil, a woman many years his junior. They moved to the country – High Falls in the Catskills – where their son David (named after Chagall's long-dead brother) was born in 1946. The Madonna and Child imagery which entered Chagall's paintings at this time reflected the peace he had found in this new relationship.

Chagall now combined the life of an artist – living and working in this remote backwater – with the demands of international celebrity. A retrospective exhibition at the New York Museum of Modern Art and the Art Institute of Chicago in 1946 was followed, in 1947, by an exhibition at the Musée National d'Art Moderne in Paris. He was besieged with offers of exhibitions from museums and galleries around the world, as well as being fêted by an endless stream of collectors, critics, dealers, journalists and publishers – his place in the pantheon of twentieth-century artists, alongside Picasso and Matisse, now assured. In 1948, Chagall decided to make France his permanent home once

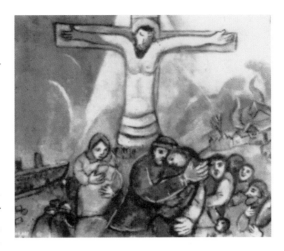

Fig. 15
Yellow Christ
1941. Gouache on paper,
27.5 x 31.5 cm.
Private Collection

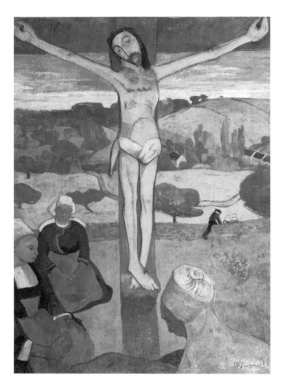

Fig. 16
PAUL GAUGUIN
Yellow Christ
1889. Oil on canvas,
92 x 73 cm.
Albright-Knox Art Gallery,
Buffalo, NY

again. He and his new family moved first to Orgeval, near Paris, and then, via Saint-Jean-Cap-Ferrat, to Vence in 1950, and finally to Saint-Paul-de-Vence in 1966. By 1952, Virginia had left him, and just as suddenly, he married again – a Russian Jewish émigré, Valentina (Vava) Brodsky – the woman with whom he would spend the rest of his life.

Chagall continued to paint (Plates 40 and 41), but at the same time began to experiment with other media: pottery, sculpture and, in 1957, stained glass – the medium which allowed him full rein for his delight in colour, and which became the glory of his old age. No commission seemed too big or too small – and Chagall's windows can be found in Gothic cathedrals, churches, chapels, a synagogue, and in many public buildings around the world (see Plate 44). It is a medium in which he once again achieved true originality. Together with his collaborator, the stained-glass specialist Charles Marq, Chagall worked to translate his profound knowledge of colour relationships in paint into the mysterious, medieval, almost alchemical processes involved in stained-glass making – one in which only the light of the sky can give colour to the surface, an inseparable interaction which fulfils Delaunay's dream of a 'dynamic poetry of transparent colour and light'.

Chagall's complete mastery of this medium was undeniable, but bitter criticisms were voiced – particularly from some Jewish quarters – about the desirability of a Jewish artist of Chagall's stature being invited to decorate Christian sanctuaries. Christian religious themes based on Russian icons were always present in Chagall's œuvre (*Holy Family* (1910) and *Golgotha* (1912)), but from 1938, the overall symbolism of such 'forbidden' imagery was unmistakably that of Jewish martyrdom. In later years, as commissions flooded in, Chagall began to divest such imagery of its identifying props – prayer shawls, phylacteries, Torahs, branched candelabra – which had made their meaning unequivocal. Drained of any specific Jewish content, and located in a church or a cathedral, a crucifix (or Old Testament imagery as a foreshadowing of the New) takes on a different meaning altogether. And while Chagall always insisted on his commitment to his 'people', and on the 'universality' of his message (he is known to have written to Chaim Weitzman, then President of Israel, and to the Chief Rabbi of France to ask for advice), he was certainly very naïve if he imagined that the context would have no bearing on the meaning – that it would not be given a Christian interpretation.

Other major commissions occupied Chagall: designs for mosaics, cartoons for tapestries, and the controversial commission in 1963 for the thirty-foot-wide dome of the Paris Opéra. As with the commission for La Fontaine's *Fables*, protests arose over the idea of such an important project being given to a 'foreigner'. André Malraux, then Minister of Culture and Chagall's champion, overruled objections. The project went ahead – with a circular design or music wheel, saturated with colour and pervaded by Chagall's familiar imagery, which paid homage to ten different composers.

In 1967, Chagall completed one of his most important commissions in the United States: *The Sources of Music* (Plate 46) and its companion, *The Triumph of Music*, two huge canvas panels for the lobby of the New York Metropolitan Opera. Chagall's earlier involvement with 'the Met' in Mozart's *Magic Flute* fed into this new project – one in which composers soar and swirl in a rococo space dominated by Chagall's beloved 'Angel Mozart'.

Chagall, whose old yearning for 'a wall' to paint had been fully satisfied by now, fulfilled this commission with what, in reality, were the familiar motifs from his repertoire writ rather too large. But the real focus of his attention was on a different project altogether. After the

war, Tériade took over and published, in quick succession, the store of etching plates which had lain gathering dust in Vollard's basement – some since the 1920s. The Bible etchings, scheduled for publication in 1956, rekindled Chagall's interest in its universal message. He conceived of a monumental cycle of paintings based on the Bible and inspired by Giotto (c.1276–1337) and Fra Angelico (c.1400–55) – a permanent pictorial display of Old Testament imagery contained in a nonsectarian, truly ecumenical space 'which each individual would interpret according to his own need'. He pursued this idea with dedication and enthusiasm over two decades. By the time the Musée National Message Biblique near Nice opened in July 1973, the full range of Chagall's artistic genius was represented: stained glass, mosaics, tapestries, sculpture, ceramics, lithography, engravings, gouaches, drawings and paintings (Plates 42, 43; Figs. 14, 40). It stands now as an enduring memorial to Chagall, who wrote of the significance which the Bible had for him: 'Ever since my earliest youth, I have been fascinated by the Bible. I have always believed … that it is the greatest source of poetry of all time … I have sought its reflection in life and Art. The Bible is like an echo of nature, and this is the secret I have endeavoured to transmit.'

Chagall was 97 years old when he died. His name in Russian is synonymous with the verb 'he strode', and with prodigious energy and a life-long devotion to art, Chagall strode Colossus-like across a century of change more dramatic than at any time in history. He was born an unregarded and impoverished Jew. He ended his life the recipient of the highest public honours – including the Grand Cross of the Légion d'Honneur – and was buried in a Catholic cemetery, embraced by the French as one of their own. His work is a poetic metaphor for his own extraordinary life: such transformation was truly Chagallian. It is imagination that works the transformation, and Chagall, moralist, mythmaker, fantasist, clown and great religious artist, used the language of the imagination – painting and poetry – to give lyrical expression to a uniquely personal vision, but one which also reached out to touch the world.

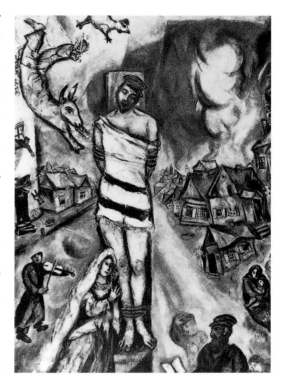

Fig. 17
The Crucified
1944. Gouache on paper,
62 x 47.5 cm.
Private Collection

Outline Biography

1887 7 July: birth of Marc Chagall (Moyshe Segal) in Vitebsk, Russia, the eldest of nine children of Zachar and Feiga-Ita.

1906 Studied briefly in the studio of the artist Jehuda Pen in Vitebsk.

1906–7 Moved to St Petersburg. A scholarship enabled him to attend the school of the Imperial Society for the Protection of Fine Art for one year.

1908–9 Enrolled at the Zvantseva School, directed by Léon Bakst and Mstislav Dobuzhinsky. Max Vinaver became his patron. Introduced to Bella Rosenfeld – his future wife – on a visit back to Vitebsk.

1910 April – May: exhibited with fellow pupils of Zvantseva School at the offices of the journal *Apollon*. August: left for Paris with the financial support of Vinaver.

1911–12 Enrolled at two art schools, Le Grand Chaumière and the Académie de la Palette.

1912 Moved to 'La Ruche', where Soutine, Léger and Modigliani also had studios. Exhibited at the Salon des Indépendants and 'Donkey's Tail' (Moscow); also at the Salon d'Automne.

1913 Exhibited at the Salon des Indépendants and at Herwarth Walden's First German Salon d' Automne (Berlin).

1914 Exhibited at the Salon des Indépendants. Went to Berlin for the opening of his first one-man show at Galerie Der Sturm. Travelled on to Vitebsk for three-month visit – prolonged indefinitely by outbreak of war in August.

1915 Exhibited at 'The Year 1915' (Moscow). Married Bella Rosenfeld. Moved to Petrograd (formerly St Petersburg) where he worked as a clerk in the Office of War Economy.

1916 Birth of his daughter Ida.

1917 February and October Revolutions in Russia.

1918 First monograph on Chagall published. Appointed Commissar of Art for Vitebsk and region.

1919 Vitebsk Academy of Art opened. Teachers include El Lissitzky and Kasimir Malevich. Worked on projects for the Theatre of Revolutionary Satire, Vitebsk. Difficulties with Malevich and Lissitzky led to resignation from Academy.

1920–1 Invited to design sets for the State Jewish Chamber Theatre (Yiddish Theatre) in Moscow.

1921–2 Lived and taught at Malkhovka, outside Moscow – a colony for war orphans. Began compiling *My Life*.

1922 Left Russia for Berlin. Learnt etching and was commissioned by Paul Cassirer to produce illustrations for *My Life*.

1923 Portfolio of etchings (*Mein Leben*) published without text. Returned to Paris. Ambroise Vollard commissioned etchings for Gogol's *Dead Souls*.

1924–9 Commissions followed from Vollard for La Fontaine's *Fables* and a project on the circus. Considered leader of the *Ecole de Paris*.

1930 Vollard commissioned etchings for an illustrated Bible.

1931–2 Travelled to Middle East and Holland.

1933 Travelled to Italy. *Auto-da-fé* of pictures in Mannheim by order of Goebbels.

1934 Travelled to Spain to look at Spanish art.

1935 Travelled to Poland for inauguration of Jewish Institute in Vilna.

1937 Granted French citizenship. Work included in 'Degenerate Art' exhibition which toured Germany and Austria.

1939 Left Paris for the south of France.

1940 Received an invitation from the Museum of Modern Art in New York to emigrate to the United States.

1941 23 June: landed in New York as the Germans attacked Russia. November: exhibition at the Pierre Matisse Gallery, New York.

1942 Commissioned by Massine to make sets and costumes for the ballet *Aleko*.

1944 September: death of Bella. Chagall stopped working for nine months.

1945 Designed sets and costumes for *The Firebird*. Began seven-year relationship with Virginia Haggard McNeil.

1946 Birth of son David. Retrospective exhibition at the Museum of Modern Art, New York and The Art Institute, Chicago.

1947 Travelled to Paris for exhibition at the Musée National d'Art Moderne.

1948 Permanent return to France. Exhibited in Amsterdam and Tate Gallery, London.

1949 Moves from outside Paris to South of France. Begins to work in clay.

1950 Exhibition at the Galerie Maeght, including pottery.

1951 Carved his first sculptures. Visited Israel for opening of his retrospective at the Bezalel National Art Museum.

1952 Visited Chartres to look at stained glass. La Fontaine *Fables* finally published by Tériade. July: married Valentina Brodsky.

1955 Began work on a series of biblical pictures.

1956 The Bible published by Tériade. First commission for stained-glass windows for chapel at Assy, Savoy.

1957 Windows installed. Third visit to Israel.

1958 Commissioned by the Paris Opéra to design sets and costumes for *Daphnis and Chloë*.

1960 Designed twelve stained-glass windows for the synagogue of the Hebrew University Hadassah Medical Centre, Jerusalem.

1962 Completed the stained glass for the first window at Metz.

1963 Began work on the ceiling of the Paris Opéra.

1964 Travelled to New York for unveiling of *Peace* window at the United Nations Building, New York.

1965 Began work on costumes and sets for Mozart's *Magic Flute* and murals for the Metropolitan Opera, New York.

1966 Moved from Vence to Saint-Paul-de-Vence.

1967 Eightieth birthday retrospective in Zurich and Cologne. 'Biblical Message' series exhibited at the Louvre.

1969 Travelled to Israel for opening of Knesset building, Jerusalem – with floor and wall mosaics and three tapestries by Chagall. 'Hommage à Marc Chagall' exhibition at the Grand Palais, Paris.

1970–2 Exhibitions and commissions for stained glass and mosaics.

1973 June: visited Moscow and Leningrad. July: inauguration of the Musée National Message Biblique Marc Chagall, Nice.

1974 Stained-glass window at Rheims Cathedral unveiled.

1975 Publication of *The Odyssey*, with 82 lithographs.

1977 Awarded the Grand Cross of the Légion d'Honneur and made an honorary citizen of Jerusalem. Exhibition at the Louvre.

1978 Stained-glass window at Chichester Cathedral, Sussex, unveiled.

1979 *The America Windows* unveiled at the Art Institute of Chicago.

1985 Major retrospective held at the Philadelphia Museum of Art and at The Royal Academy of Arts, London. March 28: Chagall died at his home in Saint-Paul-de-Vence.

Select Bibliography

Primary Sources
Chagall, Marc, *My Life*, translated by Elizabeth
 Abbott, New York, 1994

Chagall by Chagall, ed. Charles Sorlier,
 translated by John Shepley, London, 1979

Monographs
Alexander, Sydney, *Marc Chagall: A Biography*,
 London, 1979

Amiel, Leon, *et al.*, *Homage to Chagall: Special
 Issue of the XXe Siècle Review*, New York,
 1982

Baal-Teshuva Jacob (ed.), *Chagall, A
 Retrospective*, New York, 1995

Bohm-Duchen, Monica, *Chagall*, London, 1998

Compton, Susan, *Marc Chagall: My Life – My
 Dream (Berlin and Paris, 1922–1940)*,
 Munich, 1990

Haftmann, Werner, *Marc Chagall*, translated by
 Heinrich Baumann and Alexis Brown,
 New York, 1973

Kagan, Andrew, *Chagall*, New York, 1989

Kamensky, Alexander, *Chagall: The Russian
 Years 1907–1922*, translated by
 Catherine Phillips, London, 1989

McMullen, Roy, *The World of Marc Chagall*,
 photography by Izis Bidermanas,
 London, 1968

Meyer, Franz, *Marc Chagall*, translated by
 Robert Allen, London, 1964

Sweeney, James Johnson, *Marc Chagall*,
 New York, 1946

Exhibition Catalogues
Chagall, ed. Susan Compton, Royal Academy of
 Arts, London, 1985.

*Chagall to Kitaj: Jewish Experience in 20th Century
 Art*, ed. Avram Kampf, The Barbican
 Art Gallery, London, 1990

Marc Chagall and the Jewish Theatre, The
 Solomon R. Guggenheim Museum, New
 York, 1992

Marc Chagall: The Russian Years 1906–1922,
 ed. Christoph Vitali, translated by Lynne
 E. A. Murray, Schirn Kunsthalle,
 Frankfurt, 1991

Catalogue of the Musée National Message
 Biblique Marc Chagall, Nice, 1976

*'Degenerate Art': The Fate of the Avant-Garde in
 Nazi Germany*, Stephanie Barron, Los
 Angeles County Museum of Art, 1991

Other
*Apollinaire on Art: Essays and Reviews
 (1902–1918)*, ed. Leroy C Brenning,
 New York, 1972

Chagall, Bella, *Burning Lights* (with 36 drawings
 by Marc Chagall), translated by Norbert
 Guteman, New York, 1962

Chagall, Bella, *First Encounter*, translated by
 Barbara Bray, New York, 1983

Haggard, Virginia, *My Life with Chagall: Seven
 Years of Plenty*, London, 1987

Journal of Jewish Art, Vol. 5, 1978

Neumann, Erich, *Art and the Creative
 Unconscious*, translated by Ralph
 Manheim, Princeton, 1974

Roditi, Edouard, *Dialogues on Art*, London,
 1960

Schapiro, Meyer, *Modern Art – 19th and 20th
 Centuries: Selected Papers*, New York, 1996

List of Illustrations
Colour Plates

25 Cubist Landscape
1918. Oil on canvas, 100 x 59 cm.
Musée National d'Art Moderne, Centre Georges
Pompidou, Paris

26 Ida at the Widow
1924. Oil on canvas, 105 x 75 cm.
Stedelijk Museum, Amsterdam

27 Lovers under Lilies
1922–5. Oil on canvas, 117 x 89 cm.
Private Collection

28 The Bird Wounded by an Arrow
*c.*1927. Gouache, 51.4 x 41.1 cm.
Stedelijk Museum, Amsterdam

29 The Dream
1927. Oil on canvas, 81 x 100 cm.
Musée d'Art Moderne de la Ville de Paris

30 Bella in Green
1934–5. Oil on canvas, 99.5 x 81 cm.
Stedelijk Museum, Amsterdam

31 Study for *The Revolution*
1937. Oil on canvas, 50 x 100 cm.
Musée National d'Art Moderne, Centre Georges
Pompidou, Paris

32 White Crucifixion
1938. Oil on canvas, 155 x 139.5 cm.
The Art Institute of Chicago,
Gift of Alfred S. Alschuler

33 Time is a River Without Banks
1930–39. Oil on canvas, 100 x 81.3 cm.
The Museum of Modern Art, New York

34 A Wheatfield on a Summer's Afternoon:
Aleko
1942. Gouache, watercolour, wash, brush
and pencil, 38.5 x 57 cm.
The Museum of Modern Art, New York,
Lillie P. Bliss Bequest

35 The Juggler
1943. Oil on canvas, 109 x 79 cm.
The Art Institute of Chicago

36 Around Her
1945. Oil on canvas, 130 x 109.7 cm.
Musée National d'Art Moderne, Centre Georges
Pompidou, Paris

37 The Soul of the City
1945. Oil on canvas, 107 x 81.5 cm.
Musée National d'Art Moderne, Centre Georges
Pompidou, Paris

38 Cow with Parasol
1946. Oil on canvas, 77.5 x 106 cm.
Richard S. Zeisler Collection, New York

39 The Falling Angel
1923–33–47. Oil on canvas, 148 x 265 cm.
Kunstmuseum, Basle

40 Red Roofs
1953. Oil on paper mounted on canvas,
230 x 213 cm.
Musée National d'Art Moderne, Centre Georges
Pompidou, Paris

41 Bridges over the Seine
1954. Oil on canvas, 111.5 x 163.5 cm.
Kunsthalle, Hamburg

42 Moses Receiving the Tablets of the Law
1956–8. Oil on canvas, 236 x 234 cm.
Musée National Message Biblique Marc Chagall,
Nice

43 Song of Songs IV
1958. Oil on canvas, 145 x 211 cm.
Musée National Message Biblique Marc
Chagall, Nice

44 Peace
1964. Stained and leaded glass window,
3.50 x 5.36 m.
United Nations Secretariat Building, New York

45 War
1964–6. Oil on canvas, 163 x 231 cm.
Kunsthaus, Zurich

46 The Sources of Music
1967. Oil on canvas, 10.98 x 9.14 m.
Metropolitan Opera, Lincoln Centre, New York

47 The Fall of Icarus
1975. Oil on canvas, 213 x 198 cm.
Musée National d'Art Moderne, Centre Georges
Pompidou, Paris

48 The Large Grey Circus
1975. Oil on canvas, 140 x 120 cm.
Private Collection

Text Illustrations

Comparative Figures

18 PAUL GAUGUIN
Self-Portrait
c.1888. Oil on canvas, 46 x 38 cm.
Pushkin Museum of Fine Arts, Moscow

19 PAUL GAUGUIN
Parau na te varua ino (Words of the Devil)
1892. Oil on canvas, 91.7 x 68.5 cm.
National Gallery of Art, Washington;
Gift of W. Averell Harriman Foundation:
in memory of Marie N. Harriman

20 VINCENT VAN GOGH
The Night Café
1888. Oil on canvas, 72.4 x 92.1 cm.
Yale University Art Gallery, New Haven;
Bequest of Stephen Carlton Clark

21 EUGENE DELACROIX
Death of Sardanapalus
1827. Oil on canvas, 395 x 495 cm.
Louvre, Paris

22 FRANZ MARC
Blue Horses
1911. Oil on canvas, 103.5 x 108 cm.
Walker Art Centre, Minneapolis

23 MASACCIO
Expulsion of Adam and Eve
c.1425. Fresco.
Brancacci Chapel, Carmine Church, Florence

24 Cain and Abel
1911. Gouache on paper, 22 x 28.5 cm.
Private Collection, Basle

25 FERNAND LÉGER
Smokers
1911. Oil on canvas, 129 x 96.5 cm.
The Solomon R. Guggenheim Museum,
New York

26 The Green Violinist
1923–4. Oil on canvas, 198 x 108.6 cm.
The Solomon R. Guggenheim Museum,
New York

27 Study for *Self-Portrait with Seven
Fingers*
1911. Pencil and gouache on paper, 23 x 20 cm.
Private Collection

28 The Holy Coachman
1911–12. Oil on canvas, 148 x 118.5 cm
Private Collection, Germany

29 Russia
1912–13. Gouache on paper, 27 x 18.2 cm.
Private Collection

30 Znamenie – Icon of the Yaroslav School
c.1220. Tretyakov Gallery, Moscow

31 Apollinaire and Chagall
1910–11. Ink and gouache on paper.
Private Collection

32 Forward!
1919–20. Oil and pencil on cardboard, 31 x 44 cm.
George Costakis Collection, Athens

33 ROBERT DELAUNAY
The Eiffel Tower
1910. Oil on canvas, 202 x 138.5 cm.
The Solomon R. Guggenheim Museum, New York

34 JUAN GRIS
Paysage et maisons à Ceret
1913. Oil on canvas, 100 x 65 cm.
Private Collection

35 Lovers in the Lilacs
1930. Oil on canvas, 128 x 87 cm.
Private Collection

36 KARL GIRARDET
The Bird Wounded by an Arrow
Vignette in *Fables de la Fontaine*, Tours 1858,
Bk II, Fable VI

37 Photograph of Bella Chagall posing for
Bella in Green
1934

38 Zemphira: costume design for the ballet
Aleko (Scene 1)
1942. Gouache, watercolour and pencil,
53.5 x 37 cm.
The Museum of Modern Art, New York;
Lillie P. Bliss Bequest

39 ALFRED NEUMAN
 Chagall's sitting room with *Red Roofs*
 *c.*1975. Photograph.
 Collection of Alfred and Irmgard Neuman,
 Leo Baeck College, London

40 Moses Breaks the Tablets of the Law
 Etching, 29.4 x 23.1 cm.
 Plate xxxix from The Bible, Paris,
 Tériade, 1956; 105 etchings from 1931–9
 and 1952–6

41 Woman on a Trapeze
 *c.*1950. Gouache, 60 x 47 cm.
 Private Collection, London

1 Self-Portrait

1908. Oil on canvas, 30.2 x 24.2 cm. Musée National d'Art Moderne, Centre Georges Pompidou, Paris

Fig. 18
PAUL GAUGUIN
Self-Portrait
c.1888. Oil on canvas,
46 x 38 cm.
Pushkin Museum of Fine
Arts, Moscow

Chagall once said that Paul Gauguin (1848–1903) 'was the only revolutionary of his time', and this early self-portrait, in which Chagall so clearly identifies with Gauguin's vision of himself as a romantic and a rebel (Fig. 18), suggests that he too saw himself as something of an outsider. In 1908 Chagall was a student at the Zvantseva School in St Petersburg, where he was taught by Léon Bakst and other members of the Russian avant-garde, artists who were less concerned with representing the tangible world than with exploring their own feelings and sensations through painting and poetry. This Symbolist-inspired approach appealed to Chagall, who wrote, in his autobiographical sketch *My Life:* 'academic theory has no hold on me ... I get nothing except by instinct.' Artists paint portraits of themselves for many reasons – economy and availability being the most obvious – but there is also the desire to feel that they have made a mark on a tradition, joining that distinguished company of painters in the history of art who have submitted to the rigour of self-scrutiny. This self-portrait, with its barely defined features and summary paint-handling on coarse-textured canvas, not only reveals that Chagall had been looking at reproductions of Gauguin's work (which were freely available in art journals and magazines at the time), but also represents the beginning of the real and lasting influence which the symbolic character of Gauguin's art exerted on Chagall, underlining an affinity which went much deeper than superficial similarities of style and form. Both Gauguin and Chagall shared a genuine impulse towards syncretism – an unconscious desire to internalize, to integrate in a single creative synthesis the disparate sources of their inspiration. 'My symbolic poetry is unexpected, Oriental, suspended between China and Europe,' Chagall said, while he shared Gauguin's conviction that: 'Painting is the most beautiful of all arts. In it all sensations are condensed; contemplating it, everyone can ... with a single glance, have his soul invaded by the most profound recollections ... Like music it acts on the soul through the intermediary of the senses ...' Holding a small red mask which signifies his attachment to the world of the theatre, Chagall – like Gauguin – challenges and unsettles the spectator with his gaze. It is the provocative, assured gaze of a self-willed individualist.

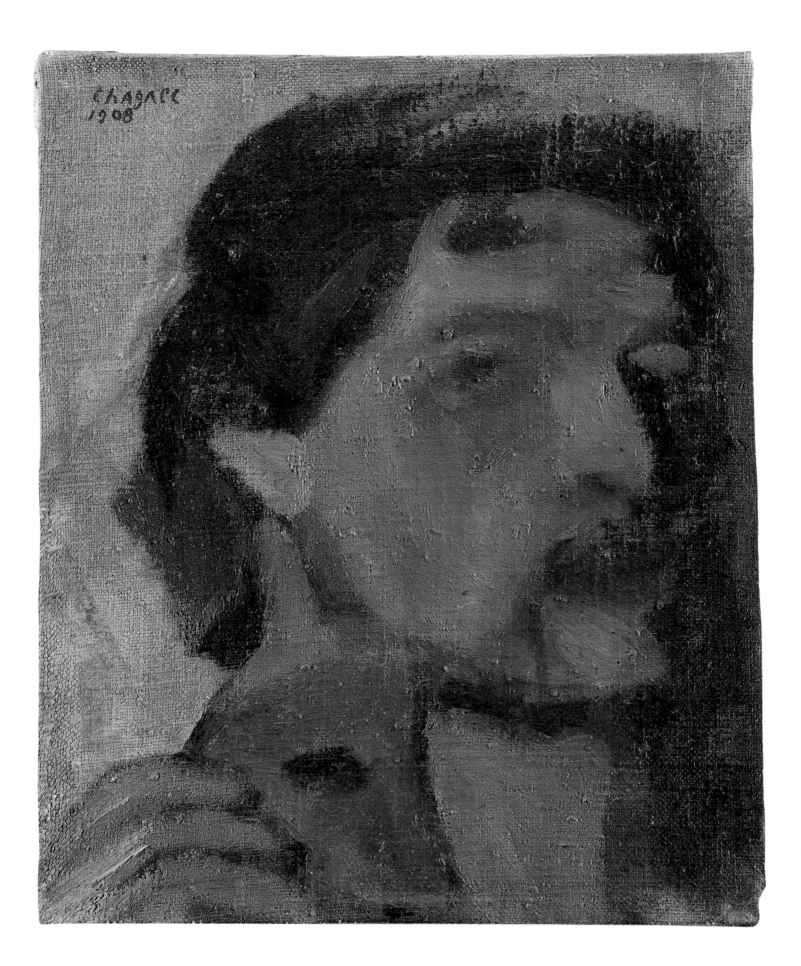

The Dead Man

1908. Oil on canvas, 68.2 x 86 cm. Musée National d'Art Moderne, Centre Georges Pompidou, Paris

In the first monograph on Chagall, published in 1918, its authors, Abram Efros and Iakov Tugendhol'd, wrote that his 'visions live entirely in the confines of the simplest mundane life, while his mundane life is entirely visionary.' This recognition of the fundamental nature of Chagall's art also captures the essence of *The Dead Man*, one of his earliest fantasies and part of a series of narrative compositions in which events, frequently dramatic, but drawn from everyday life, take on an aura of mystical unreality. On one level, the painting can be seen as the visual counterpart to an incident from Chagall's childhood which he recorded in *My Life*. He described how he was wakened 'well before dawn' by the sobs of a woman running down the street, calling on neighbours to help save her dying husband. She was afraid to stay alone with him, and it was others, those 'inured to sorrows', who 'calmly light the candles and, in the silence, begin to pray aloud over the dying man's head'. A different, deeper level of meaning was suggested by Chagall in 1959. He recalled an experience he had while teaching a pupil. Glancing out of the window, he was overwhelmed by the view of the street – eerily deserted, and with an air of impending tragedy. Wanting to record these sensations, he asked himself: 'How could I paint a street with psychic forms but without literature? How could I compose a street as black as a corpse but without symbolism?' Like Vincent Van Gogh (1853–1890) before him, Chagall rejected naturalistic methods and literary allegory and used a form of hallucinatory realism to create an illusion of mysterious intensity – the figure of a dead man lying in the street surrounded by candles, a potent representation of the inner desolation he had felt at that moment. It is an image charged with emotion – the effect heightened by the interplay of imagined figures, abnormally distorted perspective and the spectral yellowish-green of the sky. The enigmatic fiddler on the roof, 'in harmony', as Efros wrote, 'with the wind howling under a glowering sky', further enhances the air of unreality – the appearance of mundane life transformed into the visionary.

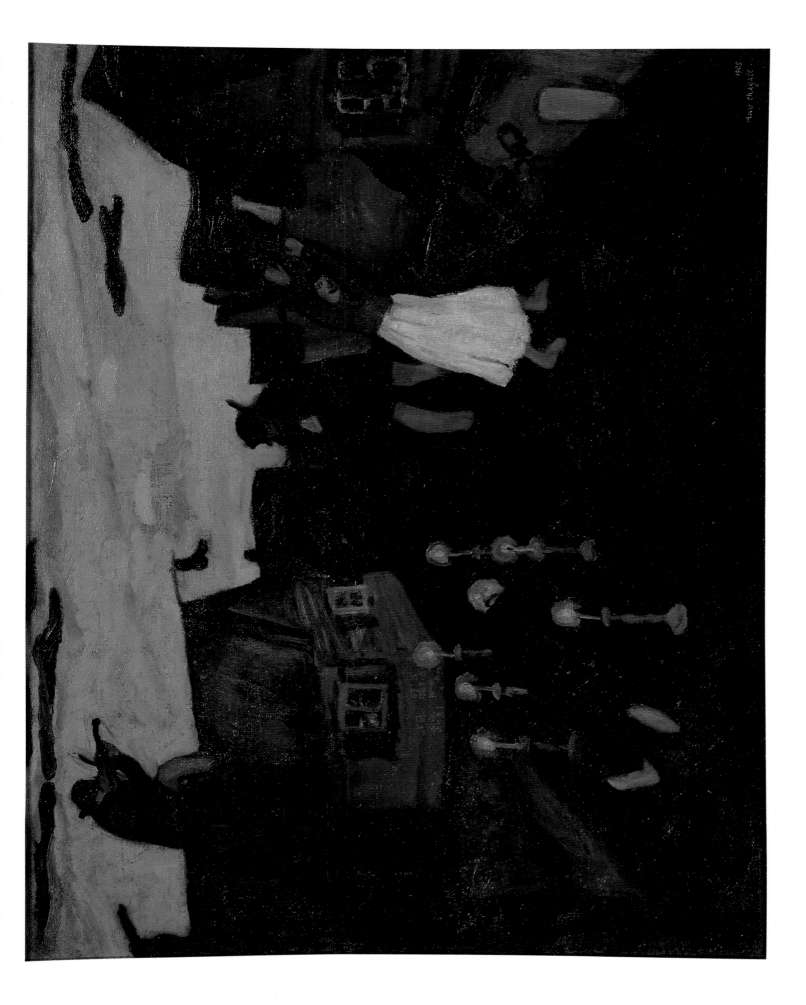

3

Birth

1910. Oil on canvas, 65 x 89 cm. Kunsthaus, Zurich

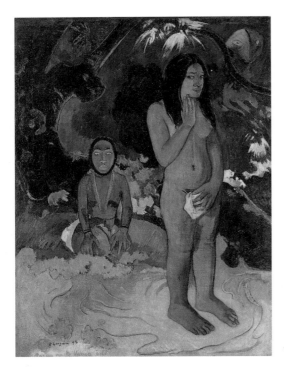

Fig. 19
PAUL GAUGUIN
Parau na te varua ino
(Words of the Devil)
1892. Oil on canvas,
91.7 x 68.5 cm.
National Gallery of Art,
Washington; Gift of
W. Averell Harriman
Foundation

Chagall's series of paintings which represent the extraordinary events of ordinary life – birth, death, marriage – are invested with a primal intensity quite different from the over-sentimentalized treatment these subjects often receive. Completed before Chagall left St Petersburg for Paris, *Birth*, like *The Dead Man* (Plate 2), has several layers of meaning. As the eldest child, Chagall was witness to his mother's eight other confinements. One, the birth of his brother David, is recalled in *My Life*, and linked to his return from St Petersburg with an uncle after treatment for a dog bite. He writes: 'I found the house full of women … and grave men … all of a sudden, the piercing wail of a newborn babe. Mama, half naked, pale, with a faint pink flush on her cheeks, is in bed. My youngest brother had just been born.' Custom required that family and friends mount a vigil at the home of the newborn – reciting prayers to protect the child from demons, and *Birth*, with the canvas split into two distinct zones, suggests such an occasion. A crowd, cautioned to silence before entering, jostles at the door, a man (father?) crouches at the foot of the bed, while a child and older man peer through the window (Chagall and his uncle?). But why the cow? Chagall may have used his knowledge of Christian iconography to paint a secular Nativity, one in which animals and humans each have their part to play. However, the focal point of the picture is a deep crimson canopy or baldachin – another icon of the Nativity – which encloses and shields this primary mystery of life from the gaze of others. A woman who has just given birth, lies naked and bleeding. On the bed behind her – holding the baby as she would a rag doll – stands the 'midwife', a figure of fear, whose grotesque, mask-like face seems to embody the evil from which the child must be protected. Gauguin's *Parau ne te varua ino* (*Words of the Devil*) (Fig. 19), with its baleful, primordial spirit that haunts Tahitians and plays on their superstitions, seems to traverse the same symbolic territory as Chagall's image. But while Gauguin's symbols were borrowed from an alien culture, Chagall's were drawn from an intrinsic system of signification – their context was his own personal domain.

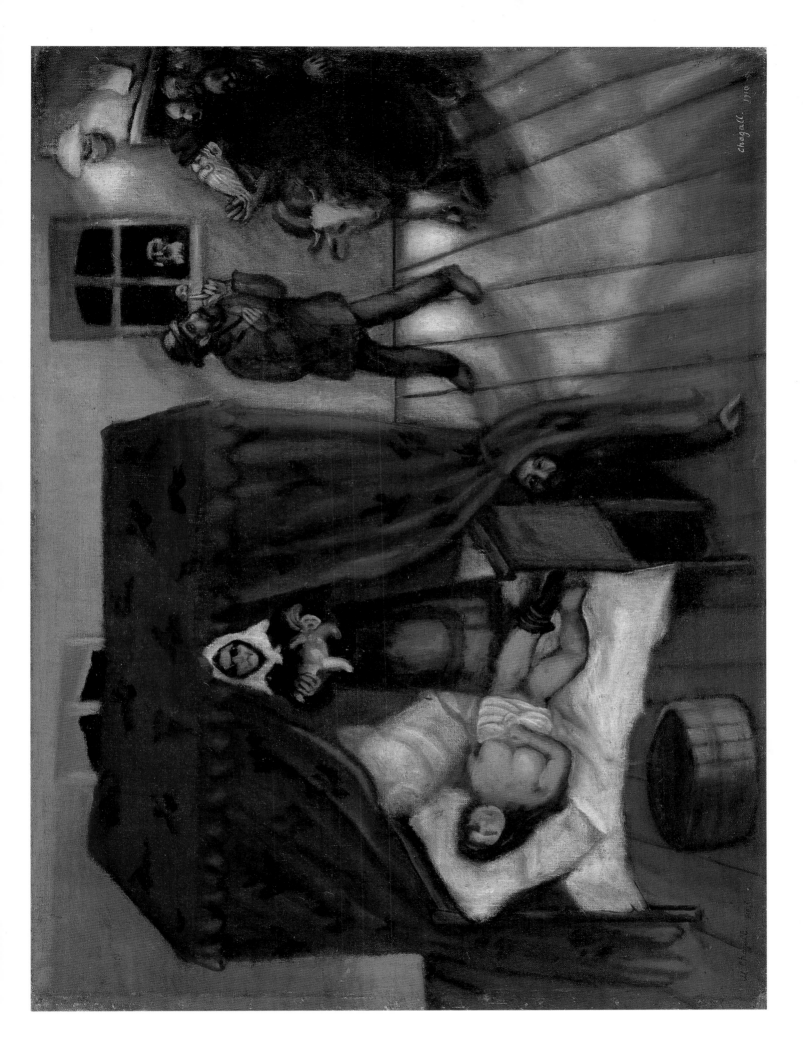

4 The Sabbath

1910. Oil on canvas, 89.8 x 95 cm. Museum Ludwig, Cologne

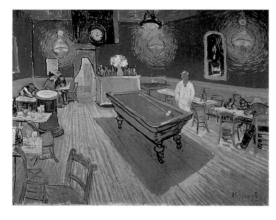

Fig. 20
VINCENT VAN GOGH
The Night Cafe
1888. Oil on canvas,
72.4 x 92.1 cm.
Yale University Art
Gallery, New Haven,
Connecticut; Bequest of
Stephen Carlton Clark

Chagall arrived in Paris in the late summer of 1910, and was overwhelmed by its size, the noise of traffic, the novelty of it all. He longed for home, writing in *My Life:* 'Only the great distance that separates Paris from my native town prevented me from returning to it immediately or at least after a week or a month.' He soon overcame these feelings, and began to enjoy all that Paris had to offer – its museums, galleries and salons, as well as the bustling life of the streets, the people he met. He was most struck by the light and colour that surrounded him, but also by 'that amazing light that signifies liberty'. He came to believe that only 'the light of liberty' could free artists to 'bring forth such dazzling pictures'; it was a freedom which as a Jew in Tsarist Russia he could only have dreamed of. Chagall was now seeing at first hand, rather than in reproduction, the work of artists he admired, and his own painting began to reflect these encounters. It is the influence of Van Gogh, whose own palette had lightened considerably on his arrival in Paris, that can be sensed in *The Sabbath*, Chagall's first Paris painting. It derives its mood in part from memories of Sabbath evenings in Vitebsk ('when Father invariably fell asleep … the prayer unfinished', when even 'the lamp rested and the chairs grew bored') and in part from the powerful effect which a painting such as Van Gogh's *The Night Cafe* (Fig. 20) had on him. Van Gogh wrote to his brother Theo that in this painting he was trying 'to express the terrible passions of humanity by means of red and green', although in reality it seems more an image of passionless estrangement. It is *The Night Cafe's* strange, oppressive mood of tedium experienced by those on the margins of society that Chagall transferred to the familiar world of Jewish ritual – evoking an aura of suffocating boredom and lethargy with figures sitting around 'like deflated puppets'. This was reinforced by irregular perspective and the expressive use of heavily impasted semi-naturalistic colour – yellow, red and green – lifting the painting to a level of imaginative intensity which a more realistic interpretation could never have achieved.

The Studio

1910. Oil on canvas, 60 x 73 cm. Musée National d'Art Moderne, Centre Georges Pompidou, Paris

When Chagall first arrived in Paris after four days of travel, he was met at the Gare du Nord by his friend Victor Mekler, who had come to Paris the previous year. After spending a few nights on the floor of Mekler's hotel room, Chagall rented the two-roomed studio of another Russian artist, Ehrenburg, who was leaving Paris for a while. No. 18 Impasse du Maine, in Montparnasse, became Chagall's first studio and the subject of this painting. He lived there (sub-letting one of the two rooms) before moving to quarters in the artist's colony 'La Ruche' (The Beehive) in early 1912. Although Chagall received a monthly allowance of 125 francs from his patron Max Vinaver, it was a time of poverty and hardship. Unable to afford new canvas, he was forced to buy old pictures which he then painted over. Even the pictures which Ehrenburg had left behind for safe-keeping suffered the same fate! Chagall is known to have used a second-hand canvas for *The Studio*, a painting in which he seems to combine the perspectival distortions of Van Gogh with the blazing colour of Matisse. It is tempting to think that Chagall would have seen Van Gogh's paintings *The Bedroom* (1888) and *Gauguin's Chair* (1888 – the latter with its high viewpoint and 'red and green night effect'), as well as Matisse's *Harmony in Red/La desserte* (1908), in which the distinction between vertical and horizontal planes is blurred by an all-encompassing red, permeating the room from floor to ceiling. Just such a blurring effect occurs in *The Studio*, where the bright emerald green of the walls bleeds down onto the head-board and bedspread. Individual colours – red, mustard yellow and blue – their intensity heightened by the saturated background, set the furniture moving to a dynamic rhythm which seems to drive the image in an anti-clockwise wheel. Several paintings decorate the walls or rest on the easel. One, hanging on the wall above an empty frame, can be positively identified as *My Fiancée in Black Gloves* (1909), which Chagall brought with him from Russia. It is one of the earliest of many portraits of Bella Rosenfeld, the woman he married in 1915.

Dedicated to my Fiancée

1911. Oil on canvas, 213 x 132.5 cm. Kunstmuseum, Berne

Fig. 21
EUGENE DELACROIX
Death of
Sardanapalus 1827
Oil on canvas,
395 x 495 cm.
Louvre, Paris

In 1827 Eugène Delacroix (1798–1863) submitted *Death of Sardanapalus* to the Salon and caused uproar (Fig. 21). This immense painting, over which he received an official warning, was inspired by one of Byron's plays – telling a heroic story of personal sacrifice in the cause of peace. Delacroix subverted the narrative climax of the play for his own purposes, turning the scene into an orgy of death and destruction, over which the Assyrian king – Sardanapalus – presides with detached impassivity. *Dedicated to my Fiancée* was exhibited at the Salon des Indépendants in 1912; it too caused outrage – the censor insisting that Chagall repaint the 'offending' lamp on the lower right to render it less phallic. While it is unlikely that Chagall had seen the Delacroix (it was only purchased by the Louvre in 1921), illustrations of it were circulating after 1873, and Chagall's friend, the critic Guillaume Apollinaire, wrote about it in his *Chroniques d'art* in 1911. Chagall's minotaur – half-bull, half-man – is a truncated mirror-image of Sardanapalus, and both are the quiescent observers of mayhem which, in the enclosed space, swirls in a vortex around them. Both reflect the relationship between artistic creation and sexuality. *Dedicated to my Fiancée* was one of the first pictures Chagall painted in 'La Ruche'. While Apollinaire suggested it was 'a golden donkey smoking opium', Chagall described it as 'a sort of bacchanal, like those by Rubens, only more abstract'. He painted it in a single night, finishing it with no light at all, but 'entirely by touch'. It is one of a number of paintings and gouaches of great inventiveness and vitality which Chagall completed at this time, using a loose Cubist structure to help bring the high levels of fantasy and irrationality – which seemed to well unmediated from his unconscious – under some sort of control. A lamp is knocked over, one woman disappears off-canvas, another climbs and entwines her bare legs suggestively around the bull-man's body, directing a stream of 'diabolical spittle' (Chagall's words) into his mouth. Chagall conveys the excitement and passion of an encounter of unbridled eroticism, but disrupts the normal conventions; unusually for that time, it is the woman who initiates the action with this figure whose 'mask' reveals that he is both beast and man in one. His expression – unsublimated carnality – hides nothing. Chagall brings to the surface a 'psychic reality' – that which we normally have access to only in our dreams.

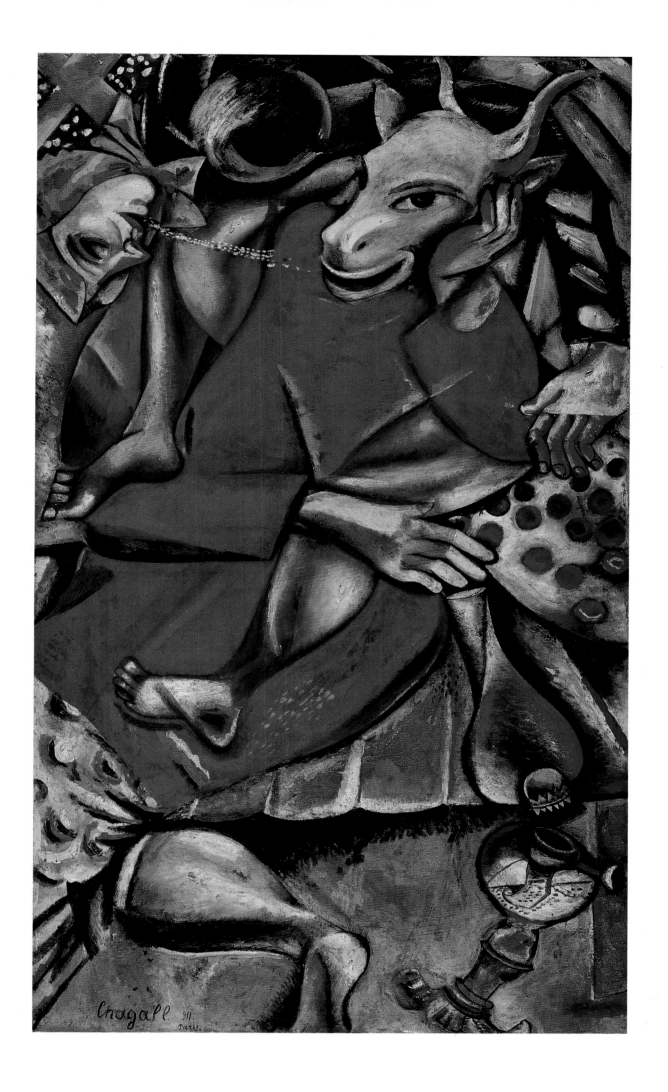

7 To Russia, Donkeys and Others

1911. Oil on canvas, 157 x 122 cm. Musée National d'Art Moderne, Centre Georges Pompidou, Paris

Like a number of paintings of this period, *To Russia, Donkeys and Others* owed its rather cryptic title to Chagall's friend, the poet Blaise Cendrars, although the 'Donkeys' of the title may also refer to Chagall's planned participation in an exhibition – 'The Donkey's Tail' – in Moscow in 1912. Paradoxically, there is no donkey in this painting, only a doe-eyed cow which suckles a calf (or lamb) and child while perched on the sloping roof of a village house. The milkmaid, pail in hand, floats through the night sky towards the cow – her head detached from her shoulders, her soul 'yearning for the vast expanses of the heavens'. The painting had its genesis in a number of naturalistic and semi-naturalistic gouaches and drawings of Russian peasant life. But the large oil, its construction based on a quasi-Cubist system of lines and diagonals, has a mysterious, other-worldly quality. It is without either logic or gravity, taking on a symbolic resonance which links it to the myths of antiquity. The velvety-black of a night sky shot through with astral lights (added after an eclipse of the sun in 1912), reinforces the painting's aura of magical intensity. Most writers connect the painting to the legend of Romulus and Remus (who were suckled by a wolf), but it has been suggested (see *Chagall*, ed. Susan Compton, 1985, p. 37) that the Egyptian deity, Hathor – identified by the Greeks with Aphrodite – may be a more likely source. In legend, Hathor was the great celestial cow who created the universe and gave birth to the sun each morning. She has been represented as a cow giving milk to the pharaoh Amenhotep II, who kneels under her like the child in the painting. Chagall, whose years in St Petersburg and then in Paris brought him into contact with movements and ideas which were a world away from his Jewish roots in Vitebsk, would have found such connections easy to make. But it was childhood experiences that formed the bedrock of his art. Speaking in 1944, he said: 'The fact that I made use of cows, milkmaids, roosters, and provincial Russian architecture as my source forms is because they are part of the environment from which I spring and which undoubtedly left the deepest impression on my visual memory of any experiences I have known ... The vital mark these early influences leave is ... on the handwriting of the artist.'

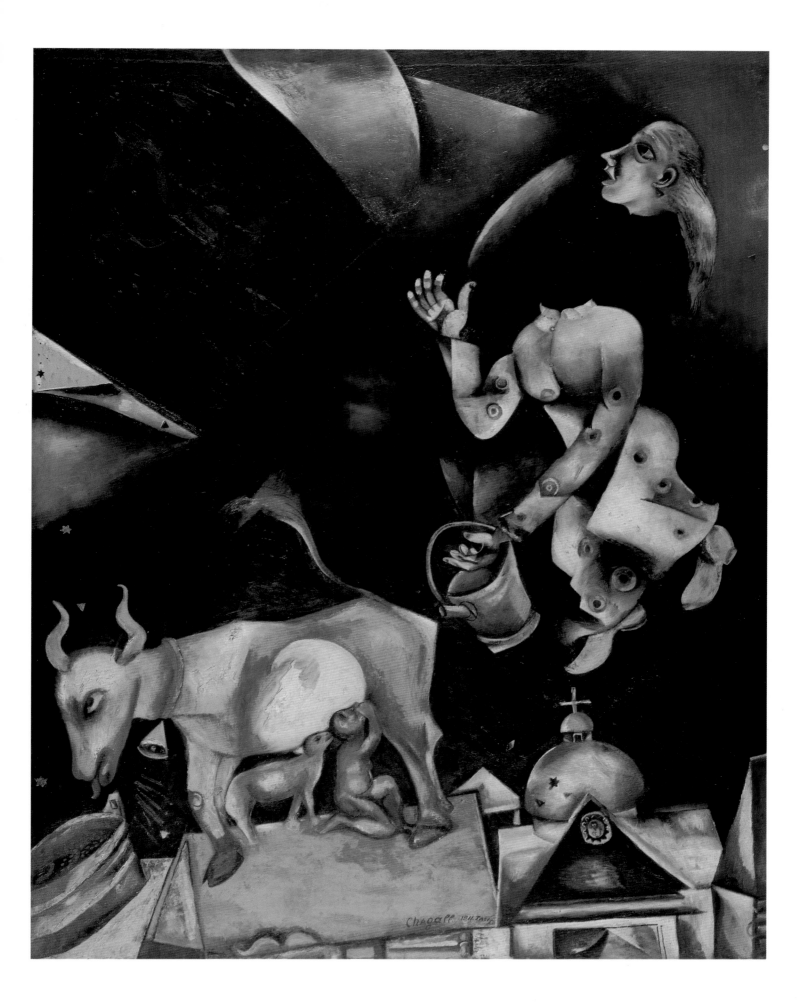

Half Past Three (The Poet)

1911. Oil on canvas, 196 x 145 cm. Philadelphia Museum of Art; The Louise and Walter Arensberg Collection

Cubism was at its height when Chagall arrived in Paris in 1910, but at first his paintings reflected the influence of Gauguin, Van Gogh and the Fauves. He then began to work out a response, both to the Cubism of its originators – Pablo Picasso (1881–1973) and Georges Braque (1882–1963) – and to others (many his friends), who incorporated Cubist devices to suit their individual styles. *Half Past Three (The Poet)* is one of the most overtly Cubist of Chagall's paintings of the period. Figure and ground are one, the planes interpenetrating and overlapping on the flattened and tilted surface, which gives the entire image the appearance of a paper cut-out. The *trompe l'oeil* decoration in the top right corner suggests a curtain or fragment of wallpaper. It is the one element of reality in a work which otherwise combines the formal structures of Cubism with Chagall's familiar motif of the detached and inverted head. The whole is activated by intense but transparent veils of colour – red, blue and green – which play back and forth between figure, cat, table and curtain, a reflection of the influence which Delaunay's experiments with light and colour were having on Chagall. Chagall, who wrote poetry himself, was always more friendly with poets and writers than with other painters, although he intensely disliked being described as a 'literary painter'. He produced very few portraits in Paris, but the obscure poet, Mazin – a fellow inhabitant of 'La Ruche' – was the subject of two. *Half Past Three (The Poet)* was developed from a drawing and a fine portrait study in oil (*The Poet, Mazin* (1911–12)), which is itself far from naturalistic. In both oils, Mazin sits quietly in a corner, drinking. The hour, we are led to believe by the title of this painting, is half past three in the morning, and poetic inspiration is flowing like the wine. Pen in hand, Mazin – or even Chagall himself (for it has been suggested that the figure represents different aspects of an artistic expression which is realized in both painting and poetry) – muses over a sheet of paper, a love verse in Cyrillic script perhaps being penned to Bella, at home in Vitebsk.

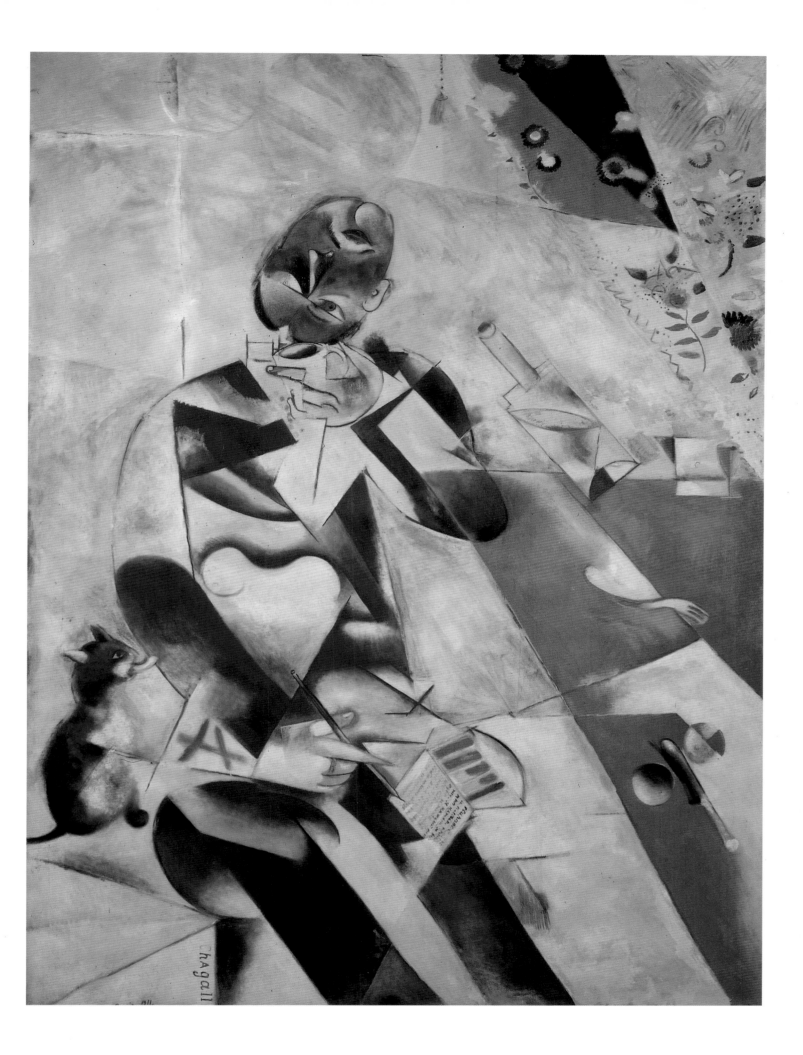

I and the Village

1911. Oil on canvas, 192.1 x 151.4 cm. The Museum of Modern Art, New York

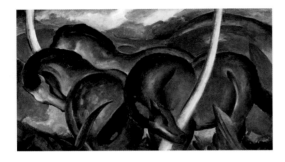

Fig. 22
FRANZ MARC
Blue Horses
1911. Oil on canvas,
103.5 x 108 cm.
Walker Art Center,
Minneapolis

'Apollinaire sat down. He blushed, swelled out his chest, smiled and murmured "*Surnaturel* ! ..." The next day I received a letter, a poem dedicated to me: "Rotsoge".' This description of Apollinaire's reaction to Chagall's paintings while on a visit to 'La Ruche' suggests the extraordinary impact which works such as *I and the Village* had on people at the time. With its jewel-like colours, smooth, lacquer-like surface and rich formal and symbolic language, it represents another high point in a creative surge which carried Chagall through to his first one-man exhibition in Berlin in 1914. By combining Cubist technical devices (interpenetrating transparent planes) and the transparent colour-veils of Orphism, Chagall evolved a style dependent not only on vision but on memory and imagination as well. It was one in which fantasy, irrationality and transformation became concrete through an expressive and lyrical arrangement of colour and form. This completely original vocabulary of images was, to a large extent, a retrospective construction of Chagall's childhood memories of his Russian homeland, and he explores that nostalgia for a lost world in *I and the Village*, one of the most powerful examples of this new form of expression. Like his German Expressionist contemporary, Franz Marc (1880–1916), Chagall had an empathic sense of identification with animals, images of which appear frequently in his paintings. However, unlike Marc, who dreamed of a world free of human intervention (Fig. 22), Chagall tied humans and their beasts firmly together in a mutually interdependent relationship, both – as in *The Cattle Dealer* (Fig. 2) and the later *Peasant Life* (Fig. 3) – bound by the rhythms and cycles of the natural world. *I and the Village*, with its circular forms reminiscent of *Homage to Apollinaire* (Plate 10), represents an idealized view of that relationship. A Russian peasant/Chagall and a cow – cross and rosary beads around their necks – regard each other fixedly, their eyes connected by a 'physical' line or current which passes between them, confirmation perhaps of that longed-for unity. A large head (Chagall's?) peers from the open door of the church; a peasant and his wife play out a topsy-turvy dream-world drama; a milking scene is enacted on the cow's cheek. Between the two giant heads, Chagall has painted a small 'jewelled' tree possibly symbolic of the 'Tree of Life', signifying immortality. It is a compelling image about the nature of memory, poetically transfigured.

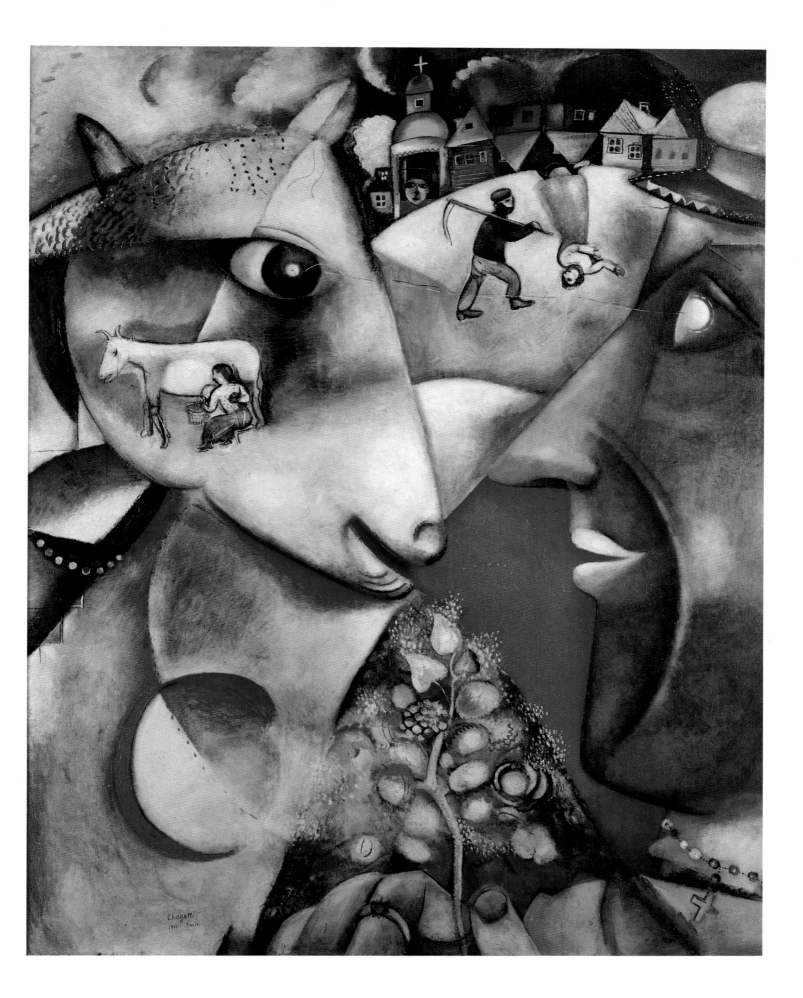

1911–12. Oil, gold and silver powder on canvas, 200 x 189.5 cm. Stedelijk van Abbemuseum, Eindhoven

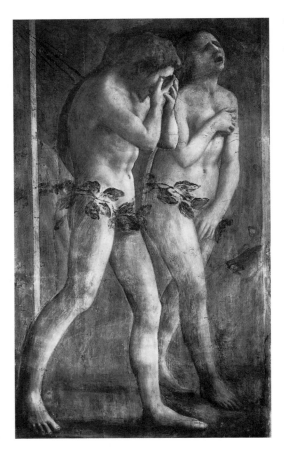

Fig. 23
MASACCIO
Expulsion of Adam
and Eve
c.1425. Fresco.
Brancacci Chapel,
Florence

Fig. 24
Cain and Abel
1911. Gouache on paper,
22 x 28.5 cm.
Private Collection, Basle

This complex and mysterious picture placed Chagall at the forefront of European painting. Shown in public for the first time in 1914 at Herwarth Walden's Berlin gallery, Der Sturm, it represents the climax of Chagall's first Paris period. It is a painting which carries within it multiple levels of meaning, and as many art-historical interpretations. A master of mystification and concealment, Chagall was always loath to disclose his intentions, but earlier studies confirm the painting's origins as a resumé of part of the Genesis story – the creation of Eve, the temptation of Adam and the Fall. Even in its final, stylized form, there are enough 'quotations' suggested by the androgynous figure[s] in the centre of the 'clock' or colour circle (a form with infinite symbolic connotations) to sustain this interpretation. One of the most interesting but so far unrecognized references is to Masaccio's Eve from the powerful and moving *Expulsion of Adam and Eve* in Florence (Fig. 23). Eve's despair, her open-mouthed entreaty, was taken and used by Chagall for his own twentieth-century exposition of the primary myth. (That Chagall was interested in the Masaccio is further confirmed by the gouache *Cain and Abel* which shows Abel – a roughly executed mirror-image of Masaccio's Adam – trying to escape Cain's fratricidal rage (Fig. 24).) The hermaphrodite Adam/Eve may have its roots in Jewish mysticism, which stresses the importance of 'unity in duality' as an emblem of reality. Although the inclusion of words and numbers in paintings became a well-established Cubist practice, the figures may also signify the hands of a clock, the dial registering only the digits 9, [1]0 and [1]1 – the hours when, according to Talmudic scholarship, God gave his warning (9.00), Eve (and Adam) transgressed (10.00), and received judgement and punishment (11.00). This painting, dedicated to Apollinaire, also includes a reference to three other important figures in Chagall's life: Cendrars, Walden and Riciotto Canudo – their four names surrounding a heart pierced by an arrow. It has been suggested that the names are also a punning reference (in French) to the four elements – air, fire, earth and water – further emphasizing the paintings mystical, alchemical sources. But one name is missing. It is in the great disc or circular form – cosmic, symbolic of unity, but also dependent for its conception on Orphist experiments with colour, light, space and form – that Chagall paid homage to his other great friend, the artist Robert Delaunay (1885–1941).

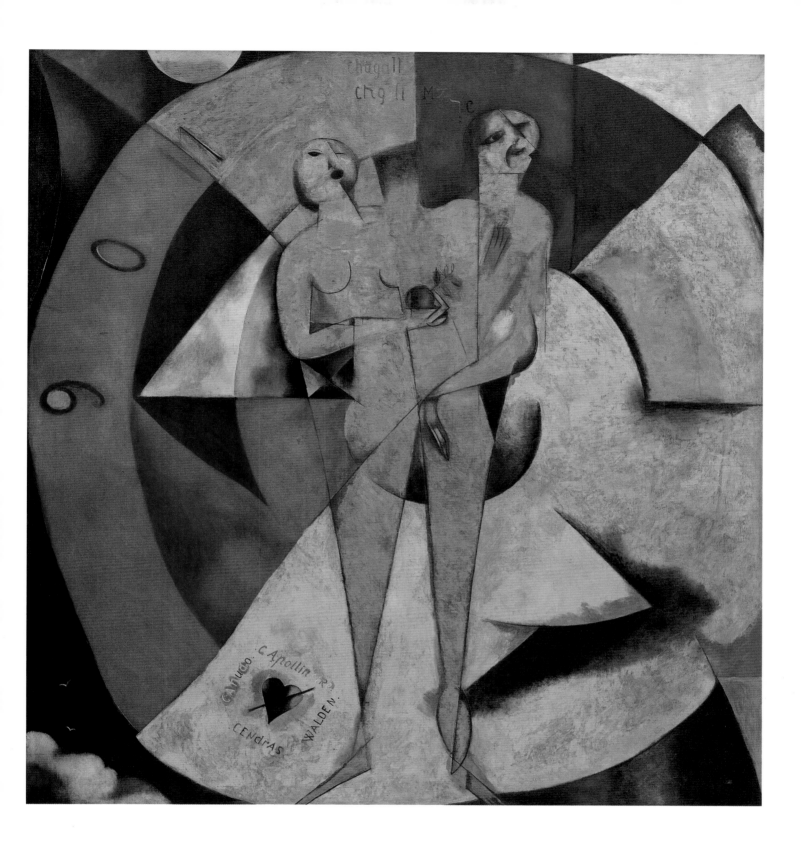

Adam and Eve

1912. Oil on canvas, 160.5 x 109 cm. St Louis Art Museum

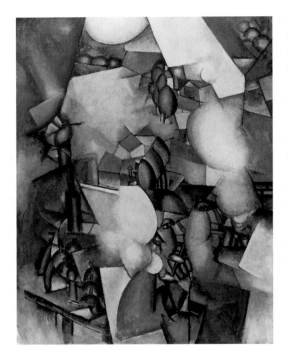

Fig. 25
FERNAND LÉGER
Smokers
1911. Oil on canvas,
129.5 x 96.5 cm.
Solomon R. Guggenheim
Museum, New York

Chagall was temperamentally unsuited to becoming a 'true' Cubist, but, like every other artist in Paris with avant-garde tendencies, he could not help but be influenced by what had effectively become a mandatory aesthetic programme. He began to use the formal and spatial procedures of Cubism as a structure, a means of controlling the high levels of fantasy and irrationality which invaded his imagery from 1911 onwards. *Half Past Three (The Poet)* (Plate 8), *Adam and Eve* and the later *Cubist Landscape* (Plate 25) are Chagall's most elaborate essays in the Cubist manner, but he subverts the idiom by introducing naturalistic or fantastic elements, reminding us of the ambivalence he felt towards a 'technical art', one which, as he said in an interview in 1944, 'only proposed a single aspect of an object to our consideration … its geometrical relationships'. *Adam and Eve* was exhibited at the Salon des Indépendants in 1913 under the title *Couple Under the Tree*. It was renamed by Apollinaire, who described it in his review of the Salon as 'a large decorative composition [which] reveals an impressive sense of colour, a daring talent, and a curious and tormented soul'. The painting shows a superficial affinity with the work of a number of artists with whom Chagall had contact – particularly Jean Metzinger (1883–1956), one of the teachers at the Académie de la Palette, and co-author of *Du Cubisme*, the first book on Cubism. Fernand Léger's (1881–1955) *Smokers* (Fig. 25), with its contrasting motifs, stylized puffs of smoke and flat angular planes of colour, also reflects the style of the period and suggests itself as one of several likely influences. *Adam and Eve* is difficult to read, with its apparently arbitrary faceting and fragmentation of forms, as the figures break into multiple planes dispersed over much of the painting's surface. Only the tree from which Eve plucks the apple grows naturalistic foliage and fruit; while on the distant rocky outcrops of this dawn of creation, a goat and a deer (a bird on its antlered head) suggest something magical, their symbolic presence drawing the painting out of what Chagall perceived to be the hollow formalism of the Cubist aesthetic, and into the more familiar realms of fantasy.

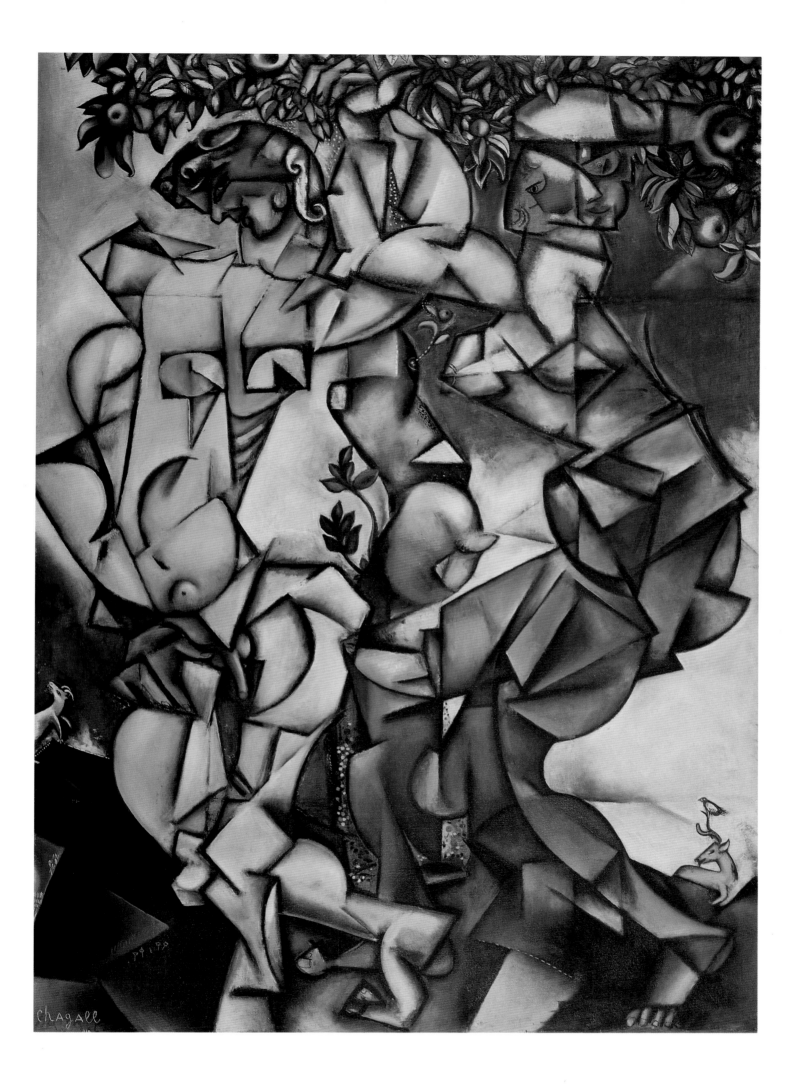

The Fiddler

1912–13. Oil on canvas, 188 x 158 cm. Stedelijk Museum, Amsterdam

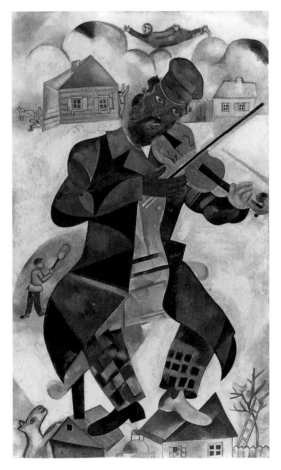

Fig. 26
The Green Violinist
1923–4. Oil on canvas,
198 x 108.6 cm.
Solomon R. Guggenheim
Museum, New York

The green-faced *Fiddler*, one foot tapping out his rhythm on the roof of a tiny wooden house, is a variant of an image which haunted Chagall throughout his life, and in one guise or another is to be found in many paintings from *The Dead Man* (Plate 2) onwards. Seldom earthbound, Chagall's violinists are enigmatic, solitary figures who inhabit the universe of his dreams as significant images from childhood memory. In the lost world of the Jewish *shtetl*, every important event in the life of the community – weddings, funerals, religious festivals – was accompanied by the music of this legendary figure whose effect on his audience was described by the great Yiddish writer, Shalom Aleichem: 'One no longer sees anything but his hand going up and down ... and the sounds flow out, and the melodies pour out, all different, but above all melancholic and full of suffering. And those who are listening hold their breath; their hearts fill with emotion, tears spring to their eyes.' *The Fiddler*, which ignores all conventions of scale and logic, was exhibited at the Salon des Indépendants in spring 1914, and it is possible that Chagall based his idea for the painting – which was preceded by a drawing and a gouache – on contemporary accounts of the abortive Russian revolution of 1905. An Estonian violinist, Edward Sormus, who was in Paris in 1912 playing at emigré fund-raising events, was reported to have led demonstrations through the streets of St Petersburg at the time, all the while playing his violin. Background details such as footprints in the snow – one the colour of blood – and the tiny three-headed manikin may suggest violence and the presence of an angry crowd. Other references, a tree of Paradise, a skinny, haloed cherub – its arms outspread in a gesture of embrace – and the green of the fiddler's face (suggestive of trance or hallucination) return the painting to the more familiar terrain of Chagall's fictional world. The significance of this particular image for Chagall is suggested by the fact that in 1920 he painted *Music* – essentially the same composition with background variations – for his mural project for the State Jewish Chamber Theatre, Moscow. In 1923–4 he painted a virtual replica of *Music – The Green Violinist* (Fig. 26), based on drawings he made after leaving Russia for good, despairing for the future of its artists.

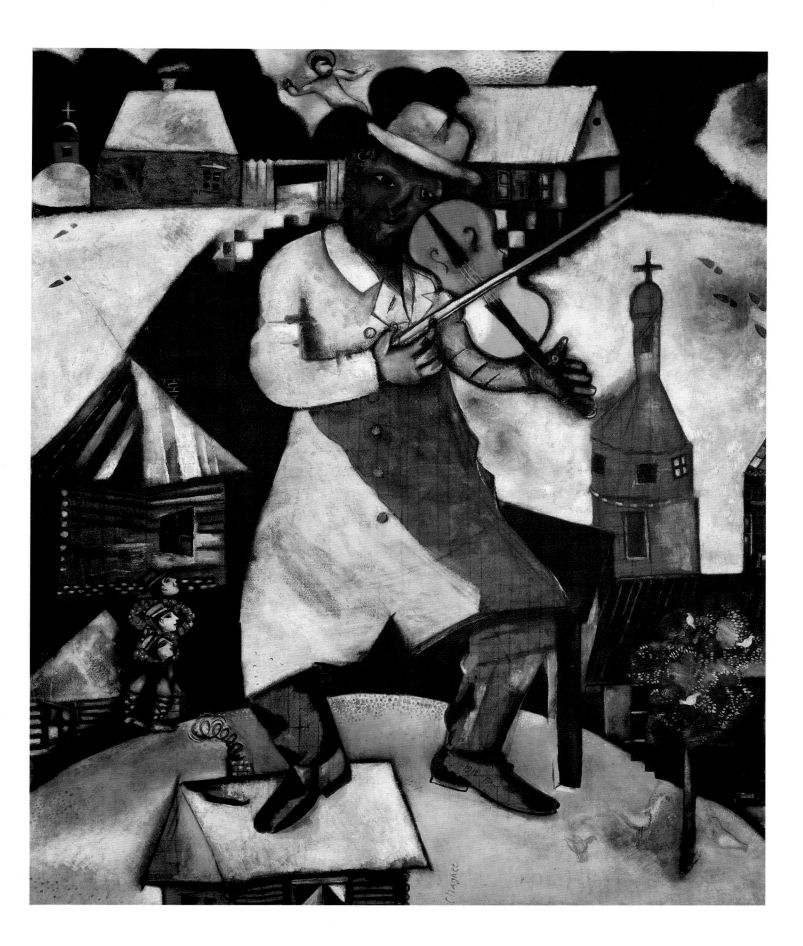

Self-Portrait with Seven Fingers

c.1912–13. Oil on canvas, 126 x 107 cm. Stedelijk Museum, Amsterdam

Fig. 27
Study for *Self-Portrait
with Seven Fingers*
1911. Pencil and gouache
on paper, 23 x 20 cm.
Private Collection

It is rare for a city as remote from the centre of world art as Vitebsk was to be the focus of such an enduring attachment. This unlikely, yet beloved '*genius loci*' of Chagall's imagination – his 'mother-town' with its familiar skyline and characteristic wooden houses – is to be found in painting after painting throughout his life. Paris, of course, was where Chagall's creative potential was liberated, and in *Self-Portrait with Seven Fingers* the two places are represented, signified both by word (the Hebrew lettering for 'Russia' and 'Paris') and by image. Hovering above the easel on which the recently painted *To Russia, Donkeys and Others* (Plate 7) rests, a memory-image of Vitebsk reflects Chagall's continuing preoccupation with his homeland, while through the studio window behind him, that 'obelisk of iron' – the Eiffel Tower – can be glimpsed, soaring into the night sky, the same view which would soon make its appearance in *Paris through the Window* (Plate 16), another major work of this period. Only four or five years separate *Self-Portrait* (Plate 1) and *Self-Portrait with Seven Fingers*, and we can see how profoundly exposure to the Parisian avant-garde had affected Chagall's style – freeing him from the constraints of a quasi-naturalism and flooding his canvas with the irrational and the a-logical, the quirky and the fantastical. In fact, an earlier study for this oil (Fig. 27) reveals that Chagall's intentions, certainly in relation to the figure itself, were less radical than in the final painting, where the artist's head and body suggest a carapace or exoskeleton rather than the Cubist planes and angles which underpin the construction. The eyes, to which the spectator is drawn, have something of Picasso's *Les Demoiselles d'Avignon* (1907) about them – they are the eyes of an idol or 'primitive' mask – and confirm that Chagall, like his contemporaries, was aware of ethnographic and folk art and sought to incorporate elements of it into his own work. Chagall's 'superstitious preference' for the number seven may account for the extra digits on the left hand, although it is also the case that to be praised in Yiddish for doing something well, is 'to do it with all seven fingers'. The artist's seven-fingered hand, which rests with justifiable pride on the canvas before him, implies that this is work well done, and that, despite being in Paris, nothing could distance him from the sources of his inspiration. What was true then remained so, for in 1934 he wrote to a friend: 'The title "A Russian Painter" means more to me than any international fame … In my pictures, there is not one centimetre free from nostalgia for my native land.'

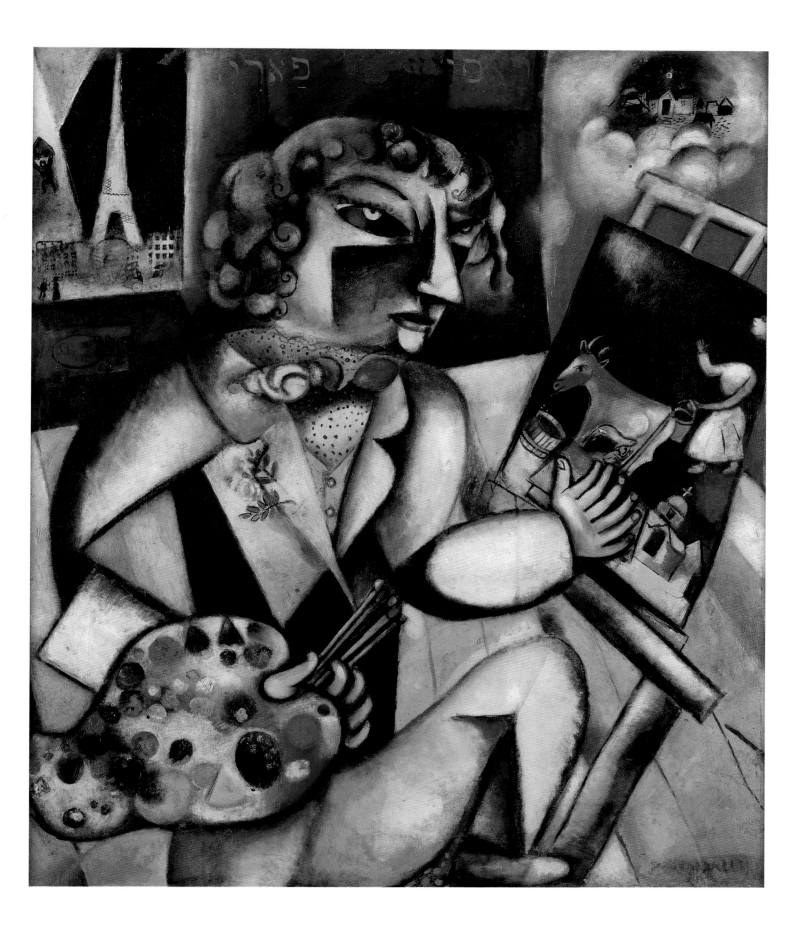

Jew at Prayer

1912–13. Oil on canvas, 40 x 31 cm. Israel Museum, Jerusalem

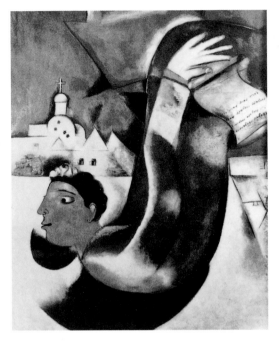

Fig. 28
The Holy Coachman
1911–12. Oil on canvas,
148 x 118.5 cm.
Private Collection,
Germany

Hasidism was an anti-intellectual, anti-rational Jewish revivalist move-ment, founded in the mid-eighteenth century by the Rabbi-mystic Ba'al Shem-Tov (Master of the Good News). It was characterized by an ecstatic approach to life which was manifested in spontaneous outpourings of emotion (jumping, tumbling and clowning in public), in religious fervour, and in the belief that 'to serve God in joy is all'. Chagall turned away from his family's strict adherence to this way of life in order to paint, but the spirit of Jewish mysticism was one of the fundamental sources of his art, and in some cases provided the material for individual paintings. On his return to Russia in 1914 Chagall painted a number of semi-naturalistic and fantastical portraits of itinerant Jewish preachers, peddlers and beggars (*Feast Day (Rabbi With Lemon)*, Plate 18 and *The Praying Jew*, Fig. 4), but it was a subject he had already established in Paris with works such as *The Pinch of Snuff* (1912) and *Jew at Prayer*. In this small, heavily impasted painting, the stylized image of an anonymous Jew sits engrossed in his text, surrounded by the accoutrements of ritual and prayer: phylacteries, *tzitzit* (twisted coils or fringes that symbolize the Law) and a Torah scroll. This dark, enclosed space of a synagogue or Yeshiva (Academy) suggests a world defined more by scholarship and meditation than by joy and emotion. However, the 'Chabad' (which means 'wisdom, insight, knowl-edge') or Lubavitcher Hasidism of the area in which Chagall grew up stressed the importance of both ways of life, and this painting, together with *The Holy Coachman* (Fig. 28) (which seems to represent uninhibited spiritual elation), are a visual counterpart or foil to one another and define two important elements of Chagall's childhood experience within the close-knit environment in which he was raised. Cendrars gave *The Holy Coachman* its title, and it was exhibited – upside down – by Walden in 1914. Chagall, who delighted in ambiguity, approved the inversion (he routinely worked at his canvas from all sides) and the strange, swooping figure – anatomically 'difficult' and even absurd – has been kept this way ever since. In its original position (which he returned to with proposed works for the theatre, such as *The Card Players*, 1919), the seated figure leans over backwards – the outward thrust of his chest and the expression of wonder or astonishment on his face suggesting a heightened state of religious intoxication. Reality and logic have no place in Chagall's world of fantasy and illogicality – one in which 'the mystique of Hasidism' and the 'gold-land' (fictional and remembered) of his particular childhood became an exotic cosmogony which was both perplexing and enthralling to his western metropolitan audience. It was, as his biographer Efros wrote, '… a dream multiplied by a dream'.

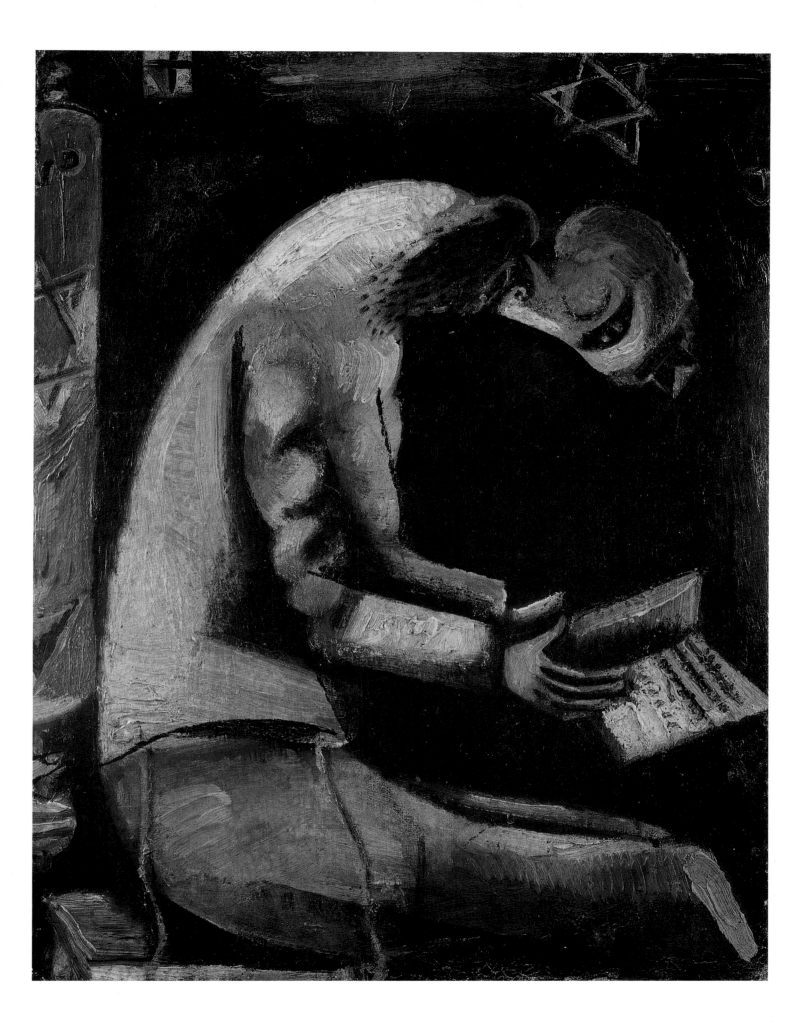

Pregnant Woman (Maternity)

1913. Oil on canvas, 194 x 114.9 cm. Stedelijk Museum, Amsterdam

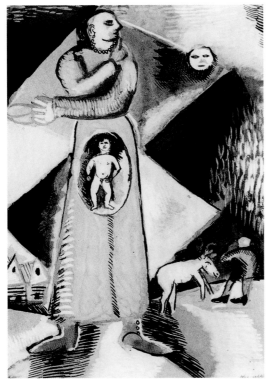

Fig. 29
Russia
1912–13. Gouache on
paper, 27 x 18.2 cm.
Private Collection

Fig. 30
Znamenie – Icon of
Yaroslav School
*c.*1220. Tretyakov
Gallery, Moscow

Chagall was profoundly influenced by Russian icon art, and *Pregnant Woman* is the image most closely associated with that influence, although in less obvious ways it is present in many of his other paintings as well. Chagall's first real exposure to icons was in 1906 when he went to live in St Petersburg. Later, he recalled visits to the Alexander III Museum of Russian Art where he felt that his 'heart was quiet with the icons ...', that through them he was 'born to mysticism and religiosity'. These sentiments, which were similar to those he expressed in relation to the 'mystique of Hasidism', were a reflection of his innate anti-rationalism, his belief that 'Art seems ... to be, above all, a state of soul ... [and] ... only the upright heart that has its own logic and its own reason is free.' But while Chagall was impressed by the long history, the sanctity and the traditional symbolic expression of icon art, he had no intention of creating icons himself. His interest lay in 'shattering' their original meaning, in developing a context in which their formal and symbolic elements could be transformed into a completely new and original idiom – dynamic, secular and personal – which could draw the spectator beyond the customary and the commonplace into that space which André Breton, writing about Chagall's art, described as 'resolutely magical'. *Pregnant Woman*, which was preceded by a gouache entitled *Russia* (Fig. 29), was inspired by the thirteenth-century *Znamenie* or *Virgin of the Sign* (Fig. 30). But whereas the Virgin looks out squarely and frontally, arms outstretched and wearing on her breast a medallion depicting an image of Christ, Chagall's painting shows a Russian peasant 'Madonna' pointing to her womb in which an unborn male child is not only visible, but fully formed and alert. Her face, green and intense, incorporates the profile of a bearded man; perhaps to suggest that conception was not immaculate, but more likely to broaden the emphasis and focus on this woman as a symbol of fecundity, analogous to all the great mother figures in ancient cultures, many of which exhibit bisexual attributes (Meyer, 1964, p. 203). Birds, clouds, a cow and the moon inhabit a sky suffused with glowing colours – orange, yellow and flaming red – while an earthbound peasant prepares to work his horse. The rhythms and cycles of life in the Russian countryside are as ancient as the great earth mother herself, a clue perhaps to the title of the gouache – (Mother) *Russia*.

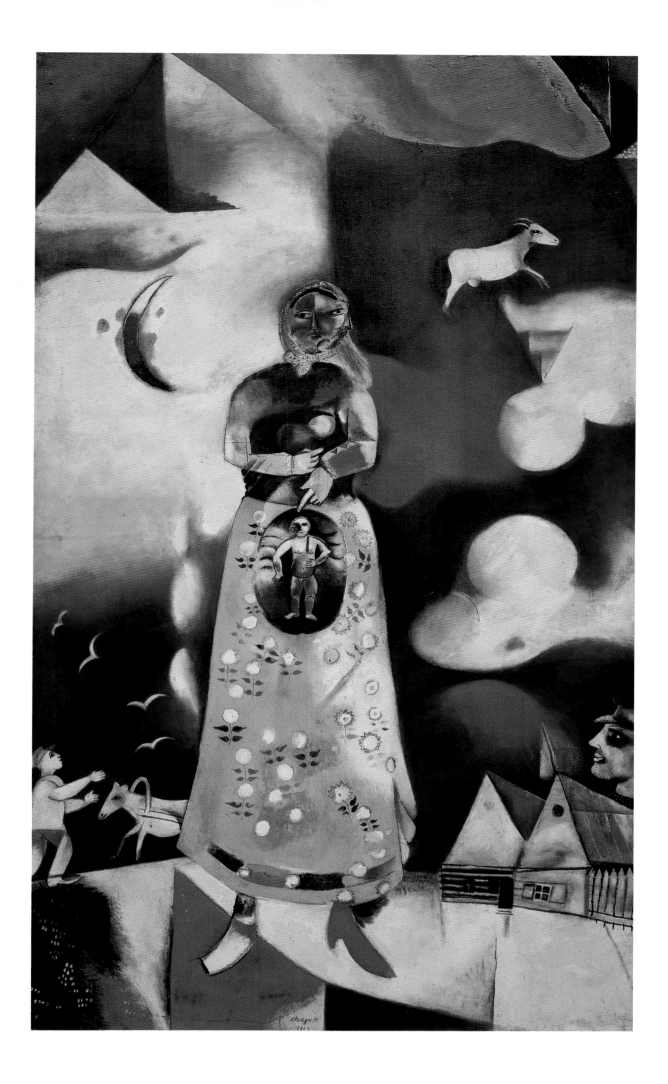

Paris Through the Window

1913. Oil on canvas, 135.9 x 141.6 cm. Solomon R. Guggenheim Museum, New York

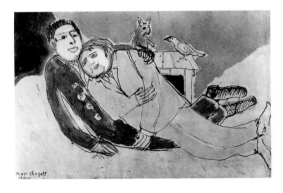

Fig. 31
Apollinaire and
Chagall
1910–11. Ink and gouache.
Private Collection

Paris Through the Window was one of the last and most Paris-centred of all Chagall's paintings of this period, and it provides a kaleidoscopic impression of the city he had come to think of as his 'second Vitebsk'. In *Self-Portrait with Seven Fingers* (Plate 13) we are shown no more than a tiny glimpse of this same view, framed by his studio window, while a memory-image of Russia hovers above his easel. 'I lived', he said later, 'with my back turned to what was in front of me.' But with this painting, he faced his present squarely, and produced an image which encapsulated those experiences – the summation of all that Paris had offered him, displayed against the backdrop of that supreme monument to the modern era, the Eiffel Tower. The influence of Chagall's friend Delaunay is evident, not only in the motif of the Eiffel Tower, which had become a central feature of Delaunay's work before he turned to abstraction (Fig. 33), but also in the transparent planes of colour and light which play across the composition, imbuing it with a dream-like otherworldliness. The magic of the image is enhanced by the strange and apparently random juxtapositions which characterize so much of Chagall's work – the upside-down train, the horizontal couple out on a stroll, the parachutist and the Janus-headed man and sphinx-like cat both gazing inscrutably into space. The illogicality of these arbitrary juxtapositions was echoed in the poetry of Chagall's friends Apollinaire and Cendrars, both of whom delighted in dislocation and non-sense which, without any apparent logical connections, punctuated their verse. 'Like my friend Chagall,' Cendrars said, 'I could paint a series of senseless pictures …' Cendrars supplied this painting's title but there is also the suggestion that 'Apollinaire's famous Roman profile' was the model for the figure at the window (and not, as often thought, Chagall himself). This is reinforced by the small golden heart painted on to the figure's hand, which corresponds with the heart, pierced by an arrow, in *Homage to Apollinaire* (Plate 10). A small gouache, *Apollinaire and Chagall* (Fig. 31), dedicated to their first meeting, shows the two gliding through the air, Chagall's arm placed protectively around the shoulders of the man he called 'that gentle Zeus' – the man whose lively interest proved decisive for Chagall's future success.

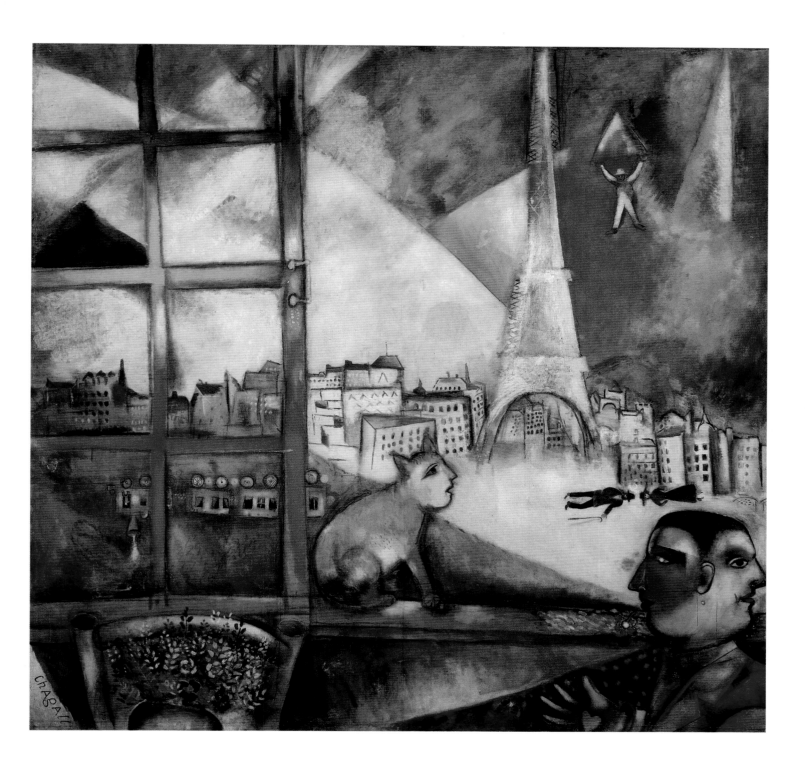

17 Acrobat

1914. Oil on brown paper mounted on canvas, 42 x 32.5 cm. Albright-Knox Art Gallery, Buffalo, NY

For Chagall, as for so many other artists, including his contemporaries Picasso and Georges Rouault (1871–1958), the circus was a central metaphor, its clowns and acrobats hiding a range of different meanings and emotions behind their masks. Traditionally on the margins, playing a part and concealing sorrow, these figures embody both suffering and compassion. Chagall said: 'I have always looked upon clowns, acrobats and actors as beings with a tragic humanity. For me they are like the figures in certain religious pictures.' Rouault, who was also commissioned by the dealer Ambroise Vollard to produce many graphic illustrations, including circus imagery, expressed similar sentiments. It was, he said, in 'the juxtaposition of shining, sparkling things made to amuse, with the infinite sadness of life … [that] … I saw clearly that the "clown" was myself, it was all of us …' Circuses had had a historical presence in Russian life since the tenth century, when Byzantine culture (and the Byzantine circus) reached the country. In addition the devout Hasidic environment in which Chagall was raised was one in which the annual rituals of festival and prayer – particularly the festival of Purim – were accompanied by spontaneous exhibitions of wild jumping, tumbling and clowning. It was a background which fed Chagall's imagination endlessly, and the circus – acrobats in particular – became a recurrent motif throughout his working life. It was a theme included in some of his most important paintings: *Introduction to the Jewish Theatre* (Fig. 8) and *The Revolution* (Plate 31), as well as being the sole subject of a number of others, of which this intense, small work is a very good example. Set against an impenetrable backdrop, the brightly costumed, attenuated figure of an acrobat leaps across the canvas – the energy and rhythm inherent in the image reinforced by the spinning hoop and the high-stepping, sinewy grace of the performer, forever playing a part. 'Lured by their colours and make-up', Chagall wrote, 'I dream of painting new psychic distortions.'

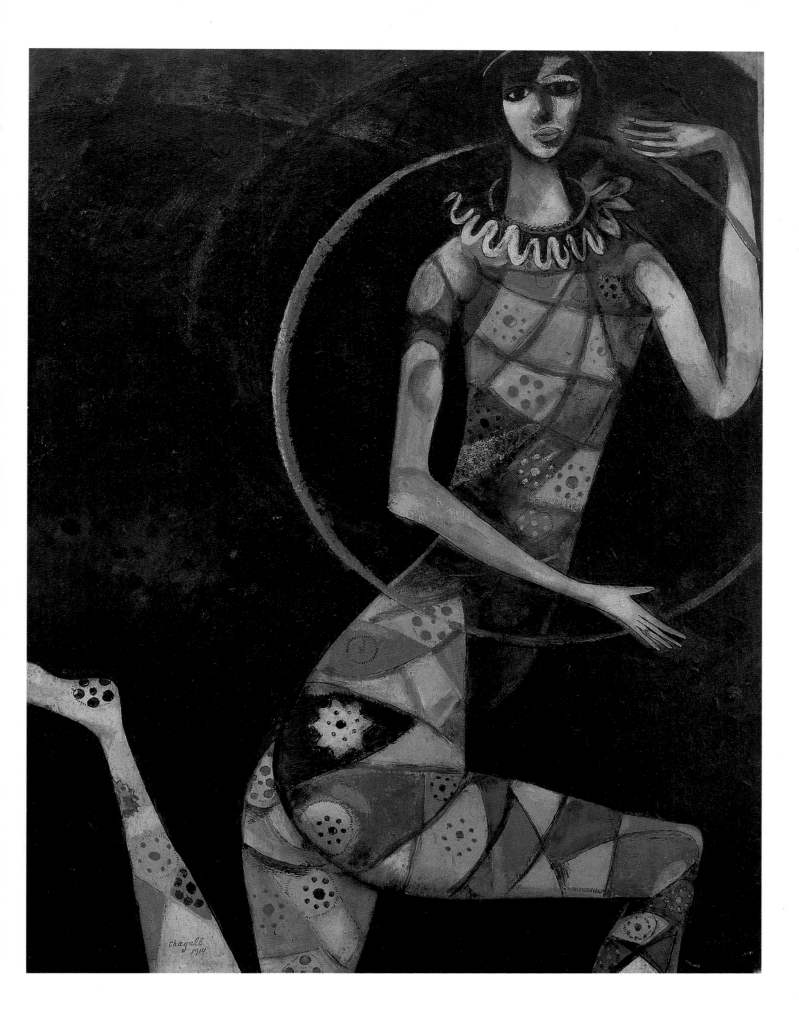

Feast Day (Rabbi with Lemon)

1914. Oil on canvas, 104 x 84 cm. Kunstsammlung Nordrhein-Westfalen, Düsseldorf

Chagall travelled back to Russia in June 1914, intending to stay no longer than three months. The outbreak of war prevented his return to Paris and he remained there for the next eight years. All his major paintings were either in Berlin or locked in his studio in 'La Ruche'. Separated from the stimulus of his former environment, he at first felt an acute sense of loss and isolation in provincial Vitebsk. Faced with the reality of the place, rather than the nostalgia he had felt for it while in Paris, he began a series of straightforward studies or 'documents' of his home town – it was a journey of rediscovery. He also made a number of studies from life, including *The Praying Jew (Rabbi of Vitebsk)* (Fig. 4), a work of immense power and gravity which combined the stylization of his previous work with a sharply observed naturalistic rendering of the old man's head. The stark contrasts of black and white, the jagged serrations of the prayer shawl (which mirror the leather binding of the phylacteries), and the intensity of his gaze all reflect the maturity and confidence with which Chagall now approached his work. Both this picture and *Feast Day (Rabbi with Lemon)* were owned by Kagan-Chabchai, Chagall's great patron during these years and the driving force behind proposals for a Museum of Jewish Art. One of Chagall's early biographers described this series of works as leading 'to that "grand art" of transformed daily life ... here the *shtetl* Jews have grown into enormous national figures, deeply rooted in their mundane typicality and, at the same time, endowed with all the internal significance of a symbol.' That Chagall 'sees the real world sharply and senses another world beyond it' was the very tendency Apollinaire recognized when proclaiming his art *'surnaturel'*; *Feast Day*, which combines an austere and timeless simplicity with the capricious and fantastical image of the Rabbi's head crowned by his diminutive alter-ego (or id), suggests just this magical quality. The painting was inspired by the harvest festival Succot (Feast of Tabernacles), and the *etrog* (lemon) and *lulav* (palm branch) have a ritual significance. But those unfamiliar with such religious symbolism might reasonably interpret these objects as a further example of Chagall's fascination with the notion of a universe governed by the possibility that 'anything may happen and does'.

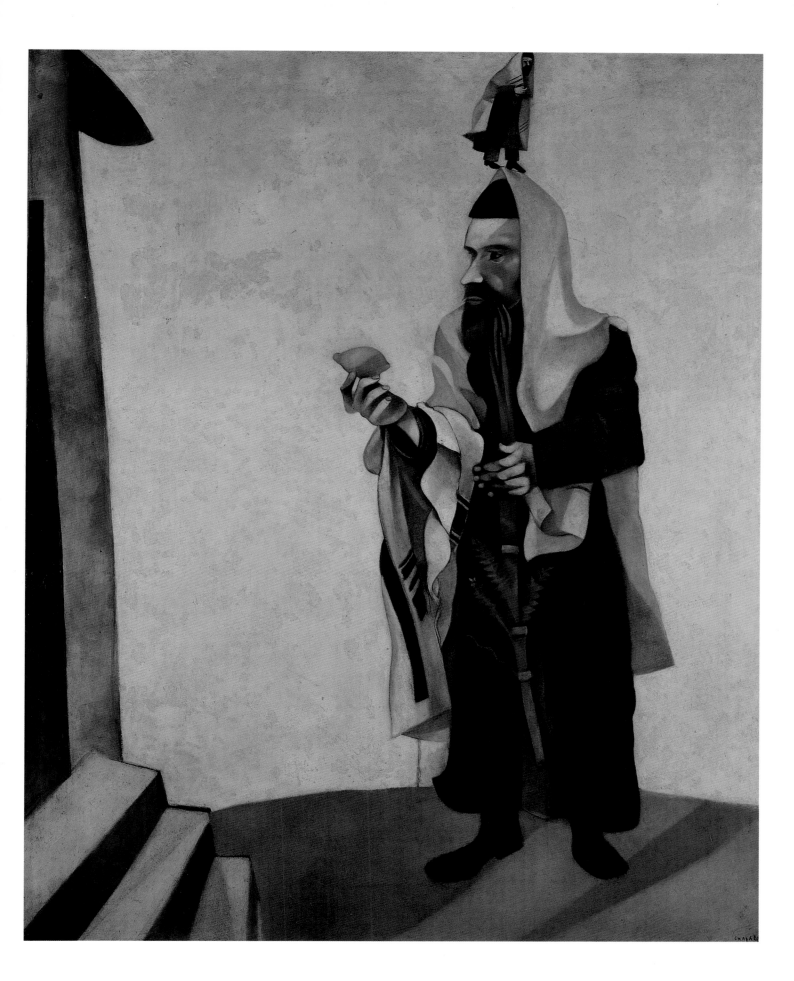

Over Vitebsk

1914. Oil on canvas, 70.8 x 90.2 cm. The Art Gallery of Ontario, Toronto, Gift of Sam and Ayala Zacks

As Chagall settled back into life in Vitebsk, his painting tended to 'document' provincial reality. 'I painted everything I saw', he wrote: '… I was satisfied with a hedge, a signpost, a floor, a chair.' But, just as the work of most artists is marked, in one way or another, by early influences, so Chagall was predisposed to mystical and irrational patterns of thought laid down in childhood, and naturalism could not satisfy him for long. The 'magical realism' of *Feast Day (Rabbi with Lemon)* (Plate 18) was carried through into *Over Vitebsk*. Here, the *'surnaturel'* imposes itself onto an ordinary – in fact rather dull – winter street scene in Vitebsk, deserted except for the airborne, larger-than-life figure of an elderly man floating gently across the centre of the picture, cap on head and cane in hand. This figure, also to be seen with his sack over his shoulder in the cataclysmic *White Crucifixion* (Plate 32) and in *War* (Plate 45), is the archetypal Wandering Jew – a figure not only from legend but to be found trudging the streets of every *shtetl* and town in eastern Europe. A number of these itinerants – beggars, peddlars and rabbis – posed for Chagall in return for a few kopeks and the chance to sit and rest. It is common in Yiddish (Chagall's mother tongue) to describe a beggar who goes from door to door as someone who 'goes over the town', and Chagall may have been giving visual expression to this idiom. He may also have been thinking of that solemn moment during the Passover meal when someone opens the door to let the prophet Elijah enter (a glass brimming with wine is provided at every Seder table for the prophet – perhaps in disguise but the traditional harbinger of Messianic tidings and therefore the symbolic link with a Passover message which promises a way out of persecution and suppression into freedom). In *My Life* Chagall recalls the opening of the door: 'A cluster of white stars silvered against the background of the blue velvet sky, force their way into my eyes and into my heart. But where is Elijah and his White Chariot? Is he still lingering in the courtyard to enter the house in the guise of a sickly old man, a stooped beggar, with a sack on his back and a cane in his hand? "Here I am. Where is my glass of wine?"'

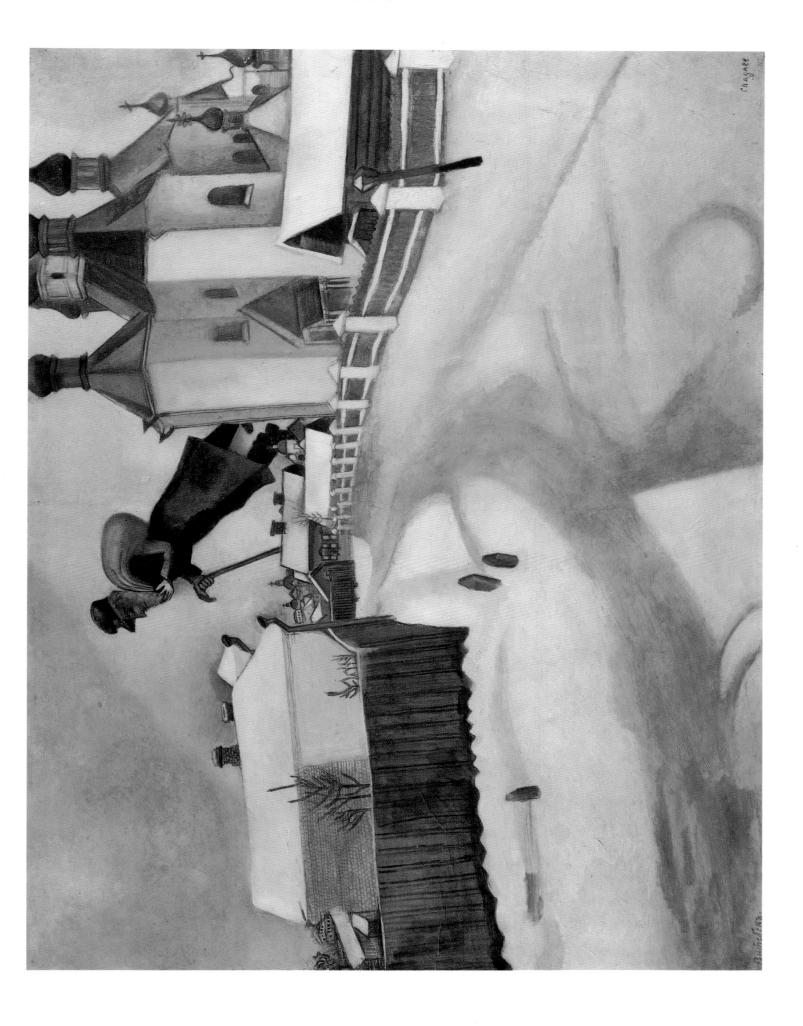

The Birthday

1915. Oil on canvas, 80.5 x 99.5 cm. The Museum of Modern Art, New York

Images of Bella, whether as fiancée, wife, mother or above all, as lover, celebrate a union which, through the medium of art, transcended the boundaries of lived reality and entered another, mythic realm – they were a long and inspired poem to the intoxicating power of love. Chagall met Bella in 1909, and on his return from Paris in 1914 resumed a relationship which at times he had feared would not survive such prolonged separation. Despite objections from Bella's family – wealthy, bourgeois jewellers who disapproved of Chagall's humble background – they made wedding plans and he began a series of paintings dedicated to their love. *The Birthday*, the earliest of Chagall's images of lovers in flight, is the visual record of an ecstatic encounter between the two – an event (Chagall's birthday) described in vivid detail by Bella in her memoir *First Encounter*. To celebrate the day, Bella gathered flowers and brought food, multi-coloured shawls, silk scarves and an embroidered bedspread to decorate Chagall's rented room. His immediate reaction as she arrived was to rummage among his canvases, calling to her, 'Don't move ... Stay just as you are!' Bella continues: 'You have thrust yourself upon the canvas which trembles under your hand. You dip the brushes. Spurts of red, blue, white, black. You drag me into floods of colour. Suddenly you tear me from the earth ... both in unison we rise above the bedecked room and we fly. At the window we want to go right through it. Outside clouds, a blue sky calls us ... Fields of flowers ... float below us.' Bella's and Chagall's imaginary evocation of their weightless (and in Chagall's case – armless) idyll transforms an explosion of sexual and emotional excitement both literally and metaphorically into an expression of intense, lyrical enchantment. *The Birthday* forms part of one of the most imaginative and enduring evocations of love in twentieth-century painting.

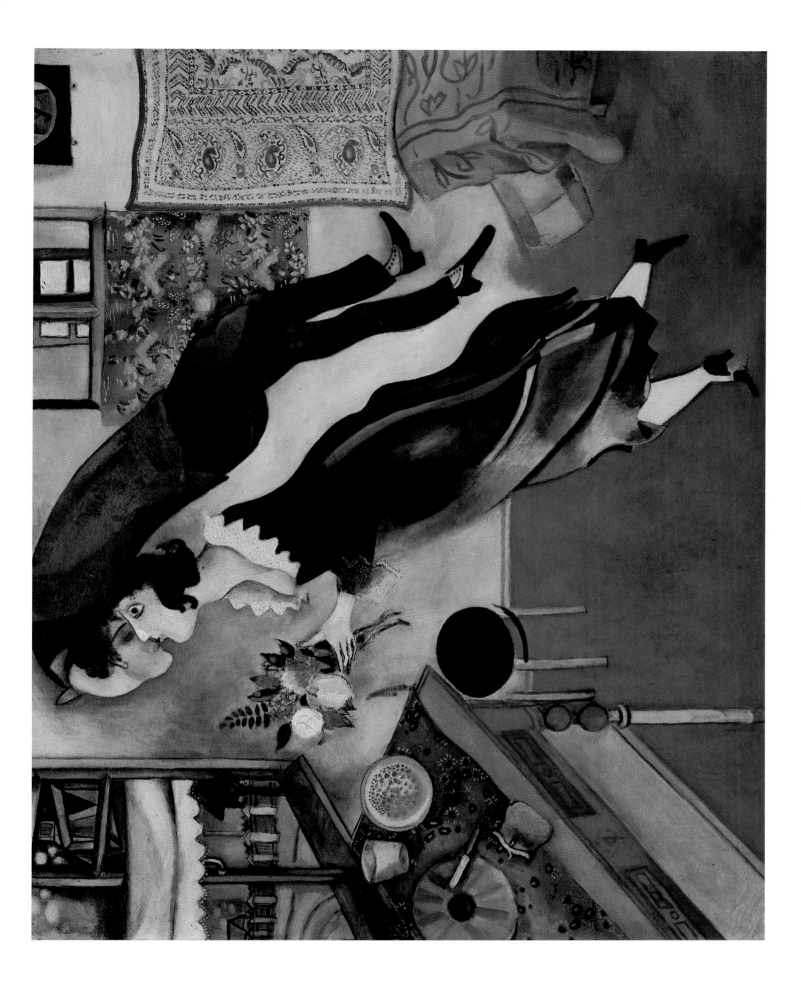

The Poet Reclining

1915. Oil on millboard, 77 x 77.5 cm. Tate Gallery, London

Despite their misgivings, Bella's parents provided a sumptuous wedding banquet to celebrate the marriage between their daughter and Chagall. He recorded that it gave 'a whole Pleiad of humble Jews' from his side of the family an opportunity for gluttony – 'the mountain of grapes and fruits, the innumerable savoury dishes' – on a scale they had never previously experienced. Afterwards, Chagall and Bella set off for a honeymoon in the countryside not far from Vitebsk, and *The Poet Reclining* is one of a number of images of rustic tranquillity which Chagall painted at this time. It almost exactly reflects what he later described in *My Life*: 'Woods, pines, solitude. The moon behind the forest. The pig in the stable, the horse outside the window in the fields. The sky lilac.' Into this vision of nature at one with itself, Chagall has inserted the figure of a 'poet' (himself) lying as stiffly as a medieval tomb statue across the bottom of the canvas. The modified Cubism of this figure is in marked contrast to the naïve naturalism of the rest of the image which is somewhat reminiscent of the work of 'le Douanier' Rousseau (1844–1910), which was known to Chagall from his years in Paris. As the poet lies dreaming in the meadow, we are reminded that Chagall's 'magical realism' not only detached his head from his shoulders and floated him to the ceiling, but also expressed itself in a profound anthropomorphism and 'primitive' animism which endowed all of nature with a living soul. Such beliefs were not uncommon in Hasidism, and from his memoirs we know that it helped Chagall commune with the cows, pigs, goats, chickens and horses, so familiar from his paintings, which roamed freely in the gardens and alleyways of Vitebsk. It also kept him in touch with the whole of the natural world (plants, trees, flowers) and with the cosmos itself. For Chagall creation and transformation were one – they were, he believed, in the air he breathed.

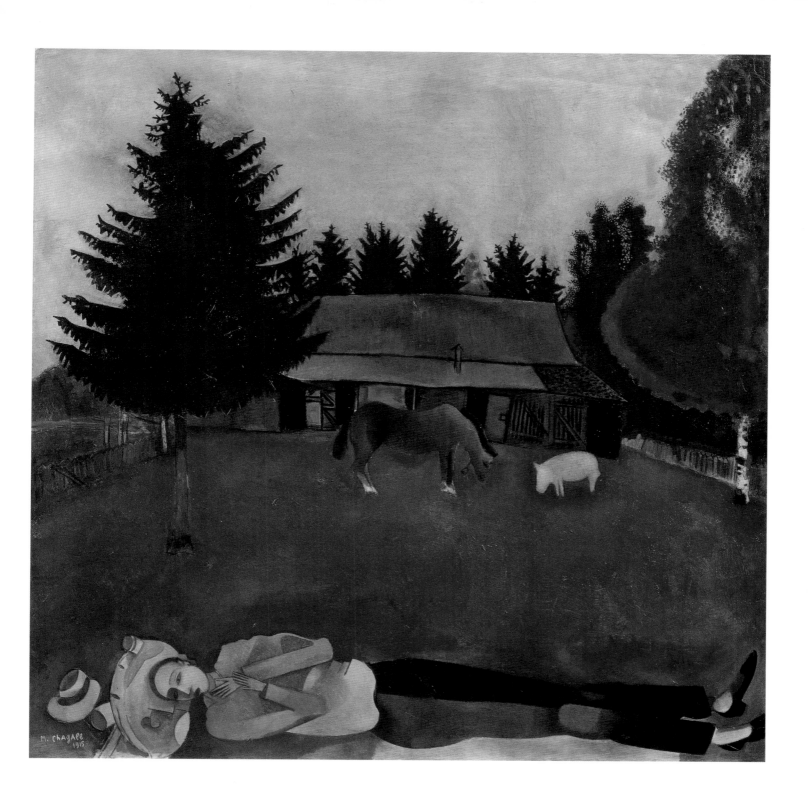

The Blue House

1917. Oil on canvas, 66 x 97 cm. Musée d'Art Moderne, Liège

After their marriage in 1915, Bella and Chagall moved to Petrograd where, in order to avoid military service, Chagall spent the war years working in the Office of War Economy. During this time he participated in several important exhibitions and became friendly with a group of writers and intellectuals. In 1916 their daughter Ida was born, and holidays were spent either in Vitebsk or in the surrounding countryside. The series of realistic studies or 'documents' of Vitebsk and its environs which had characterized Chagall's work immediately after his return from Paris gave way to a new series of pictures, less realistic and more monumental in conception, which he painted on a visit home in the summer of 1917. Based on this much-loved landscape, *The Blue House* foregrounds a rough-hewn wooden peasant dwelling, shored up by a wall of red bricks and set above the Dvina river. In the distance the old stone buildings of the city cluster around the monastery, its baroque towers etched against the sky. Unusually for Chagall there is no obvious human presence, although careful scrutiny will reveal a pig rooting around in the centre foreground and a tiny figure on the path leading down to the river's edge; while just visible in the dim interior of the house is the partially obscured profile of a seated woman, her skirt and foot caught by the light. At first glance the radiantly coloured blue house, set off against a mustard-yellow ground, the massed shapes of the distant city skyline, and the landscape in between appear as a vision of reality. But in fact, the whole is subtly disturbed by the gentlest of seismic tremors which set the planes – the verticals and horizontals – rocking to a subterranean rhythm. It was this same dynamic which set the furniture in motion in *The Studio* (Plate 5), as Chagall's hallucinatory tendencies transformed the painting from one of disciplined naturalism to its magical opposite – a reflection of his own subjective consciousness.

Onward! (The Traveller)

1917. Gouache and graphite on paper, 38.1 x 48.7 cm. Art Gallery of Ontario, Toronto; gift of Sam and Ayala Zacks

Fig. 32
Forward!
1919–20. Oil and pencil on
cardboard, 31 x 44 cm.
George Costakis
Collection, Athens

In this remarkable image 'the reclining poet' (Chagall himself) (Plate 21) has risen from his afternoon siesta in the Russian countryside and set off with eager, high-stepping strides towards the revolutionary future so wholeheartedly embraced by Russia's avant-garde. '*Chagalle*' in Russian means 'to stride forward with big steps', and indeed Chagall's airborne figure, striding across a sky of deepest blue (a colour which for him always signified joy and freedom), seems a perfect embodiment of the energy and euphoria engendered by the October Revolution, when art and politics shared a common purpose and a common goal. Chagall's appointment as Commissar for Art in Vitebsk coincided with the first anniversary of the revolution, and he organized a vast street spectacle to rival those of Moscow and Petrograd. *Onward, Onward Without a Pause...* or *Onward! (The Traveller)* was designed as a decorative banner to hang alongside others by Chagall, displaying 'green cows and flying horses' – images that had 'nothing to do with Marx and Lenin', according to disgruntled party officials. A later version – *Forward!* (Fig. 32) seems to have been the design for a stage curtain for Gogol's *Card Players* and *Wedding*. Although this project was never realized, the sketch is of great interest as it reflects – perhaps with a touch of unconscious irony – the struggle between Chagall's artistic individualism and the non-objective art of his great rival Kasimir Malevich, whose charismatic personality and Suprematist aesthetic eventually came to dominate the Vitebsk Academy of Art. Under the name UNOVIS (Affirmation of the New Art) Suprematism was held to be 'a complete and universal system ... realized in collective work' – and it is against a backdrop of UNOVIST squares that this second 'traveller' now strides energetically onward. For just as Chagall had integrated many elements from Cubism into his painting without becoming a Cubist – so he began, almost playfully, to incorporate geometric form in his work at this time without ever accepting the uncompromisingly idealist theory underpinning the practice. Throughout his life, Chagall affirmed and reaffirmed the human dimension of his art – 'let them eat their fill of their square pears on their triangular plates', he had written dismissively of Cubism, and now, in the increasingly frenzied political atmosphere of post-revolutionary Russian art, Chagall yearned 'to be occupied only with painting'. 'After all', he wrote, 'the artist (at least in my case) has no more worthy place to stand than at the easel.' It was a place from which, in his own idiosyncratic and whimsical way, he believed he could communicate with all humanity.

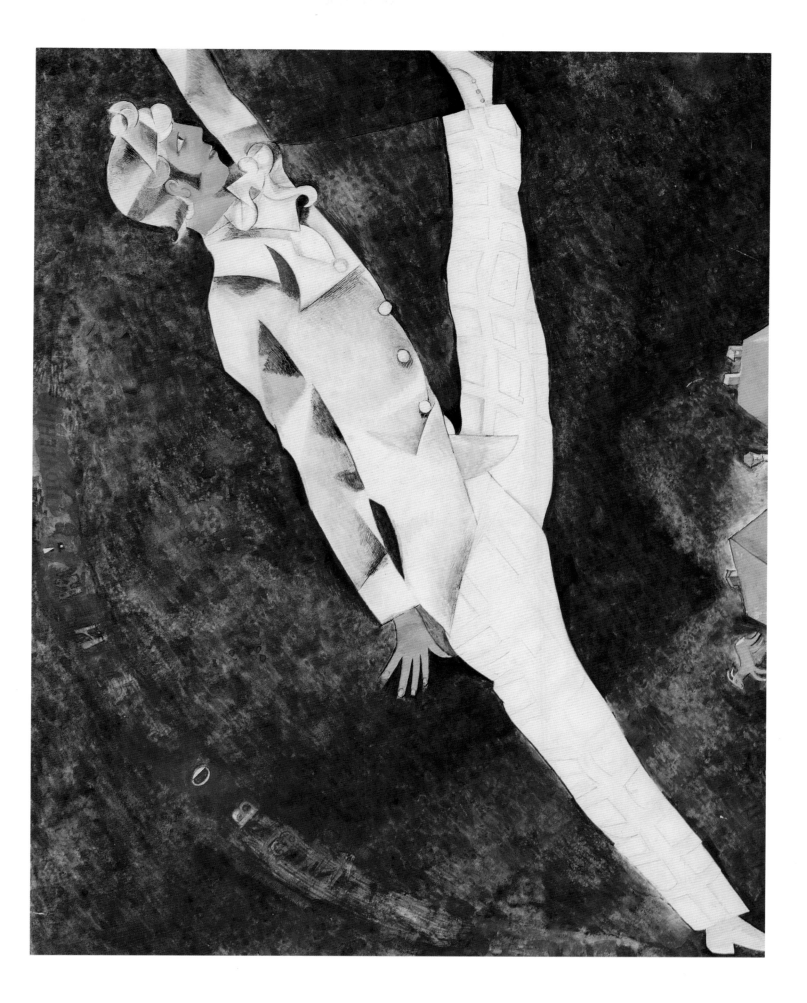

Double Portrait with Wineglass

1917–18. Oil on canvas, 235 x 137 cm. Musée National d'Art Moderne, Centre Georges Pompidou, Paris

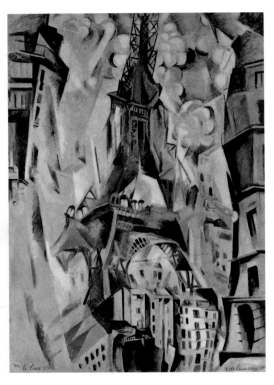

Fig. 33
ROBERT DELAUNAY
The Eiffel Tower
1911. Oil on canvas,
202 x 138.5 cm.
The Solomon R.
Guggenheim Museum,
New York

Double Portrait with Wineglass belongs in spirit to the same group of paintings as *The Birthday* (Plate 20), *Over the Town* and *The Promenade*. They are all images of lovers levitating or in flight – a motif that was to obsess Chagall from this point on, and one which, over the years, was to become a defining characteristic of his painting. These images not only surprise the viewer with their literal interpretation of such verbal metaphors as 'walking on air' and 'up in the clouds', but they also symbolize the extremes of sexual and emotional feeling which Chagall experienced in his relationship with Bella – freeing his psyche from the forces of gravity and allowing him either to float with her over the rooftops of Vitebsk or, as in this painting, to straddle her shoulders as she rises above the dark green waters of the Dvina river. But this exuberant image of life and love is not only a double portrait, it is also a double celebration – capturing both the force of their desire and the sense of elation which Chagall experienced after the October Revolution of 1917. For like all Jews compelled to live under the social and political repressions of Tsarist Russia, Chagall believed that the revolution and the new order which it signalled was the fulfilment of a utopian dream, and for a few short years that optimism was well founded. *Double Portrait with Wineglass*, a toast to the joy of life, has a compositional structure not unlike that of Delaunay's *Eiffel Tower* (Fig. 33), one of a series of paintings expressing his dynamic vision of a modern city with which Chagall would have been familiar; but as always, the influence was converted to his own completely original aesthetic ends. In both images, an extreme, attenuated verticality directs the eye upwards; in both, the images literally 'reach for the sky'. This link between the terrestrial and the divine, in Chagall's painting, suggests the Cabalistic exhortation to strive towards establishing a happy harmony with God. All people had their part to play in the redemption of the world, even if only through eating and drinking in a joyous manner. Thus Chagall, with his consecrated glass of wine, was lifted nearer to God's light. In Cabalistic terminology, he 'caused the sparks to ascend'.

Cubist Landscape

1918. Oil on canvas, 100 x 59 cm. Musée National d'Art Moderne, Centre Georges Pompidou, Paris

Fig. 34
JUAN GRIS
Paysage et maisons à
Ceret
1913. Oil on canvas,
100 x 65 cm.
Private Collection

Cubist Landscape (dated 1918 but probably executed in 1919) was painted while Chagall was still at the centre of revolutionary art and politics in Vitebsk. At no other time in his life was he so politically engaged, and while his activities as Commissar for Art (with powers to 'organize art schools, museums, lectures on art and all other artistic ventures within the city and region of Vitebsk') prevented him from being as prolific as usual, he nevertheless found time to paint and to collaborate on various theatrical projects. He also became the subject of a monograph and enjoyed the privilege of being allocated two special rooms to show his work at the First State Exhibition of Revolutionary Art, held in the old Winter Palace, Petrograd, between April and July 1919. Chagall received critical acclaim and sold twelve works to the State – the last such 'official' purchases of his work in Russia. *Cubist Landscape*, a major painting of this period, is something of an anomaly at this juncture, and represents a departure from Chagall's usual highly personal iconography. It is painted in a Synthetic Cubist style strongly reminiscent of that developed by Juan Gris (1887–1927) who, together with Picasso and Braque, was responsible for moving Cubism on from its early Analytic period into collage and painted surfaces which resembled collage, as for example in *Paysage et maisons à Ceret* (Fig. 34). Here, in this forceful and assured work, Gris's system of non-transparent, overlapping planes – vertical, diagonal, horizontal and triangular – gives a strong spatial structure to the composition, a structure which Chagall adopted for *Cubist Landscape*, although the construction of this latter work also reveals Chagall's familiarity – particularly in the semi-circular geometric forms – with the formalist experimentation of Malevich and the Suprematists. It was a format he was to return to a year or so later with *Introduction to the Jewish Theatre* (Fig. 8) and *Love on the Stage*. As with *Adam and Eve* (Plate 11), Chagall cannot resist 'quoting' the world outside the abstract geometry of the image, and we find a tiny line-drawn goat and man with an umbrella walking towards one another in front of the Vitebsk Academy of Art. Apart from this 'Chagallian whimsy', the introduction of painted wood-grain and lettering – in this case the name 'Chagall' written again and again using Cyrillic, Roman and (in one instance) Hebrew script – were typical Cubist devices and perhaps suggest a recapitulation or retracing of old steps – a nostalgia for Paris and the world left behind in 1914 when Chagall returned to Russia, inadvertently getting caught up in war and revolution, events entirely beyond his control.

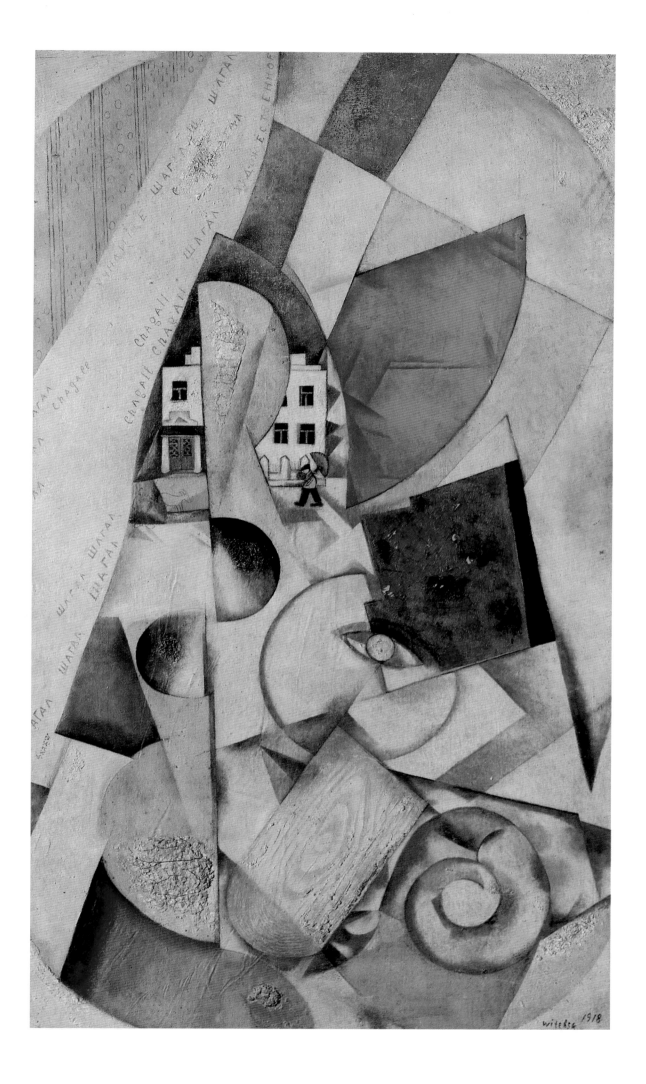

Ida at the Window

1924. Oil on canvas, 105 x 75 cm. Stedelijk Museum, Amsterdam

Chagall left Russia in 1922, deeply disillusioned by the way the political climate was turning against artists and intellectuals. After a year in Berlin, during which time he learnt etching and engraving techniques with the master print-maker Hermann Struck, he returned to Paris and was immediately commissioned by Vollard to illustrate Nicolai Gogol's *Dead Souls* (Fig. 12). Although the Surrealists were by now the dominant influence on Parisian intellectual life, Chagall chose, despite their overtures, not to ally himself with a group so self-consciously reliant on 'automatic writing' for their inspiration (even though his paintings between 1911 and 1913 seem to anticipate the movement). Having settled in a studio on the Avenue d' Orleans, and with a steady income from his graphic work assured, Chagall and his family began to explore the French countryside for the first time – a landscape that became for him 'an object of love'. In June 1924, when Ida was eight years old, they spent a month on the island of Bréhat, off the coast of Brittany. With the tension and strain of the last years in Russia just a memory, *Ida at the Window* suggests a degree of serenity not previously seen in Chagall's work. Reminiscent perhaps of Henri Matisse's *The Open Window* (1905), Chagall has painted his daughter sitting on the windowsill gazing pensively at the view, a vase of brightly coloured flowers at her side. This splash of colour forms a strong contrast with the silvery tones of green, blue and white which predominate in the work and give it the look of a northern summer – atmospheric and filled with a softly nuanced luminosity so different from the clarion colours of a Mediterranean palette. While nature, colour, light and landscape became a preoccupation for Chagall, he very rarely painted *en plein air* as the Impressionists had done. He preferred the view from the window – that boundary between indoors and out which had intrigued him since childhood, and which occurs as a characteristic motif throughout his life. Chagall's biographer Franz Meyer has suggested that for his encounter with the landscape to produce 'an allegory of the relationship of soul and world' Chagall nearly always required the additional intervention of figures or flowers, for his concern was with the relation between 'the inmost soul and the spiritual forces without'.

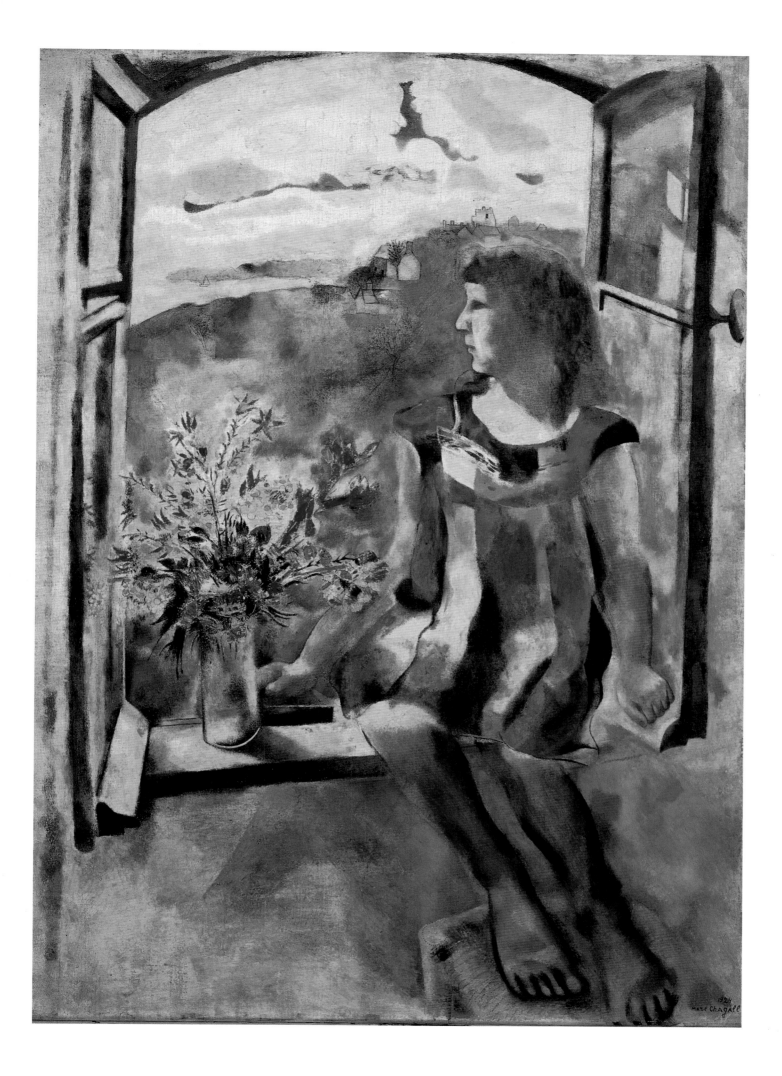

Lovers under Lilies

1922–5. Oil on canvas, 117 x 89 cm. Private Collection

Fig. 35
Lovers in the Lilacs
1930. Oil on canvas,
128 x 87 cm.
Private Collection

Paintings of lovers – whether earthbound, in flight or surrounded by bouquets of flowers – are among the images most closely associated in the public mind with Chagall's name. While in Paris between 1910 and 1914 he painted *The Lovers* (1911–14), the beginning of what would become a lifelong celebration on canvas of his love for Bella. After returning to Russia in 1914 he painted a whole series of *Lovers* – in 'Blue', 'Black', 'Green', 'Grey' and 'Pink' – as well as the extraordinary and imaginative *The Birthday* (Plate 20), the earliest of Chagall's images of lovers in flight and the visual record of an ecstatic encounter between Bella and himself. *Lovers under Lilies* marks the beginning of a new cycle of such images – only now the lovers are accompanied, not by a small, hand-held bunch of flowers as in *The Birthday*, but by burgeoning, and in some cases all-enveloping bouquets of cut flowers which are often as weightless as the lovers nestling in their dense foliage (Fig. 35). It is possible that one of the early influences on this motif may be the *lubok* or Russian folk-print, where figures of women are frequently associated with flowers and fans. If this was the case, Chagall certainly transformed the motif and made it quintessentially his own. *Lovers under Lilies* is one of the most overtly sensuous and lyrical of this new cycle begun during the 1920s. With its delicately painted figures, surmounted by heavily impasted peonies and lilies silhouetted against the backdrop of a pastel sky, it reflected a new mood of serenity and tenderness as Chagall and his family settled down to their new life in France after the rigours of post-revolutionary Russia. Chagall was one of the great colourists of the century, and it was at this time that a change occurred in his attitude to colour, tied in with his exploration of the countryside and his new cycles of lovers and flowers. Believing, like Kandinsky, that 'colour directly influences the soul', Chagall developed a way of modulating his palette so as to create webs or 'tissues' of colour which could profoundly affect the emotional tenor of the work, a change that would eventually lead (both with stained glass and with painting) to the intense, rapturous and non-naturalistic colour (often quite independent of the forms) with which we now associate his later work. In conversation with the writer, poet and painter André Verdet, Chagall reminisced (in extreme old age) about the central significance of flowers in his life: '… you could wonder for ages about what flowers mean, but for me they're life itself, in all its happy brilliance. We couldn't do without flowers. Flowers help you forget life's tragedies, but they can also mirror them …'

The Bird Wounded by an Arrow

*c.*1927. Gouache, 51.4 x 41.1 cm. Stedelijk Museum, Amsterdam

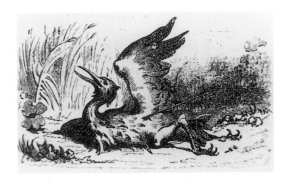

Fig. 36
KARL GIRARDET
*The Bird Wounded by
an Arrow*, vignette in
Fables de la Fontaine,
Tours, 1858, Bk II,
Fable VI

There was uproar in France, and Chagall was contemptuously described as 'a Vitebsk signpainter' in the Chamber of Deputies when it became known that he – a Russian Jew – was to illustrate a new edition of La Fontaine's *Fables*, universally regarded as a masterpiece of seventeenth-century French literature and taught in schools throughout the country. Ambroise Vollard, who had commissioned the work to follow on from the etched illustrations for Gogol's *Dead Souls* (Fig. 12), replied to the criticism by pointing out that not only were the *Fables* of universal and timeless significance, but that, far from inventing the stories, La Fontaine had himself drawn on and adapted sources such as Aesop and the folk-legends of India, Persia, Arabia and China. These tales had also been adapted in the early nineteenth century by the Russian fabulist Ivan Krylov, and were probably familiar to Chagall, but Vollard's insistence on Chagall for the task rested more on his belief that the artist, a fabulist and 'poet' in his own medium, would be the person most likely to convey the spirit of the text and to create its visual equivalent. 'In my opinion', Vollard said, 'one can only demand such a rendering from an artist of temperament, an artist with a creative talent bursting with pictorial ideas … [Chagall's] … aesthetic seems to me in a certain sense akin to La Fontaine's, at once sound and delicate, realistic and fantastic.' Vollard's initial plan was for a series of colour etchings based on preparatory gouaches by Chagall. Various processes were tried, but it proved impossible to translate the original gouaches into a different medium, and Chagall eventually resorted to making a set of 100 black and white etchings which achieve a remarkable painterly effect, in some ways akin to the painterly freedom of the gouaches themselves. While working on the gouaches, Chagall was staying in the French countryside, and in these and other paintings of that period, we can see how strongly influenced he was by his observation of rural life and the antics of humans and animals alike, in their mutual interdependency. This is the world of the *Fables*, and Chagall, who tended not to illustrate the moral – the 'instructive aspect' – of each story, but to suggest the fantastic, the tragic and the comical, was able to draw once again on the familiar world of childhood memory and his already well-established empathic sense of identification with animals and the natural world. In *The Bird Wounded by an Arrow* (with its almost Van Gogh-like hatching and brushstroke) Chagall has, unusually, based the image directly on an engraved vignette by the nineteenth-century illustrator Karl Girardet (Fig. 36) and suggested a moral, perhaps to calm bruised French sensibilities; for the bird lying wounded on the ground laments the hunter's thoughtlessness and cruelty in winging his deadly arrow with the feathers of another bird.

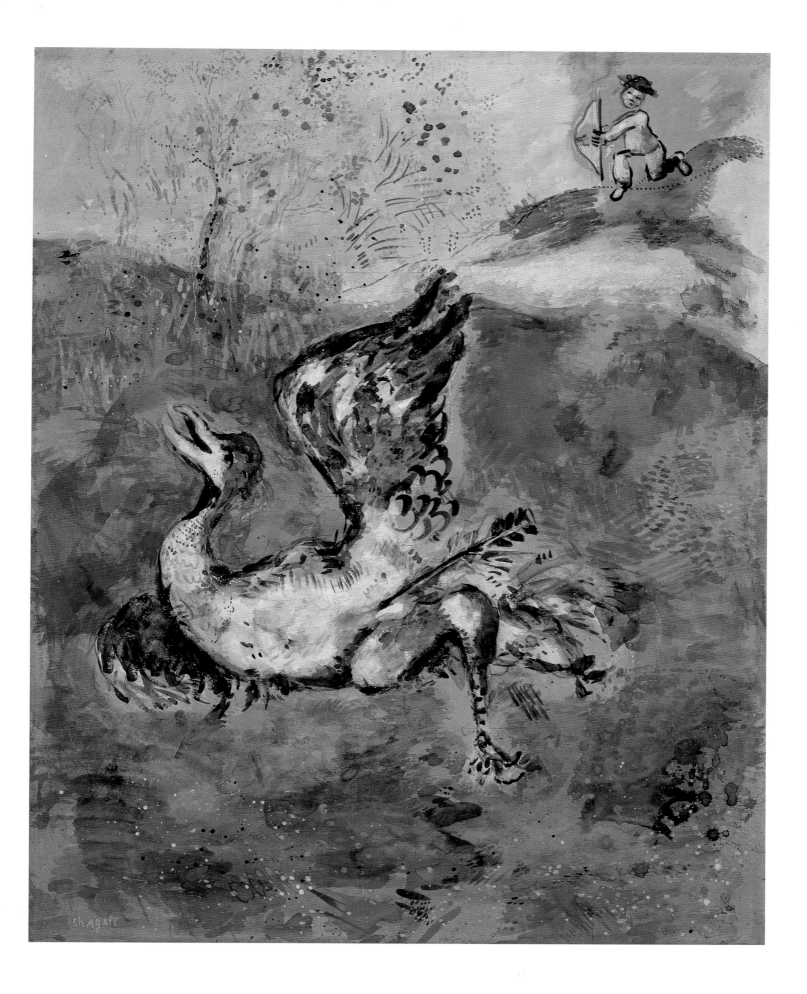

The Dream

1927. Oil on canvas, 81 x 100 cm. Musée d'Art Moderne de la Ville de Paris

Vollard kept Chagall busy with commissions during the 1920s, and once the etchings for Gogol's *Dead Souls* (Fig. 12) were completed, he proposed that Chagall embark on a further two projects – the *Fables* of La Fontaine (Plate 28), and a series based on the circus. *The Dream* (its first title was *The Rabbit)* carries stylistic hints of both these cycles, but really belongs to neither, for Chagall had painted an earlier version on the same theme two years before. Entitled *On the Donkey*, it prefigures, in more decorous form, the central motif of *The Dream*, and was described by Franz Meyer (Chagall's biographer) as 'an enchanting parable of the fraternal confidence of man and beast … her brother the donkey is carrying her off.' It seems more likely that the girl/bride was being carried off by her lover/Chagall, a presumption reinforced by *The Dream* which, with its freely associated fantasy of a woman lying supine and bare-breasted on the back of a hybrid creature – variously described as a rabbit or a donkey – suggests sexual abandon rather than 'fraternal confidence'. Metamorphosis or transformation was almost always intrinsic to Chagall's purpose, and the sensuality of the image may also parody the mythical story of Europa (who was carried off and seduced by Jove, transformed into a bull). Whether or not Chagall was painting a self-consciously 'surrealist' picture, the intensity of the painterly impulse, the title of the work and the confused and fantastical upside-down dream-scape – where both figures and landscape defy logic and gravity – suggest that he was reaching deep into the world of dreams. It is an image which derives its force from a pagan vitality centred on such archetypal symbols as (wo)man, animal, world, night and moon, and on the transfiguration of sensuality – a sensuality concealed but nevertheless ecstatic as, lit by the moon, the 'creature' and its burden hover between earth and sky.

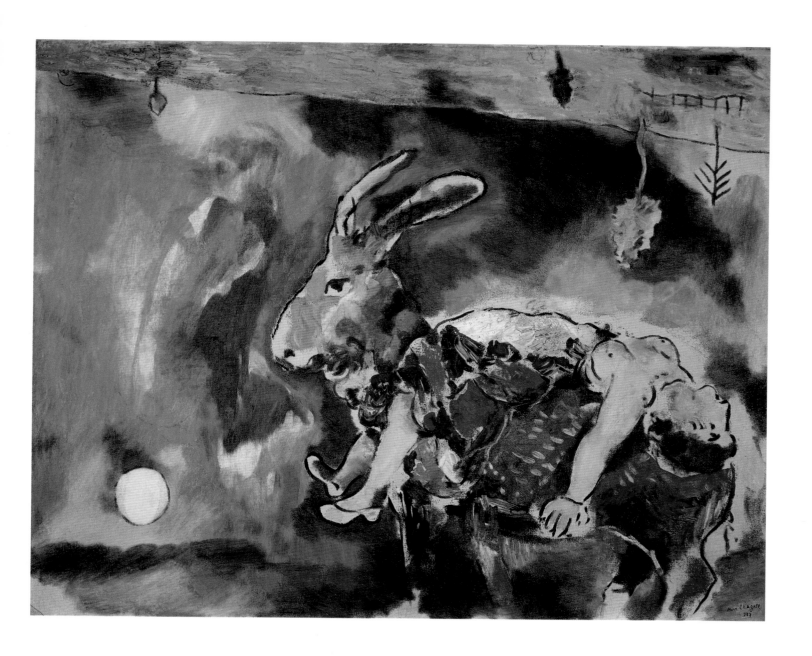

Bella in Green

1934–5. Oil on canvas, 99.5 x 81 cm. Stedelijk Museum, Amsterdam

Fig. 37
Photograph of Bella
posing for *Bella in Green*
1934

During the 1920s Chagall travelled extensively in France, but by the 1930s – in those last few years before the Nazi onslaught turned the whole world upside-down – he began to journey further afield in search of new ideas. In 1930–1 a major commission came from Vollard for a series of Bible etchings and gouaches. This encouraged Chagall to visit the biblical sites and experience the heat, the light and the scenic grandeur at first hand. In 1932 and 1934 he travelled to Holland and Spain respectively, and his painting gained a new monumentality as a result of seeing large collections of the work of Rembrandt (1606–99) and that of the Spanish masters, El Greco (1541–1614), Velázquez (1599–1660) and Goya (1741–1820). The impact which this study of the Old Masters had on Chagall can be seen both in the compositional structure of the Bible etchings and in this superb formal portrait of his wife Bella, with its echoes of Spanish court portraiture and the seventeenth-century Dutch tradition. Shown wearing a dark green velvet dress enlivened by a precious lace collar and cuffs, a decorated fan in her hand and a bouquet of lilacs above her shoulder, this portrait of Bella is comparatively rare in Chagall's *œuvre* for its emphasis on realistic representation. Just how accurately his observation is matched by 'reality' can be seen in the photograph of Bella posing for *Bella in Green* (Fig. 37), although judging by an earlier study for this work, Chagall's original intention was much closer to his other, more imaginatively inspired images of lovers with flowers. For in the sketch, Bella is depicted as a young girl, her head surmounted by a halo of flowers, and with an angel standing protectively beside her. In this final, wholly realistic rendering, only the ghost-like outline of a much smaller angel drifts in the air to the right of Bella's head, its shadowy image close to that of the airborne figure which flies in the sky above Chagall's head in his ecstatic toast to the joy of life: *Double Portrait with Wineglass* (Plate 24) – a figure widespread in icon painting, and so frequent in Chagall's work that it can almost be described as a distinguishing characteristic.

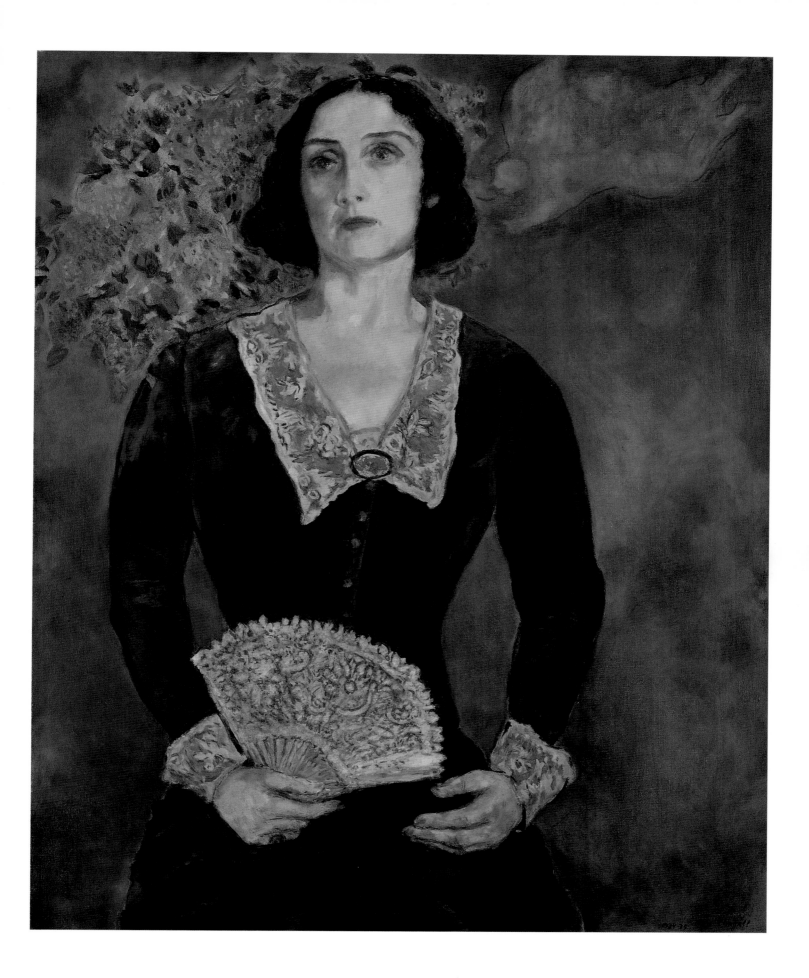

Study for *The Revolution*

1937. Oil on canvas, 50 x 100 cm. Musée National d'Art Moderne, Centre Georges Pompidou, Paris

This fully developed oil study for *The Revolution* – together with some working studies – is all that remains of a monumental painting which Chagall cut into three sections and subsequently reworked. Two of these, *Resistance* and *Liberation*, have the notion of revolution implicit in their titles, and it is likely that in embarking on the original canvas, Chagall was hoping, like Picasso with *Guernica* (1937), to make an important personal and political statement about the Spanish Civil War and the looming Nazi threat – but mediated through the lens of his own experience twenty years before. No one embraced the Russian Revolution with more enthusiasm than Jews and avant-garde artists. Jews because they became full citizens for the first time; artist because they saw no contradiction between revolutionary politics and the type of formalist experimentation engaged in by the avant-garde on behalf of 'the masses'. This romantic but misconceived delusion was soon to be brutally crushed by Lenin who, in 1920 – a year of famine and civil war – published a pamphlet entitled *Left Wing Communism: an Infantile Disorder*, which condemned all avant-garde tendencies in art and demanded a new aesthetic – Socialist Realism – to replace Suprematist 'geometry' with 'heroic' images of workers, agriculture and industrial output. Chagall left Russia in 1922 having completed, against all odds, his first monumental work: *Introduction to the Jewish Theatre* (Fig. 8). He was deeply disillusioned by all he had witnessed, and it is hard not to interpret *The Revolution* in the light of such experiences. Wielding sticks and waving flags, the revolutionary mob on the left makes its first appearance in a painting by Chagall; while on the right we find the familiar repertoire of lovers, animals, floating figures, musicians and the artist at his easel. A white ground or 'stage' cuts a path through these two domains – and it is upon this stage that the equivocal figure of Lenin performs his amazing feat, a French tricolore held between his legs, his free arm pointing towards Chagall's world of 'idealized freedom' and love; a place where the red flag of revolution has been laid to rest. Alongside Lenin, and nearest the mob, sits the sorrowing and meditative Jew from *Solitude* (Fig. 13), at his feet gravestones, a corpse and the stain of blood on snowy ground – a harbinger of bitter things to come. Was Chagall deliberately turning Lenin (who had himself 'turned Russia upside down') into an object of ridicule, or is this Bolshevik 'clown' or acrobat performing his balancing act, one of Chagall's 'beings with a tragic humanity' – an 'everyman' image conveying a whole range of hidden meanings? Perhaps Chagall, who used the circus as a central metaphor for life in all its complexity, hoped to highlight the paradox at the heart of all mass movements – how to protect individual freedom in the process of often violent social and political change. Whatever the truth, the painting's message proved too complex, its symbolism too dense and overdetermined to be successful, and Chagall laid it, like the red flag, to rest.

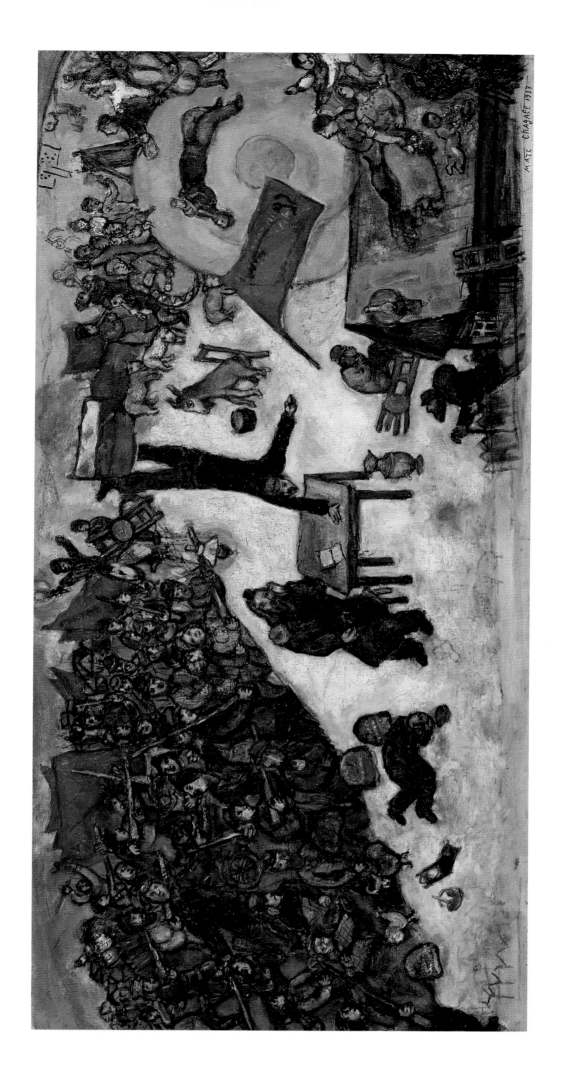

White Crucifixion

1938. Oil on canvas, 155 x 139.5 cm. Art Institute of Chicago, Gift of Alfred S. Alschuler

In 1934 Chagall's *The Pinch of Snuff* (1912) – which had been bought by the Kunsthalle, Mannheim – was the subject of an ominous window display in the city, which bore the sign: 'Taxpayer, you should know how your money was spent.' This painting, together with another three works by Chagall, was subsequently included in the infamous 'Degenerate Art' exhibition which toured Germany and Austria between 1937 and 1941. These events, and a visit to Poland in 1935, brought the danger and isolation of the Jews into sharp focus for Chagall, as Nazi atrocities and deportations became ever more frequent, and as synagogues began to burn. He expressed his anguish using the visual language of the Western Christian tradition – the Passion and Crucifixion of Christ – and turned the image into a searing and unredemptive symbol of Jewish martyrdom. *White Crucifixion*, the first and most powerful in a long series in which Chagall reacted to the crisis (Figs. 15, 17), was located in contemporary history. In it, Chagall divested the crucified figure of its specific Christian associations and placed this Jewish Jesus at the still centre of a maelstrom of orchestrated violence, burning and Nazi desecration – images only too clearly drawn from his own childhood memories of pogroms and persecution. These images (in common with a Russian icon tradition which ignores laws of perspective and narrative sequence), are dispersed around the central figure in separate but simultaneous scenes of suffering and despair. A swirling vortex of terror develops as houses, a synagogue and Torah scroll burn, a refugee-filled boat rows away, an armed mob comes over the hill, and one man flees with a salvaged Torah while another, on whose breast-cloth were once inscribed the words 'I am a Jew', holds out his hands in supplication. Here also is the familiar figure of the beggar/Elijah, a bundle on his back (Plates 19, 45). This traditional harbinger of Messianic tidings comes, but in vain, to help his people in this time of trouble. The whole painting is illuminated and unified by an intense shaft of white light which falls diagonally from above. Above, too, float Old Testament elders – the lamenting and helpless witnesses to an unfolding catastrophe which lies beyond human understanding.

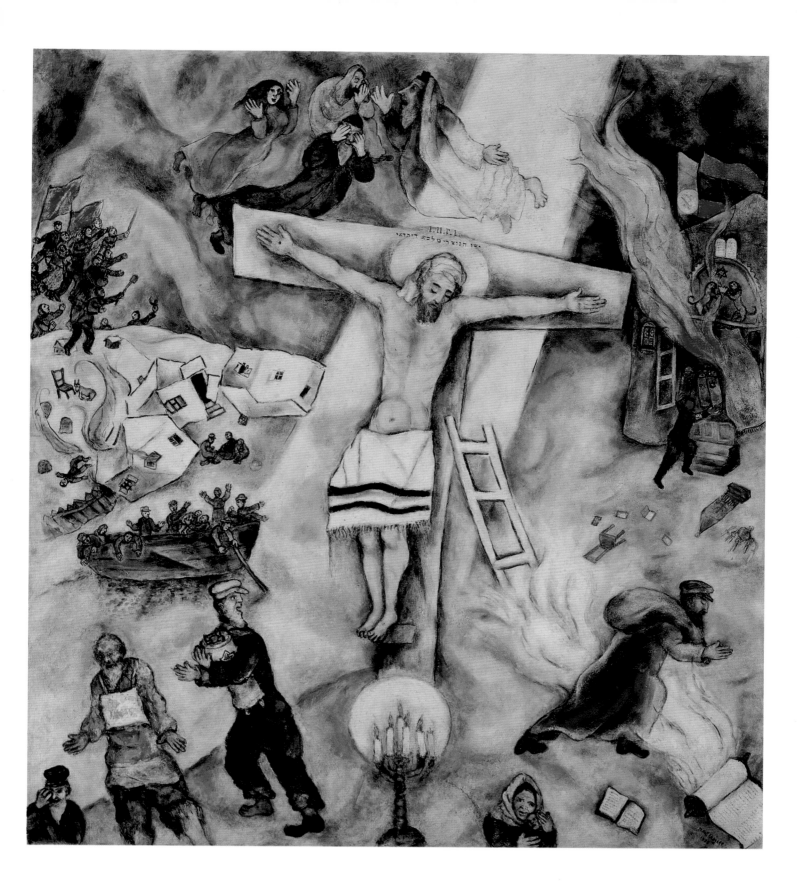

Time is a River Without Banks

1930–9. Oil on canvas, 100 x 81.3 cm. The Museum of Modern Art, New York

This is Chagall at his most 'surreal'. The image of a wall-clock, familiar from *Clock*, his 1914 painting of this mysterious timepiece, has met in strange conjunction with a flying fish above the waters of the Dvina river. As an image, it is no less enigmatic than the nineteenth-century poet Lautréamont's definition of 'beauty' as 'the chance encounter of a sewing machine and an umbrella on an operating table'. This bizarre set of juxtapositions, adopted by the Surrealists as emblematic of their search for unexpected combinations of incompatible objects, was close to Chagall's own taste for surprise and ambiguity. But while the Surrealists believed that the 'omnipotence of the dream … and … the disinterested play of thought' could summon up imagery, Chagall evolved a deeply personal pictorial symbolism, based on childhood memory, from which to construct his mythological world. Speaking in 1946, he said of his paintings: 'I don't understand them at all. They are not literature. They are only pictorial arrangements of images that obsess me …' *Time is a River Without Banks* (the title is a line from Ovid's *Metamorphoses*) contains many images that obsessed Chagall throughout his life: Vitebsk and its river, lovers, violins, the herrings which his father hauled in brine-soaked barrels for a meagre living, and the prized living-room clock from his childhood home. All these, and the quintessentially Chagallian colour blue, found their way into this disquieting work which subverts all expectations of the logical order of things, taking us into the realm of dream and fantasy. The clock, its pendulum swinging wildly behind the glass of its heavy baroque case, was not only a symbol of Chagall's lost childhood; it was, he said, 'an extraordinary mystical object', symbolic of the passage of time – an image which hung, floated, flew and even trudged through the snow in a large number of pictures from the early 1930s on through the war years and beyond (see Plate 39). In the most disturbing of these, *Winter* (1941), the clock-case, one-winged and containing a crucified clock-faced figure standing in the street of a snow-bound Russian village, is clearly associated with Chagall's crucifixion imagery (Fig. 17). This suggests that Chagall's 'clock' may conflate with that other central image of his *œuvre* at the time, the figure of the martyred Jew/artist, mocked, scorned, reviled and ultimately crucified – its associations with sorrow and despair expressive of the upheavals in Europe which were to force Chagall into exile for a second time.

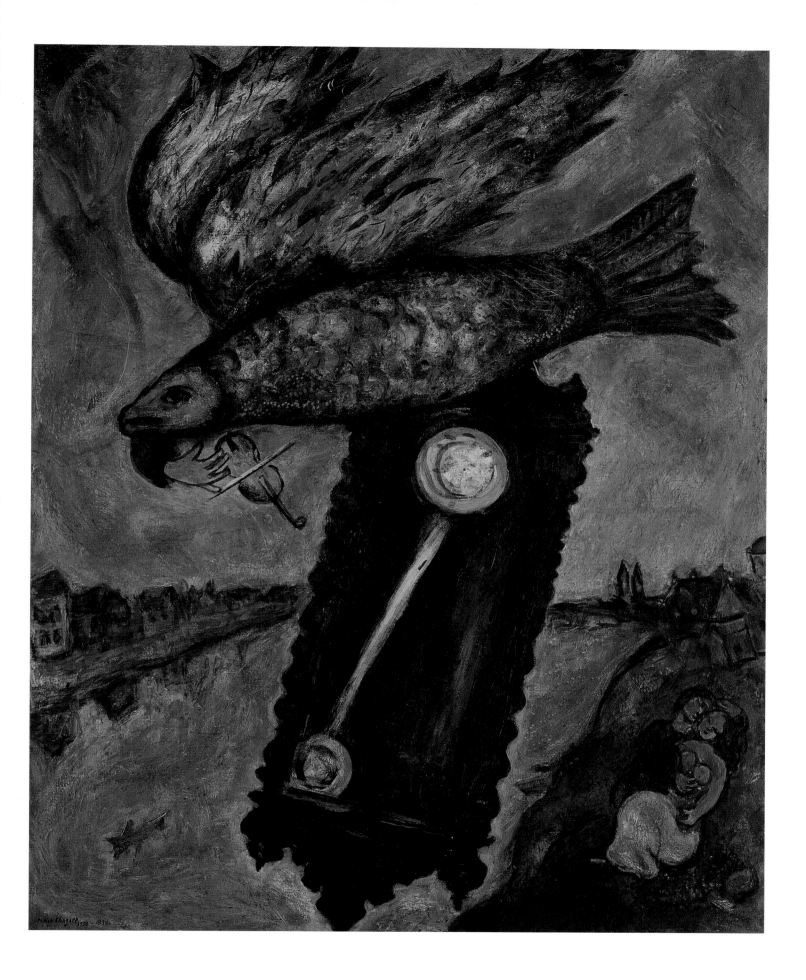

A Wheatfield on a Summer's Afternoon: Aleko

1942. Gouache, wash, brush, watercolour and pencil, Scene 3 – study for backdrop, 38.5 x 57 cm. The Museum of Modern Art, New York, Lillie P. Bliss bequest

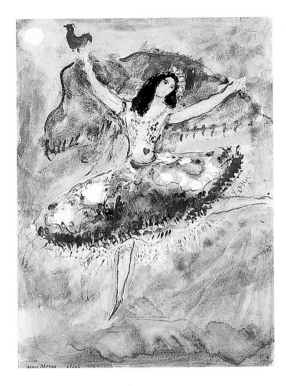

Fig. 38
Zemphira: Costume
Design (Scene 1)
Gouache, watercolour and
pencil, 53.5 x 37 cm.
The Museum of Modern
Art, New York, Lillie P.
Bliss Bequest

It was once said of Chagall that he had 'a capacity for elation', and despite his growing agitation at events in Europe, and the proliferation of apocalyptic imagery which this engendered, he was capable of being diverted. Arriving in New York after he and Bella were forced into exile by the Nazi occupation of France, Chagall was immediately offered an exhibition by Pierre Matisse (son of Henri Matisse), who became his dealer, regularly showed his work and kept in close personal contact during the years of American exile. Chagall never learned English, but relied on contact with exiled artists and writers from France, and with the thriving expatriate Russian community which, for a while, included old friends from his time at the Jewish Chamber Theatre in Moscow. It was the Russian choreographer, Léonide Massine, who provided Chagall with the opportunity to demonstrate that 'capacity for elation' when, in spring 1942, he commissioned him to design the scenery and costumes for the New York Ballet Theatre's production of *Aleko*, based on Tchaikovsky's *Trio in A Minor* and Pushkin's poem *The Gypsies* – a tragic love story of betrayal, jealousy and death. Union difficulties prevented the ballet from being premiered in New York, and the whole company moved to Mexico City in August 1942, where Chagall and Massine continued their close collaboration. Once again, as in the murals for the Jewish Theatre (Fig. 8), Chagall was involved in every aspect of the production, determined to prevent any hint of naturalism creeping into an art form which he believed to be fundamentally anti-realistic: 'There is no equivalence between the world in which we live and the world we enter in this way', he said. The ballet was a great triumph, both in Mexico and on its transfer to New York – its success due in large part to Chagall's four superb backdrops which stunned the audience with their colour and vitality. Chagall's imagination had been caught by the vastness of the American landscape, and by the quality of Mexican light, and *Wheatfield on a Summer's Afternoon*, with its blood-red sun and red, white and yellow target moon set in an almost abstract colour-field of brilliant yellow, provides a spectacle independent of all but colour and sensation – expressing an energy and an urgency not seen on this scale since his days with the Jewish Theatre in Moscow.

35 The Juggler

1943. Oil on canvas, 109 x 79 cm. The Art Institute of Chicago

Chagall's work on the ballet *Aleko* and his exposure to the light and colour of Mexico fed into a new cycle of paintings with fantastic motifs and intense colours which he worked on alongside the 'Crucifixions'. The arresting image of *The Juggler*, one of the major works of Chagall's American period, combines these new influences with iconographic elements from previous paintings, to create a work of mysterious ambiguity. As well as the familiar bestiary of birds, beasts and fish which populated Chagall's canvases from very early on – and which were largely drawn from the environment in which he grew up – he had also developed his own private mythological bestiary – winged fish, violin-playing cows, bird-headed figures (not unlike the bird-headed gods, Horus and Thoth, of ancient Egypt). These were, in some sense, a dynamic projection of his desire to represent 'psychic reality' (the Unconscious) in a work of art. In *The Juggler* he returns to the circus theme (which for him was a central metaphor for the human condition). The picture is dominated by the rooster-headed and winged figure of a circus performer, on whose out-stretched arm hangs a clock – symbolic of the passage of time, but associated too with sorrow, despair and political upheaval (Plate 33). Now limp and lifeless, it bears a striking resemblance to those 'soft watches' draped over objects in a landscape in Salvador Dali's celebrated Surrealist work *The Persistence of Memory* (1930). Chagall probably knew the work, although it had a rather different genesis – being more concerned with entropy or decomposition than with personal mythology. Surrounding the juggler (who stands on one leg – the other flung up to meet his neck in what had become a pose emblematic of the circus theme) are the familiar images from a Vitebsk childhood – small wooden houses, picket fences, a tree, the ubiquitous violinist playing his melancholy tune. A trapeze artiste swings in the air above the arena – the whole a swirling stream of earth and air in which images of people and things seem veiled and indistinct – as if a palimpsest, the picture's meaning is ultimately withheld.

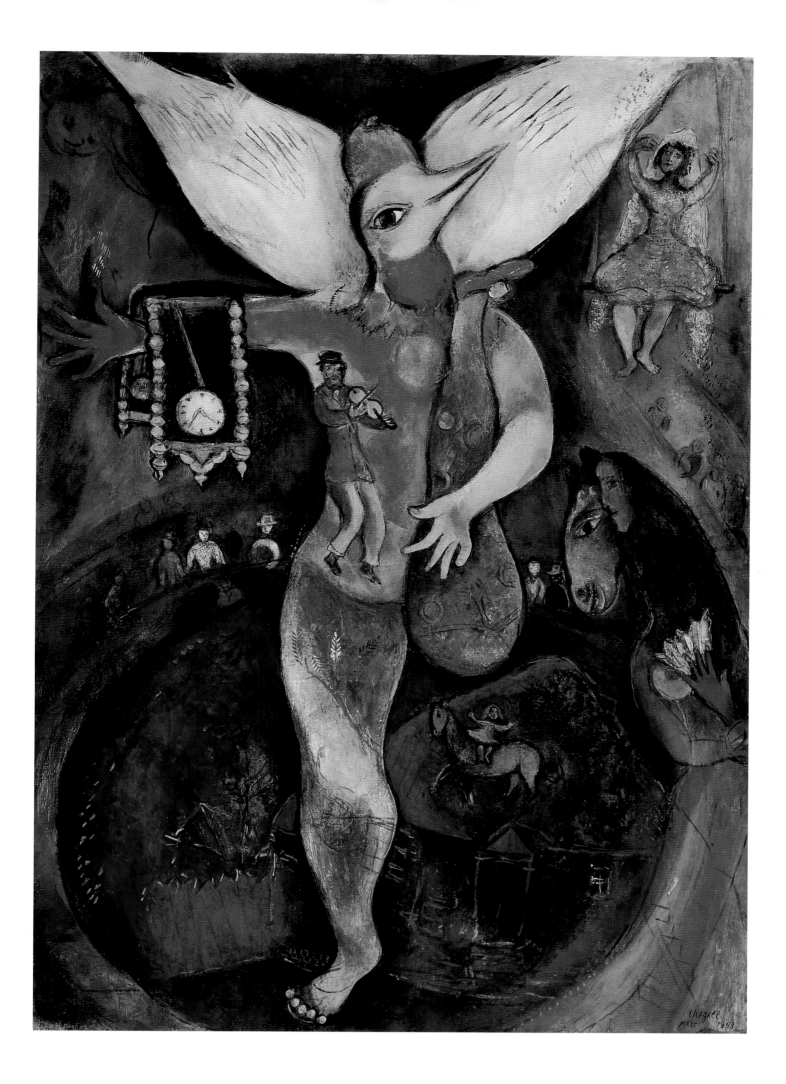

Around Her

1945. Oil on canvas, 130.9 x 109.7 cm. Musée National d'Art Moderne, Centre Georges Pompidou, Paris

In the late summer of 1944, shortly after news of the liberation of Paris was announced, Bella became ill with a virus infection from which she died. Elation turned to despair, and for nine months Chagall was unable to paint, let alone think of returning to France as they had planned. Instead, he helped his daughter Ida with the French translation of *Burning Lights*, Bella's autobiographical account of her childhood in Vitebsk, surrounded by a close family circle and bound by Jewish ritual and tradition. Writing in Yiddish – her mother-tongue – Bella first began the work after a trip to Poland in 1933 alerted them to the threat of Fascism beyond Germany's borders. She finished it with unusual haste and apparent foreboding shortly before her death. When Chagall felt able to work again, he began by cutting a large canvas – *Circus People* – in half and painting two new pictures. The right-hand side became *Wedding Candles* (1945), while the left half, which he worked on first, became *Around Her*. Although most of the original features of the earlier painting have been retained in this work, the mood has altered significantly. What had been a light-hearted circus fantasy became a haunting, shadow-filled memorial – a painting redolent with the memory of their long and loving relationship. Bella weeps and leans inwards towards a well-remembered image – a vision of Vitebsk which, lit by a crescent moon, lies within the crystal ball or magic circle drawn by the acrobat's hoop. Chagall appears at his easel, palette in hand and with his head inverted – a position characteristic in his work of both inner turmoil and reverie. Where, in the earlier picture, a samovar and lighted candle stood, a bird now spreads its wings, a single memorial candle in its outstretched human hand. Equally unhampered by gravity and sheltered within a bower of leaves (a relic of the earlier work) a bridal couple float and dream, their idyll reminiscent of the cycle of works begun in the late 1920s which have lovers and flowers as their theme (Plate 27). This theme, which had its origins in the small bouquet which Bella holds in *The Birthday* (Plate 20) was an evocation and a celebration of a love that was to inspire Chagall until his own death in 1985.

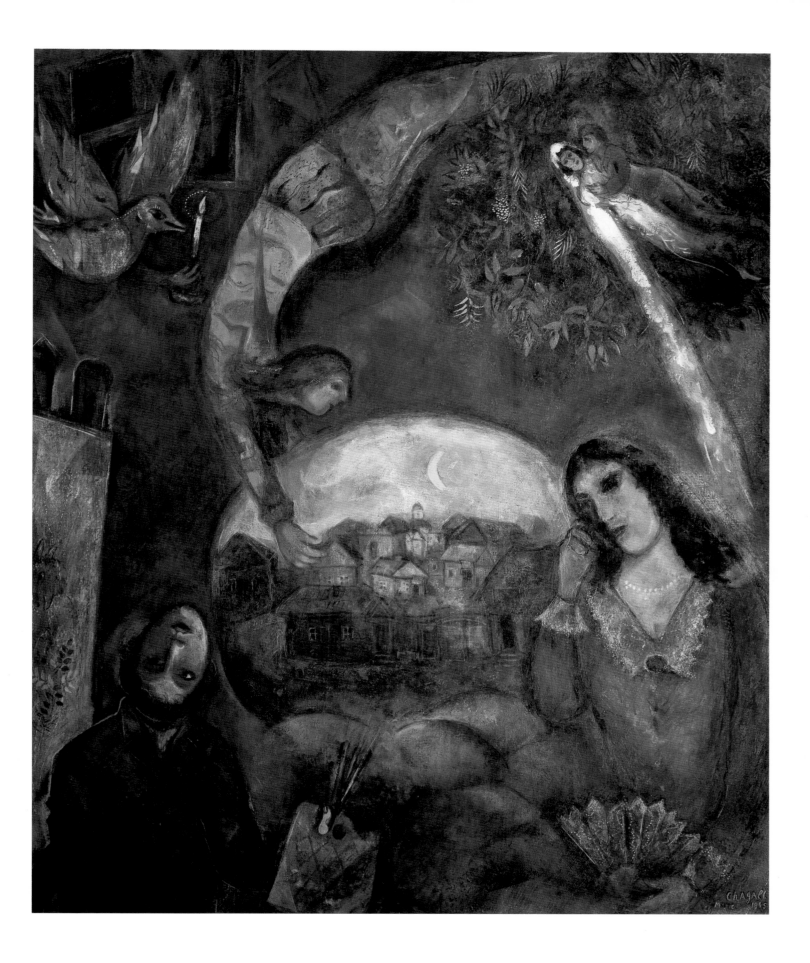

1945. Oil on canvas, 107 x 81.5 cm. Musée National d'Art Moderne, Centre Georges Pompidou, Paris

At the end of the war, Chagall had very little to celebrate. Bella was dead, Vitebsk had been reduced to rubble, and from Europe a horrifying truth was emerging about the wholesale slaughter of millions of innocent human beings. Chagall was in shock, and many of his paintings from 1938 onwards bear witness to his continuing anguish (Plate 32). Crucifixion imagery is a defining characteristic of such paintings, and although Chagall's perceptions may have altered somewhat when he began accepting commissions for cathedrals and churches, there can be no doubt that, at this point, the figure on the cross signified not the Passion of Christ as a symbol of redemption but the martyrdom of the Jews on the cross of persecution (Figs. 15, 17). Chagall's lifelong identification with animals and the natural world, his animistic belief in the living soul of inanimate things, ran like a thread through his paintings from the beginning of his career to its end; and it is likely that in choosing *The Soul of the City* as a title for this painting, not only was he expressing the profound grief which overwhelmed him when he learned of Vitebsk's fate, but he was also trying, in some curious way, to 'save' the dying soul of his city by putting it on canvas, trying to 'get [it] out of harm's way' – a sentiment he had already expressed in *My Life* when describing an incident during a pogrom. Touches of colour here and there only serve to emphasize the sombre tonality of a work which appears to have been formed from dust and ashes rather than painted in oil. A Janus-faced artist (Chagall) gestures towards the easel on which a Crucifixion painting rests, while a flying cart or sleigh emerges above the rooftops and wooden houses so familiar to spectators from earlier work. An Ark of the Covenant, curtained in red and surmounted by heraldic lions, floats along in Bella's wake as she streams through the air with serpentine grace; disembodied and ghostly, her wedding veil (or winding-sheet) is mirrored by the curling smoke from distant chimneys. The enigmatic presence of a woman cradling a rooster adds further mystery to what is already a painting of great internal complexity. It was fortunate for Chagall that during 1945 he was commissioned to design the sets and costumes for a production of Stravinsky's *Firebird*, an event which, together with meeting Virginia Haggard McNeil, brought colour and life back into his life and work. In reality, though, he continually 'alternated between joyous fantasies and tragic memories', and in 1946–7 his poem *My Land* reprised the sentiments which underpinned *The Soul of the City*:

Only that land is mine
That lies in my soul.
As a native, with no documents,
I enter that land.

It sees my sorrow
And loneliness,
Puts me to sleep
And covers me with a fragrance-stone.

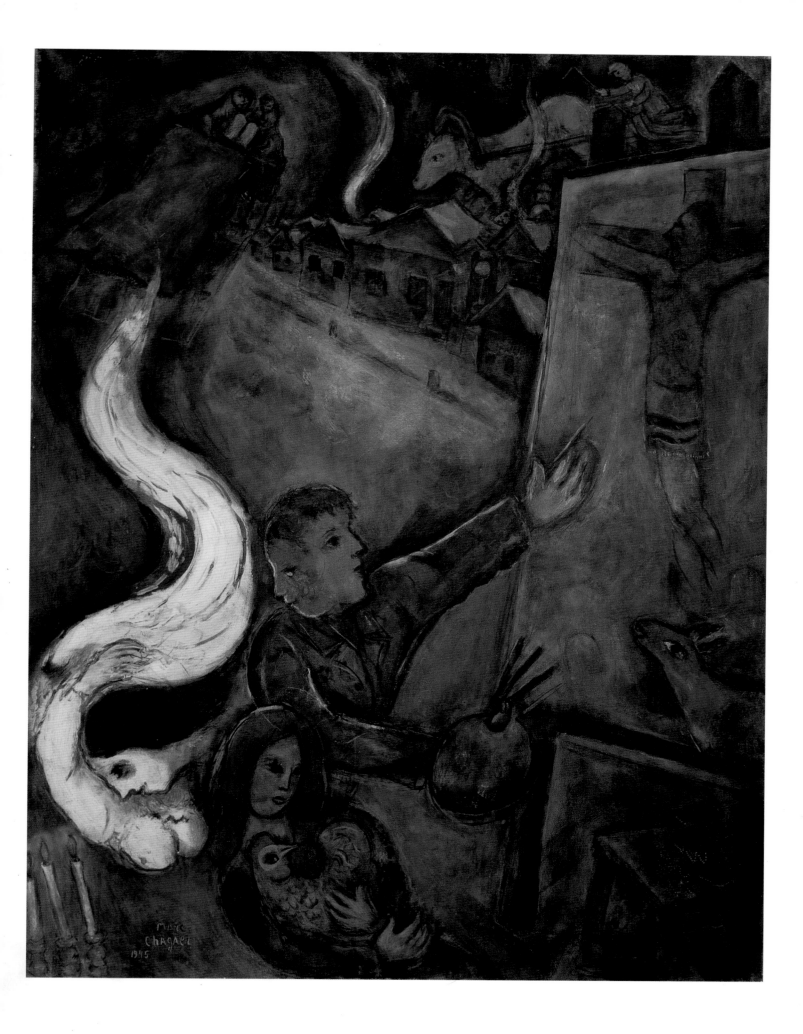

Cow with Parasol

1946. Oil on canvas, 77.5 x 106 cm. Richard S. Zeisler Collection, New York

Chagall, who was never hampered by logic, continued to produce images full of wit and imagination. And despite his other, profoundly more serious and reflective side, these images epitomize the world of dream and fantasy with which he became so widely identified in people's minds. His magical early work, *To Russia, Donkeys and Others* (Plate 7), which had been seen in New York in 1941 and again in 1946, was probably fresh in his mind when he began work on *Cow with Parasol*, for in both, a rather pre-scient cow – symbol of nurturing motherhood – suckles her young while balanced precariously on the rooftops above Vitebsk. The affinity ends there, however, for now, in this fantastical scene, shadowed by twilight, the cow – its tail sweeping up to form the familiar bride and groom motif – strides forwards purposefully, the absurdity of the image compounded by the clown she tramples underfoot, and by the parasol she 'carries' to shade her from the molten glow of a fiery sun. Just as the earlier painting had its genesis in drawings Chagall had previously made of Russian peasant life, so a rekindled interest in folk art after his time in Mexico fed into *Cow with Parasol* – a work in which gravity, in both senses of the word, has been abandoned, and where, freed from accepted logic, this wild and exotic flight of the imagination has alighted once again in Vitebsk, the rich and inexhaustible source of Chagall's imagery and inspiration.

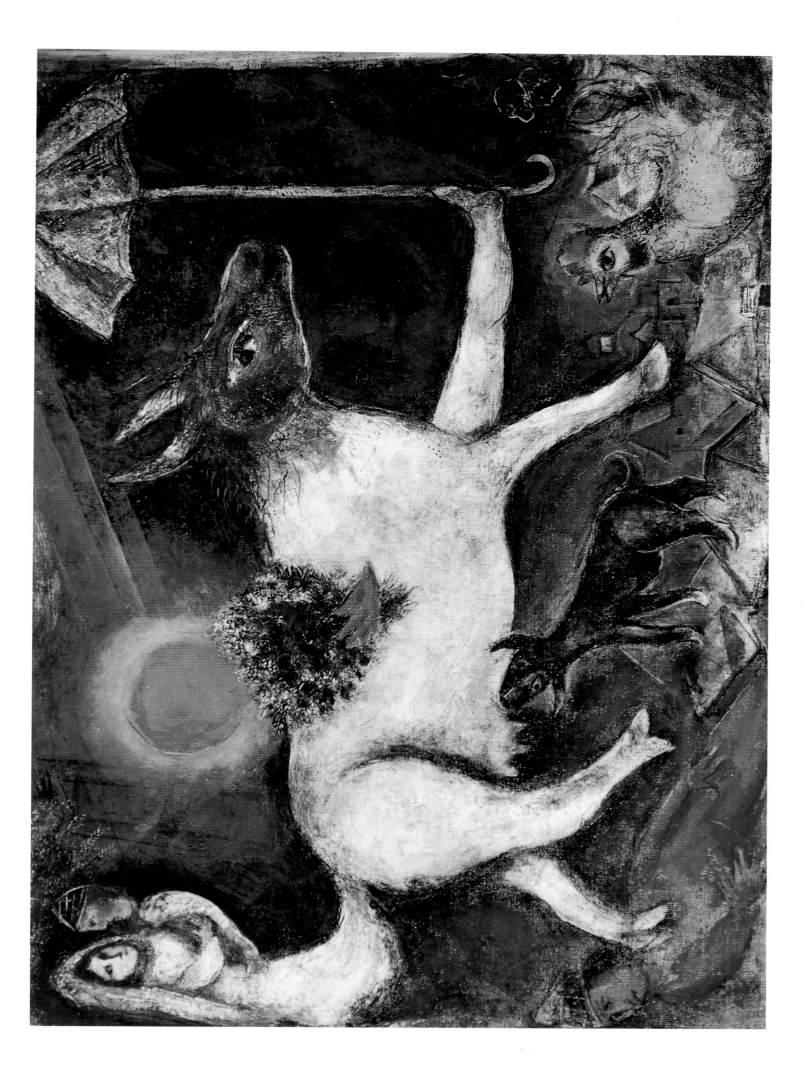

The Falling Angel

1922–33–47. Oil on canvas, 148 x 265 cm. Kunstmuseum, Basle

In 1947 Chagall was able to complete this huge painting which he had begun in 1922, worked on again in 1933 and taken into exile with him when he and Bella fled Nazi-occupied France in 1941. And just as Picasso used his own personal mythology and iconography in a passionate protest against the saturation bombing of the defenceless Basque village of Guernica in 1937, so *The Falling Angel*, in its final state, carries within it Chagall's deeply personal response to the great tragedy which had befallen Europe and its Jews. Scenes from earlier paintings, in which Chagall confronts exile and death, are re-enacted once more; while a new image – the demonic figure of an angel, as red as flame and with wings outspread – plummets to earth in a diagonal sweep across the darkened sky. This fall seems to parallel that plunge into Hell which occurs in John Milton's *Paradise Lost* (1667). Here Satan, having 'Raised impious war in Heaven' against 'the throne and monarchy of God', is 'Hurled headlong flaming from the ethereal sky/With hideous ruin and combustion down/To bottomless perdition …' This 'Region of sorrow …' in which he and 'his horrid crew' found themselves, was a place '… where peace/And rest can never dwell, hope never comes/That comes to all, but torture without end …' In the immediate aftermath of war, and with the full realization of its horror beginning to sink in, many people believed that hell was to be found on earth, that God had indeed turned His back on the world. Earth, like Milton's Hell, had become 'As far removed from God and light of Heaven/As from the centre thrice to the utmost pole'. Whether or not the glow of a single candle which mirrors the light of the moon shining down on this apocalyptic scene has redemptive possibilities, is for each individual to determine. For Chagall, whose wife had died suddenly in September 1944, it is perhaps a memorial as well as being a convincing summation of his preoccupations during the war years; a seminal painting in his *œuvre* which marked the end of his American exile.

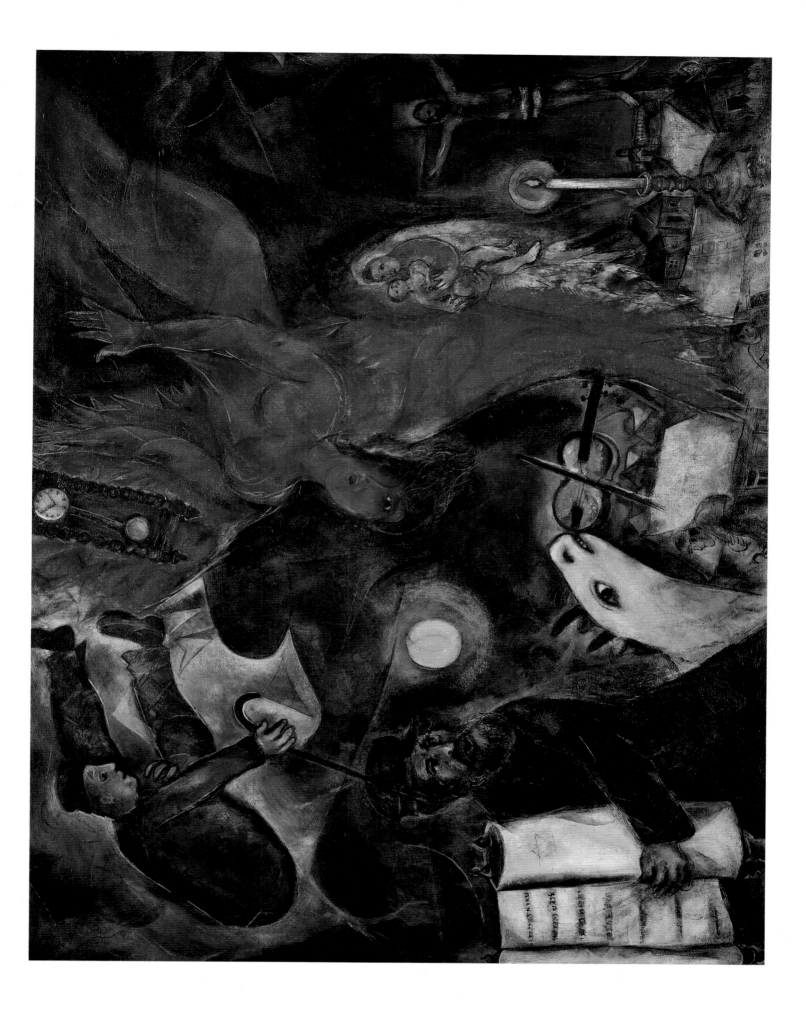

Red Roofs

1953. Oil on paper mounted on canvas, 230 x 213 cm. Musée National d'Art Moderne, Centre Georges Pompidou, Paris

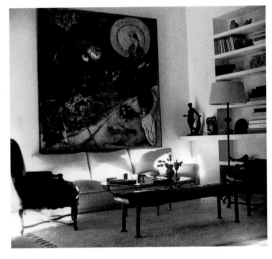

Fig. 39
ALFRED NEUMAN
Chagall's sitting room
with *Red Roofs*
c.1977. Photograph
Collection of Alfred and
Irmgard Neuman, Leo
Baeck College, London

Chagall returned to France in August 1948. He was, by now, a celebrated artist besieged by offers of exhibitions from museums and galleries around the world – his place as one of the great figures of twentieth-century art assured. Chagall had tentatively begun to think of Paris as his 'second Vitebsk' between 1910 and 1914, and it became the place of which he dreamed while living in America. It was, he said, the place he '… rediscovered enriched by new life … Absence, war, suffering were needed for all that to awaken in me and become the frame for my thoughts and my life. But that is only possible for one who can keep his roots. To keep one's roots and find another earth, that is the real miracle.' For Chagall, the new earth was now France, the new city Paris, for with Vitebsk reduced by war to little more than ashes, the psychological link with his past was severed – only the memory of a memory remained. Chagall began work on a series of large pictures – the 'Paris series' – to celebrate his return, but as with works such as the earlier *Self-Portrait with Seven Fingers* (Plate 13), both cities found their way on to the canvas. *Red Roofs*, the largest and least Paris-centred of these paintings, contains many of the most intimate recollections of his childhood, including, on the extreme left (within the diagonal swathe of red which signifies Vitebsk), a tiny image of the family living room with its now familiar wooden-framed wall clock. The shadowy bulk of Notre Dame, with the Seine flowing by, lies above the ethereal dream-image of the painter, through whose trans-parent form the rooftops of Vitebsk can be seen; while below, on the snowy white ground, the strange double figure of a young Chagall and his bride, Bella – ghost-like and inverted – stand hesitantly, a bouquet held out to the artist (also Chagall) who in turn proffers his palette and brushes. Outlined against the disc of the moon, the familiar figure of the Jew with his Torah watches and waits. It is as though the earth of Vitebsk – the inner world of memory – is being 'given', transferred; as though the miracle of finding a present for the past, of finding a new earth for old roots is becoming palpable.

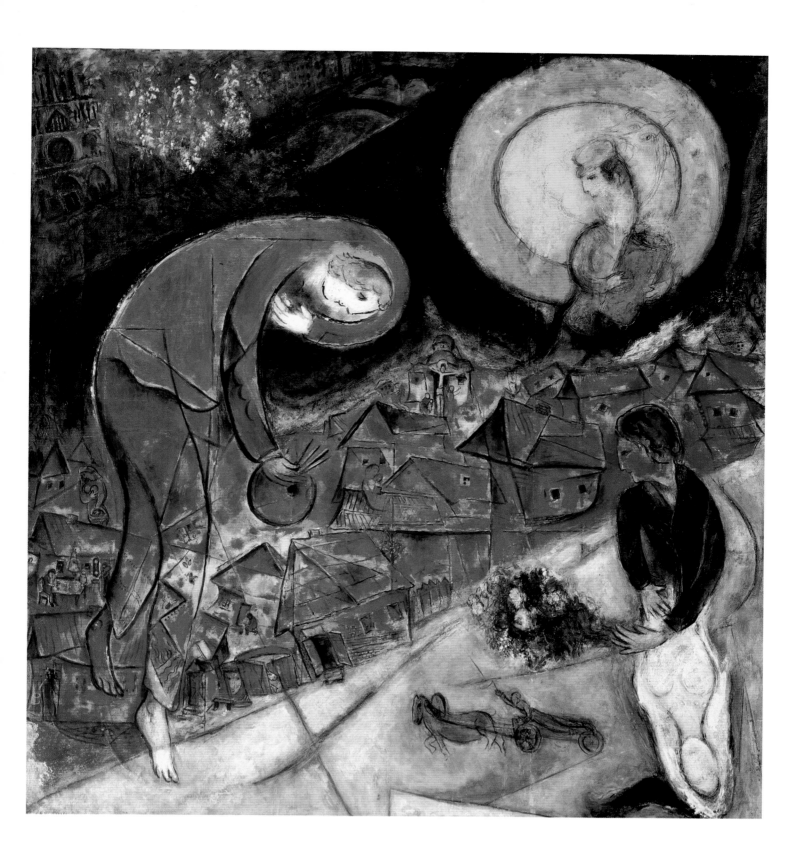

Bridges over the Seine

1954. Oil on canvas, 111.5 x 163.5 cm. Kunsthalle, Hamburg

This painting forms part of the 'Paris series' which preoccupied Chagall during the 1950s. Unlike the earlier *Red Roofs* (Plate 40), which is imbued with an overlay of nostalgia for Vitebsk, *Bridges over the Seine* has as its focus the towers, the domes and the bridges of Paris – a city which, like the recumbent lovers, is at rest under an enchanted, penumbral sky. The plunging, hell-bound figure from *The Falling Angel* (Plate 39) is here transformed into a feathery lilac and blue cock, in whose wings nestle a mother and child – the woman's dress a flame-like tongue of red which counters, with its surging upward trajectory, the rather gentle downward movement of the bird. Such imagery and vivid colouring, set against the shrouded greeny-blue of the city, recall Apollinaire's appreciation of Chagall as ' a gifted colourist who yields to every suggestion of his mystic, heathen fantasy'. But it was after the extraordinary impact created by his set designs for *Aleko* (Plate 34) and *The Firebird* (1945) that Chagall's reputation as a conjuror with colour was universally acknowledged. Kandinsky's belief that 'colour directly influences the soul' was echoed by Chagall, and it was in the exploration of this conviction, in the dramatic shift to colour – intense, rapturous, non-naturalistic and often independent of the forms – that the future direction of Chagall's art lay, as he settled back into life in France, a hostage now to the insatiable demands of international celebrity.

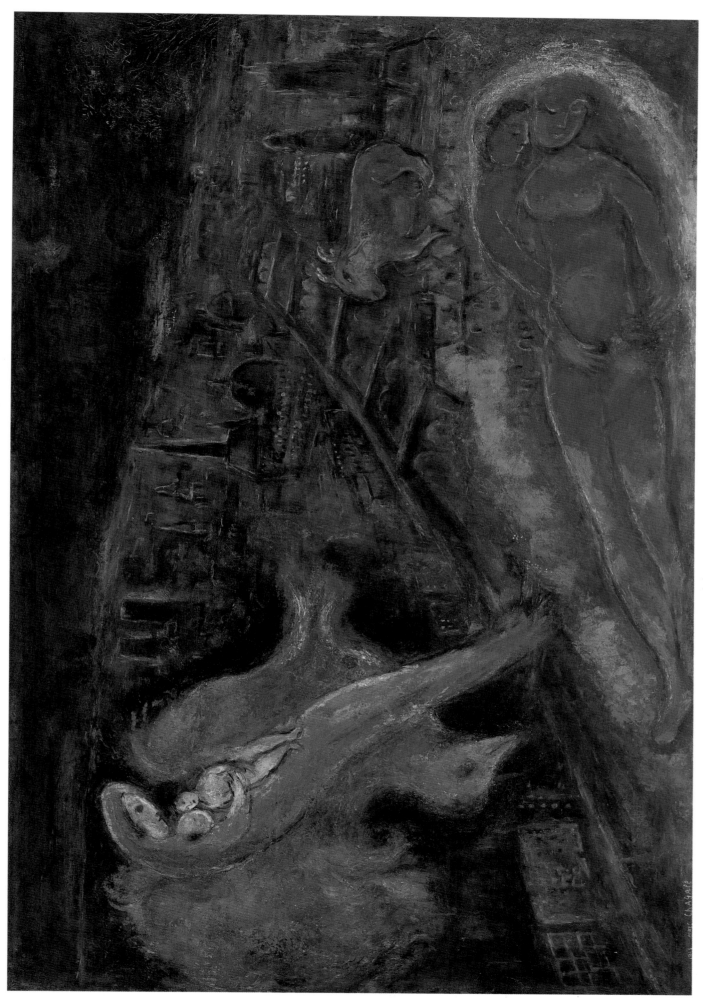

Moses Receiving the Tablets of the Law

1956–8. Oil on canvas, 236 x 234 cm. Musée National Message Biblique Marc Chagall, Nice

Fig. 40
Moses Breaks the
Tablets of the Law
Etching, 29.4 x 23.1 cm.

Plate xxxix from The

Bible, Paris, Tériade,

1956; 105 etchings from

1931–9 and 1952–6

During the 1950s, Chagall began experimenting with stained glass, sculpture and ceramics. He also began to think of his painting – as he did his graphic work – in terms of cycles. Vollard's successor, Tériade, announced his intention to publish the Bible illustrations Chagall had begun in the 1930s, and this news, together with a return visit to what was now Israel in 1951, revived Chagall's interest once again. He conceived the idea of a series of monumental paintings based on the Old Testament – a work which he believed to be 'the greatest source of poetry of all time ...', one which had exerted the most profound influence during his childhood, and which continued to work its spell throughout his life. The level of enthusiasm and commitment which Chagall brought to this project during the 1950s and 1960s led to the creation of the Musée National Message Biblique Marc Chagall, near Nice – a lasting memorial both to the artist and to his belief that whatever their religion, anyone surrounded by colour, light and line (made numinous in the quiet, ecumenical spaces of the museum) would experience 'love' and deep spiritual contentment. This effort to visualize the Old Testament brought Chagall back into the mainstream tradition of Western art, although his idiosyncratic and original iconography brings an unmistakably 'Chagallian' dimension to otherwise familiar Biblical imagery. In fact, as a twentieth-century rather than medieval or Renaissance artist, Chagall did not have to follow any prescribed rules of interpretation or exegesis, and freed from such constraints he was able to indulge his imagination to its fullest extent. *Moses Breaking the Tablets of the Law* (cf. Fig. 40), passionate, intense and inspired by El Greco – was not included in the cycle of works which entered the collection, but its pendant – *Moses Receiving the Tablets of the Law* – is one of seventeen monumental works which form the principal donation. According to his biographer, Franz Meyer, Chagall believed that Moses was the embodiment of the lofty, perilous destiny of the Jews – 'the source from which all springs, even Christ'. Not only was he a mythic figure – one of the founding ancestors with singular and awesome responsibilities – but he was in perpetual dialogue with God and thus had a unique role as the transmitter and expounder of 'the Law'. The painting depicts that moment when God, with all but his hands hidden in a storm cloud – passes the Tablets to Moses who is precariously perched on the top of Mount Sinai. Moses reaches out across the void, his expression of awe mirrored in the faces of those waiting below, although a hint of the trouble to come can be glimpsed in the distance where less reverential characters are preparing to worship the Golden Calf. The whole scene is lit by a blinding celestial light which emanates from behind this primordial cloud – a light which reaffirmed Chagall's belief that Moses was 'the source from which all springs', that out of these hostile wilderness conditions the most significant event in the history of human ethics was born.

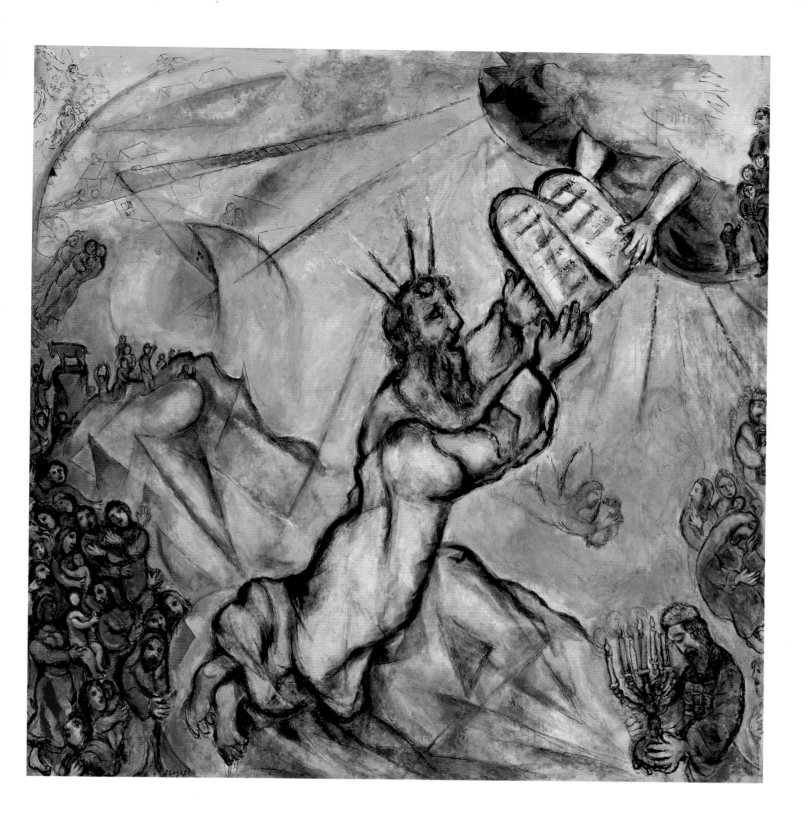

Song of Songs IV

1958. Oil on canvas, 145 x 211 cm. Musée National Message Biblique Marc Chagall, Nice

'I found him whom my soul loveth
I held him and would not let him go'
Song of Songs III, 4

The *Song of Songs* or *Song of Solomon* is one of the great hymns to love in world literature, and Chagall quite naturally chose to dedicate his cycle of paintings on the theme to Bella's memory. Unlike most of the other paintings which Chagall donated to the Musée National Message Biblique, this cycle was not conceived as part of the earlier group of Bible etchings, nor does it follow the Biblical text very closely, except in the sense that 'love' – sensual and celestial, intimate and universal – is its dominant theme. Reds of every hue fill the picture space on each of the five successive canvases which form the cycle, and each contains the flying figures and familiar motifs which were by now as much a 'Chagallian' signature as any handwriting. The scale on which Chagall liked to work in later years had, to some extent, outstripped the size or capacity for enlargement of the pictorial concept, and this resulted in some work appearing overblown and repetitive; however, *Song of Songs IV*, the most tightly organized of the five canvases, does not suffer this problem, and the image of a winged and airborne horse – Pegasus perhaps – soaring with its lovers through a sky suffused with the red hot colour of flame, both bewitches and allures, drawing one with anticipation to the words of the *Song* itself. Solomon, whose wisdom was legendary, is believed to be the author of this canticle, its title *Song of Songs* in Hebrew signifying that it is the greatest, the best and most beautiful of all songs – unparalleled in its poetic representation of love in all its manifestations. It seems to move or shift in turn between two lovers, Solomon and a woman of Shulam (a town in northern Palestine) and a chorus – the 'daughters of Jerusalem' – and with its langorous and melodic verse structure, its evocation of great love, sentiment and desire, as well as its place in the Jewish Passover liturgy as an allegory of the love of God for Israel, it brings to mind Chagall's description in *My Life* of his childhood experiences in synagogue at the side of his beloved grandfather as he intoned the prayers with the same sonorous, mesmeric effect which a reading of the *Song of Songs* creates:
'Beneath the drone of the prayers, the sky seemed bluer to me. The houses float in space. And each passer-by stands out clearly.
Behind my back they are beginning at prayer and my grandfather is asked to intone it before the altar. He prays, he sings, he repeats himself melodiously and begins over again. It is as though an oil mill were turning in my heart! Or as though a new honey, recently gathered, were trickling down inside me.
And when he weeps, I remember my unsuccessful sketch and I think: Will I be a great artist?'

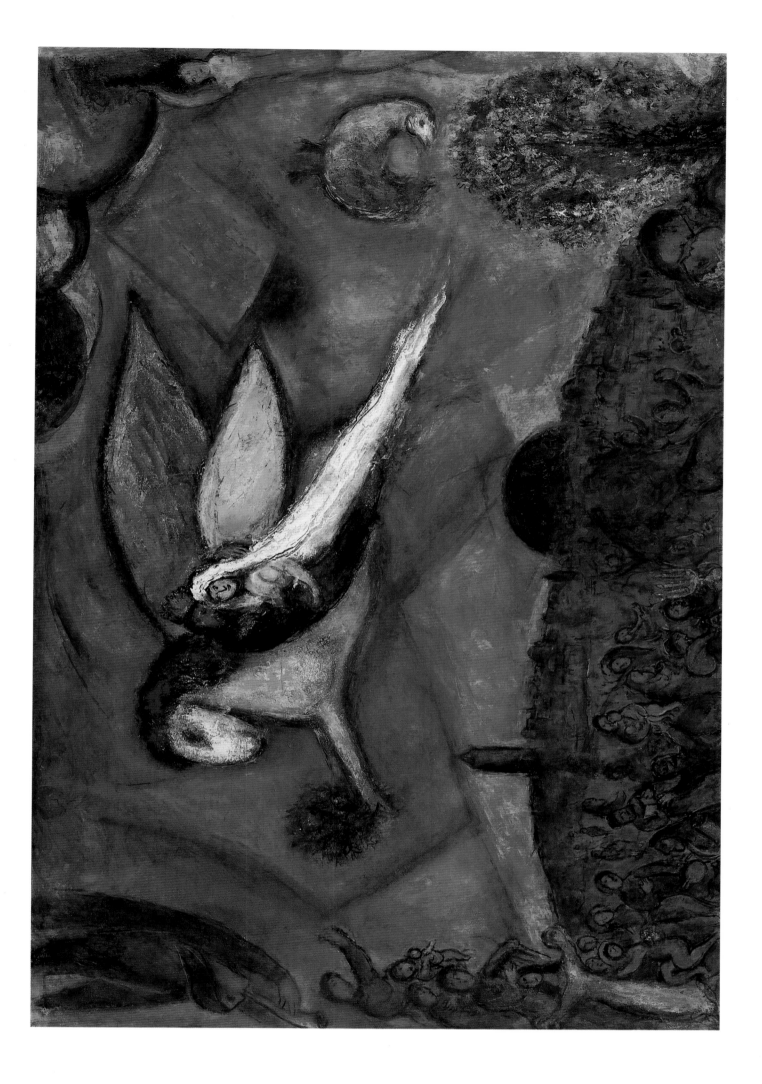

44 Peace

1964. Stained and leaded glass window, 3.50 x 5.36 m. United Nations Secretariat Building, New York

Chagall first began thinking about stained glass as a suitable working medium in 1950, when the possibility of decorating an unused chapel presented itself. In 1952 he visited Chartres Cathedral specifically to study its Gothic windows, and in 1956 he received his first commission for leaded-glass windows for the baptistry of a chapel in Assy. This collaborative project, with contributions from other distinguished artists such as Matisse, Bonnard, Léger, Braque and Rouault, marked a tentative beginning to what would become an important and original new direction for Chagall's art – the logical continuation of his new-found monumentality, his stunning play with large areas of saturated colour, and his preoccupation with biblical themes. Further commissions followed – for the Cathedral at Metz, for the Synagogue of the new Hebrew University Hadassah Medical Centre in Jerusalem, and for many other cathedrals, churches and public buildings around the world. Alongside the Metz commission, Chagall began what amounted to an apprenticeship in the techniques and methods of stained-glass making. He learned under the tutelage of Charles Marq at the Atelier Jaques Simon at Rheims, and together they worked on the complex and mysterious process of translating gouache designs on to glass – an undertaking in which Delaunay's dream of a 'dynamic poetry of transparent colour and light' was to find its most perfect expression. When Chagall attended the unveiling of the Hadassah Hospital windows, he made an appeal for tolerance and understanding among peoples and nations, saying: 'The more our era refuses to see the whole face of the world for the sake of looking at a very small part of its skin, the more worried I become ...' Perhaps it was with this in mind that he accepted a commission in 1964 to create a 'Peace' window for the United Nations Secretariat building in New York. Dedicated to the memory of its late Secretary General, Dåg Hammarskjöld, the idea of tolerance is intrinsic to its conception, and this is reinforced as much by the predominance of a celestial blue as by its theme – the prophesies of Isaiah 11:6 regarding the future harmony of the world: 'The wolf also shall dwell with the lamb, and the leopard shall lie down with the kid; and the calf and the young lion and the fatling together, and a little child shall lead them.'

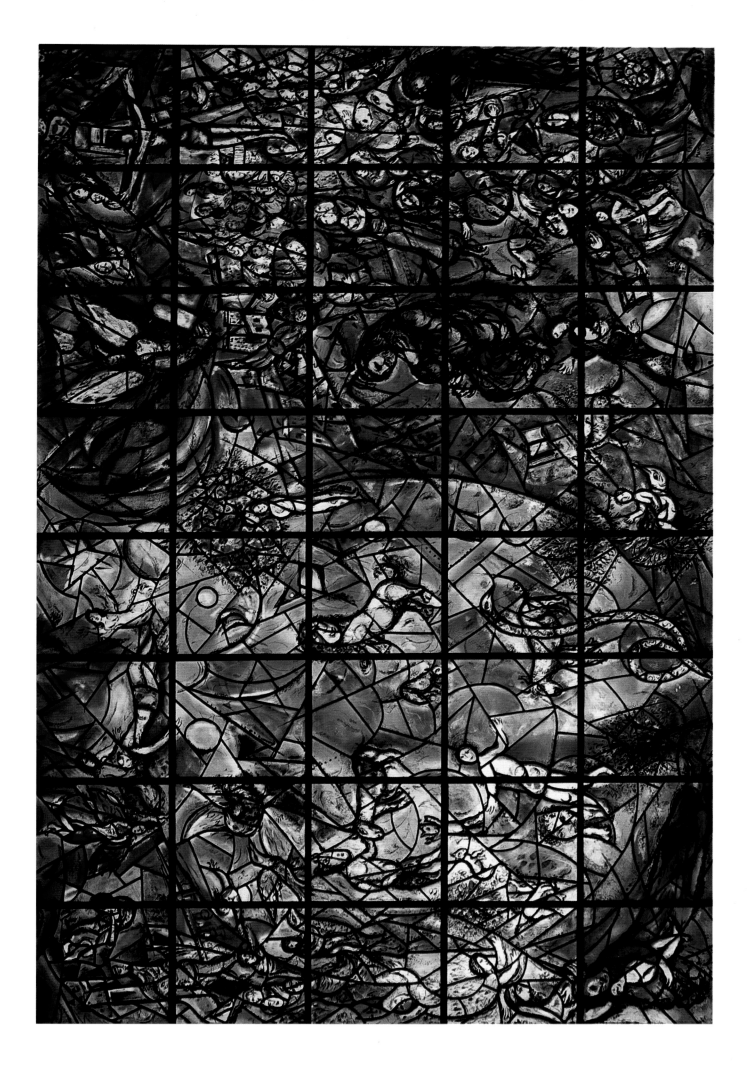

45 War

1964–6. Oil on canvas, 163 x 231 cm. Kunsthaus, Zurich

War is once again the focus of this apocalyptic scene of carnage and chaos, the human cost of which is incalculable. But while Chagall's previous images of war were in response to a specific conflict, there seems no obvious reason why he chose this subject-matter in the mid-1960s – except, perhaps, that having just completed the *Peace* window (Plate 44) for the United Nations, he also wanted, in this monumental work, to remind people of the horrors of war – of how rare and fragile peace always is if it is not nurtured and protected. Flames lick into old wooden houses on this night of destruction, while figures familiar from earlier paintings such as *White Crucifixion* (Plate 32) huddle in small groups – weeping, mourning, comforting the injured or setting off on the road as homeless and dispossessed refugees. A great creature rises out of the snow-covered earth – a 'Chagallian' animal, part horse, part cow – perhaps a reference to the cows slaughtered by Chagall's grandfather as ritual butcher of Lyozno, or to the fourth horse of the Apocalypse: '... a pale horse, and his name that sat on him was Death, and Hades followed with him. And power was given unto him over the fourth part of the earth, to kill with sword and with hunger, and with death, and with the beasts of the earth' (Revelation 6:8). Whether or not Chagall had these thoughts in mind, the painting's epic, biblical dimensions are clear, particularly in the Crucifixion scene and in the figure of Moses – oversized and in an attitude of urgent, despairing exhortation as he stands on the back of the beast, his cries blown away on the wind. Chagall depicts a world in which human beings are at the mercy of arbitrary and irresistible forces, a world in which happy endings – of the sort that he is normally associated with – are an exception.

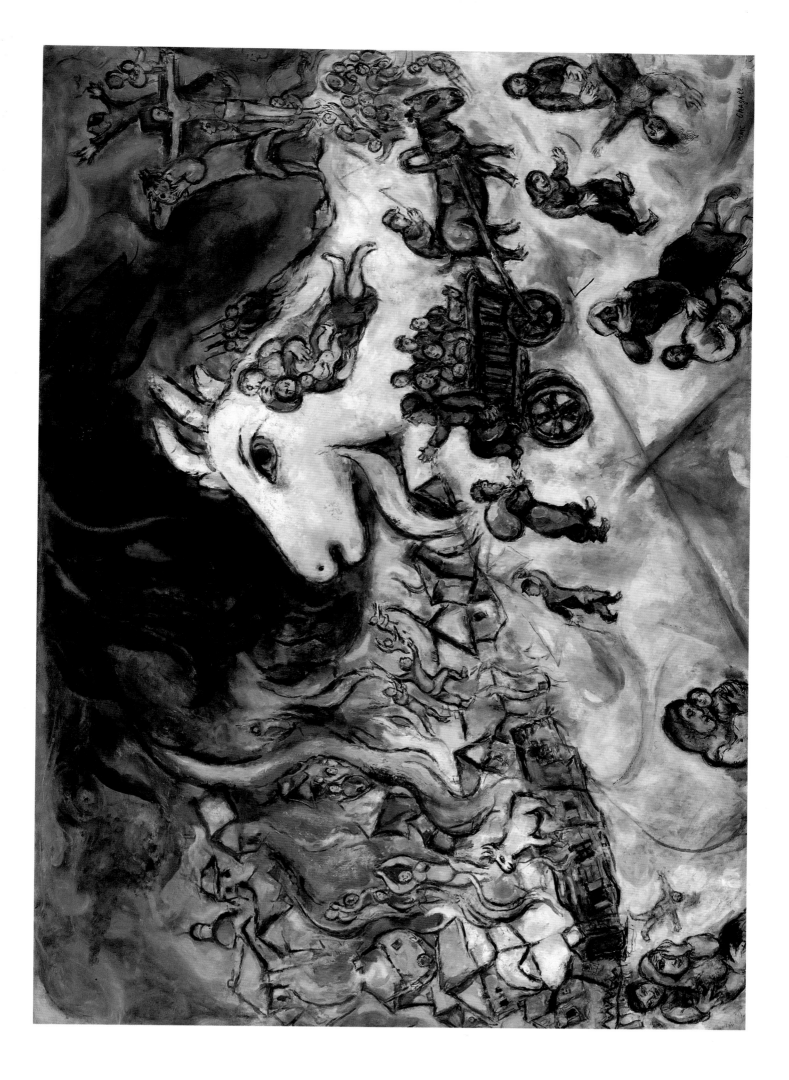

The Sources of Music

1967. Oil on canvas, 10.98 x 9.14 m. Metropolitan Opera, Lincoln Centre, New York

At the age of eighty, when most people are well into retirement, Chagall was accepting ever-bigger commissions for stained-glass windows, for mosaics and tapestries, and for large-scale murals – such as those for the Metropolitan Opera at the Lincoln Centre in New York (for whom he had already concluded a successful production of Mozart's *Magic Flute*). This was one of Chagall's most important commissions in North America, and he chose, in two immense canvas panels – *The Sources of Music* and *The Triumph of Music* – to explore the world of music, an art form which, like painting, has the power to overwhelm the senses, to 'invade the soul with the most profound recollections' (Gauguin). In these paintings which glow with the colour of old stained glass – flamboyant red and golden yellow – Chagall paid homage to the great musicians and composers of the past, just as he had with his commission for the domed ceiling of the Paris Opéra in 1963. *The Sources of Music* is dominated by two figures – 'The Angel Mozart', floating in the air above the Manhattan skyline while embracing, within his transparent form, characters from *The Magic Flute*, and the curious double-headed figure holding a lyre who represents both King David and Orpheus. Around them swirl a host of smaller images of composers and their works – Beethoven, *Fidelio*, Bach and Sacred Music, *Romeo and Juliet*, Wagner (*Tristan and Isolde*), and a homage to Verdi. But we find, too, many of the familiar motifs from a lifetime of picture-making – the Tree of Life, flying lovers, and a bestiary of birds, horses and hybrid creatures – without which no painting by Chagall would seem complete. Chagall's ability to achieve monumentality primarily through colour and fluidity of line came from his long association with the world of the theatre – the world in which his imagination was allowed (not always without criticism) to soar unfettered, and where the 'correspondence' or psychic association between colour, form and sound finds its most intense, harmonious expression.

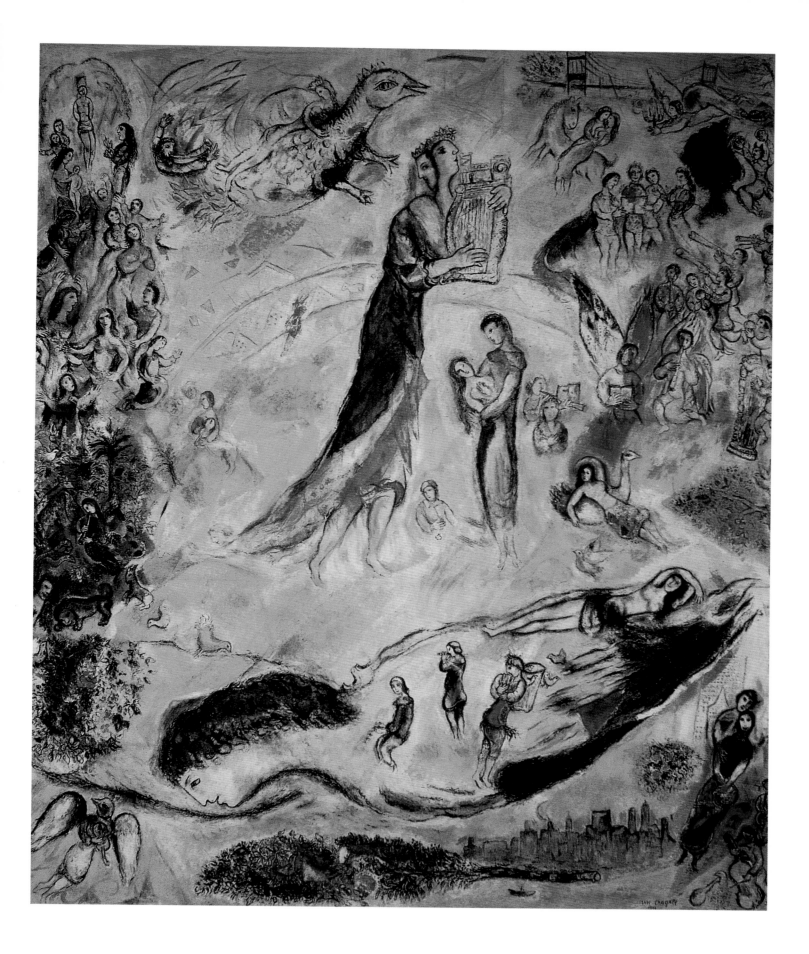

The Fall of Icarus

1975. Oil on canvas, 213 x 198 cm. Musée National d'Art Moderne, Centre Georges Pompidou, Paris

Metamorphosis is one of the most characteristic features of Chagall's art, and it is puzzling that he did not produce more paintings during his lifetime which drew on the myths and legends of ancient Greece – a source rich in images of transformation. However, an edition of Homer's *Odyssey*, with 82 lithographs by Chagall, was published in 1974, and although not in any way connected, the Homeric epic may nevertheless have suggested the subject-matter for this monumental work, which captures in paint the final moments of Icarus's fatal plunge – a story which carries as its subtext the admonition that 'pride comes before a fall'. Daedalus, father of Icarus, and architect of the Cretan labyrinth in which the Minotaur lived (until slain by Theseus), longed to escape from the island where he was held prisoner by Minos, its legendary king. Knowing that Minos controlled the land and sea, but not the air, Daedalus constructed two pairs of artificial wings. Imitating the wings of a bird, he arranged the feathers, row on row, and held them together with thread and wax. As he worked, he instructed his son on how to fly, suggesting that as the boy flew in his wake, he should be sure to steer a middle course half-way between the waves of the sea and the sun, the heat of which would melt the wax if he got too close. Icarus, thrilled by this great adventure, disregarded his father's warnings and began to explore the skies – swooping and soaring like a bird. But he flew too high, the wax binding the feathers together melted, and he fell to his death in the sea – as much the victim of his father's 'god-like' efforts to alter nature's laws, as of an overweening pride in his own new-found ability to fly. In the myth, Icarus fell into the sea (which now bears his name), but Chagall has painted him hurtling to earth in the familiar surroundings of a Russian village. As villagers throng the streets, the drama unfolds – a swathe of pinky-red, suggestive of great heat, cuts a path through the crowd, while a turbulent sky and greyish sun hint that Icarus may indeed have drawn fire away from the sun itself in his epic fall.

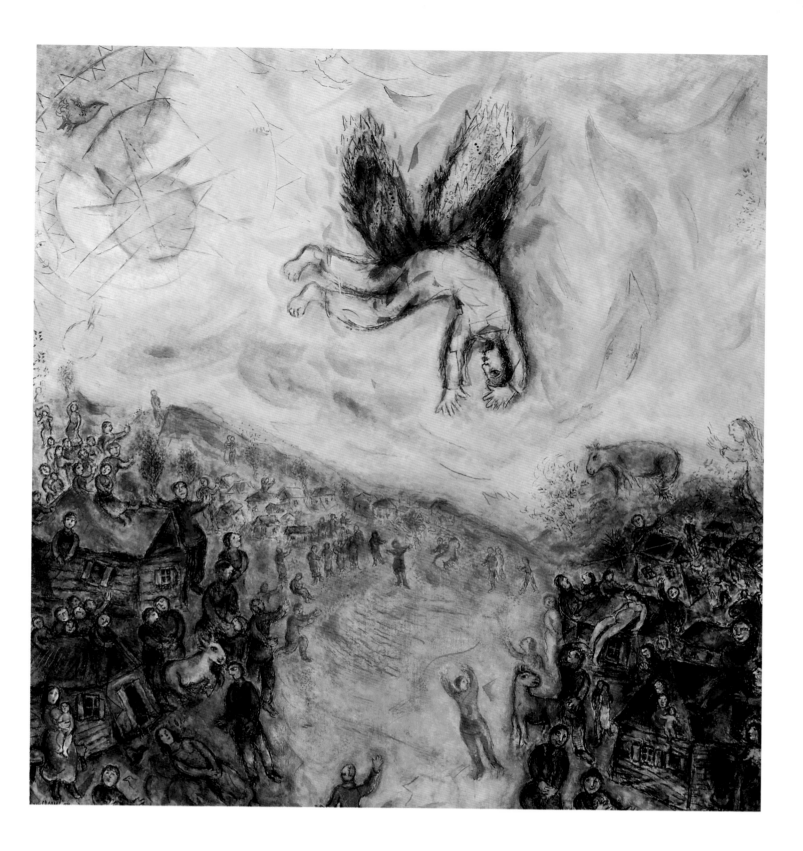

The Large Grey Circus

1975. Oil on canvas, 140 x 120 cm. Private Collection

Fig. 41
Woman on a Trapeze
*c.*1950s. Gouache,
60 x 47 cm.
Private Collection,
London

With the timelessness of an ever-recurring dream or poetic reverie, circus imagery entered into Chagall's art again and again throughout his life – his imagination fed by the exotic 'otherness' of this magical world and its people. He was first drawn to the circus as a child in Russia, but this early fascination grew into a profound belief that the circus was also a mirror to life – a parallel universe of joy and sorrow, hidden behind the mask and the spangled display. Unlike his contemporary, Georges Rouault (for whom the circus only exemplified tragedy), Chagall did not strip away the disguise to a reveal a trapped 'soul', but used it as a dramatic, anti-realist, sometimes satirical device to carry the imprint of early memory – the transformation of the mundane into the make-believe. Chagall spent many evenings with Vollard at the Cirque d'Hiver during the late 1920s, and produced nineteen large gouaches (the *Cirque Vollard*) on the theme. It was also a theme he included in a number of his most important works – specifically the murals for the State Jewish Theatre in Moscow in 1920–1 (Fig. 8), and the monumental canvas, *Revolution* in 1937 (Plate 30), both of which carried a subversive subtext. However, it was the world of make-believe which was probably uppermost in Chagall's mind as he painted *The Large Grey Circus* and *The Woman on a Trapeze* (Fig. 41) (the date of which is uncertain). This latter work has a richly textured, dark grey monochrome ground from which the familiar figures of the circus ring materialize as if 'through a glass darkly', the glow of light catching on sequins and tulle as the performers work their magic. Chagall was in his late 80s when he painted *The Large Grey Circus*, and these final circus images (see also *The Grand Parade*, 1979–80) can be seen as both a reprise and a requiem as a life-time of picture-making drew to its close. Here, on a light grey monochrome ground, with spectators banked up tier on tier, the people of the circus – musicians, a brightly costumed harlequin and an equestrienne – acknowledge the greeting of a figure who stands with arms outstretched in the centre of the ring. It is Chagall as a young man, and he comes, in this elegiac work, to pay homage to figures who, for him, embody all that is human, all that connects with his own art and its place in the world.

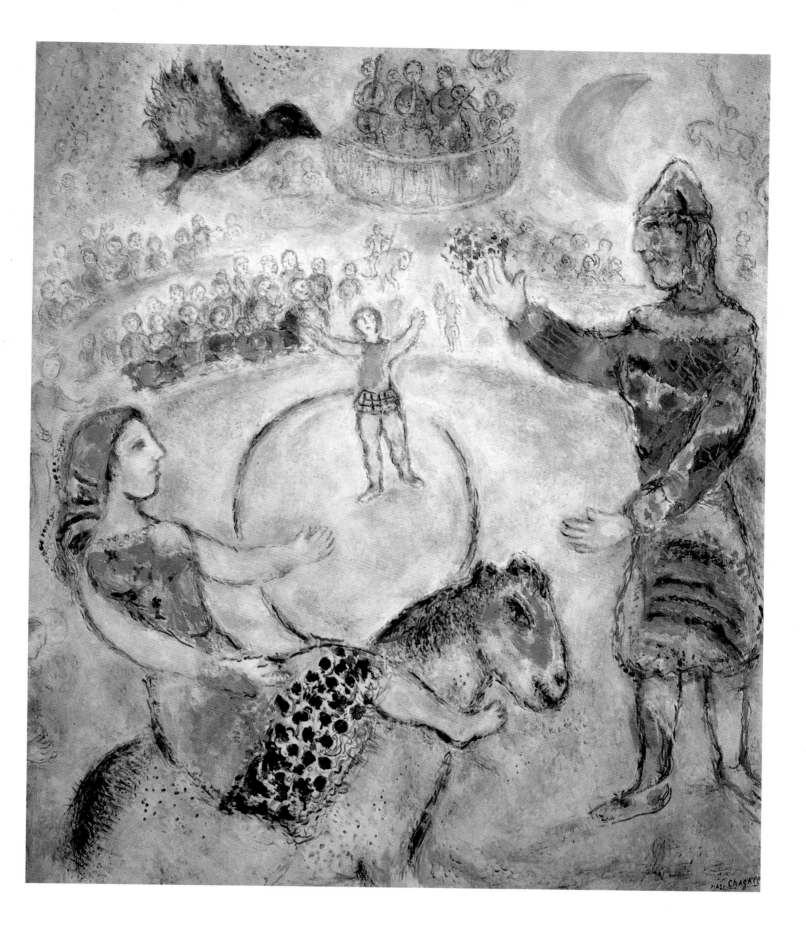

PHAIDON COLOUR LIBRARY
Titles in the series

FRA ANGELICO
Christopher Lloyd

BONNARD
Julian Bell

BRUEGEL
Keith Roberts

CANALETTO
Christopher Baker

CARAVAGGIO
Timothy-Wilson
Smith

CEZANNE
Catherine Dean

CHAGALL
Gill Polonsky

CHARDIN
Gabriel Naughton

CONSTABLE
John Sunderland

CUBISM
Philip Cooper

DALÍ
Christopher Masters

DEGAS
Keith Roberts

DÜRER
Martin Bailey

DUTCH PAINTING
Christopher Brown

ERNST
Ian Turpin

GAINSBOROUGH
Nicola Kalinsky

GAUGUIN
Alan Bowness

GOYA
Enriqueta Harris

 (missing)

HOLBEIN
Helen Langdon

IMPRESSIONISM
Mark Powell-Jones

**ITALIAN
RENAISSANCE
PAINTING**
Sara Elliott

**JAPANESE
COLOUR PRINTS**
J. Hillier

KLEE
Douglas Hall

KLIMT
Catherine Dean

MAGRITTE
Richard Calvocoressi

MANET
John Richardson

MATISSE
Nicholas Watkins

MODIGLIANI
Douglas Hall

MONET
John House

MUNCH
John Boulton Smith

PICASSO
Roland Penrose

PISSARRO
Christopher Lloyd

POP ART
Jamie James

**THE PRE-
RAPHAELITES**
Andrea Rose

REMBRANDT
Michael Kitson

RENOIR
William Gaunt

ROSSETTI
David Rodgers

SCHIELE
Christopher Short

SISLEY
Richard Shone

**SURREALIST
PAINTING**
Simon Wilson

**TOULOUSE-
LAUTREC**
Edward Lucie-Smith

TURNER
William Gaunt

VAN GOGH
Wilhelm Uhde

VERMEER
Martin Bailey

WHISTLER
Frances Spalding

CHAGALL